VISION
ARY

VISION
ARY

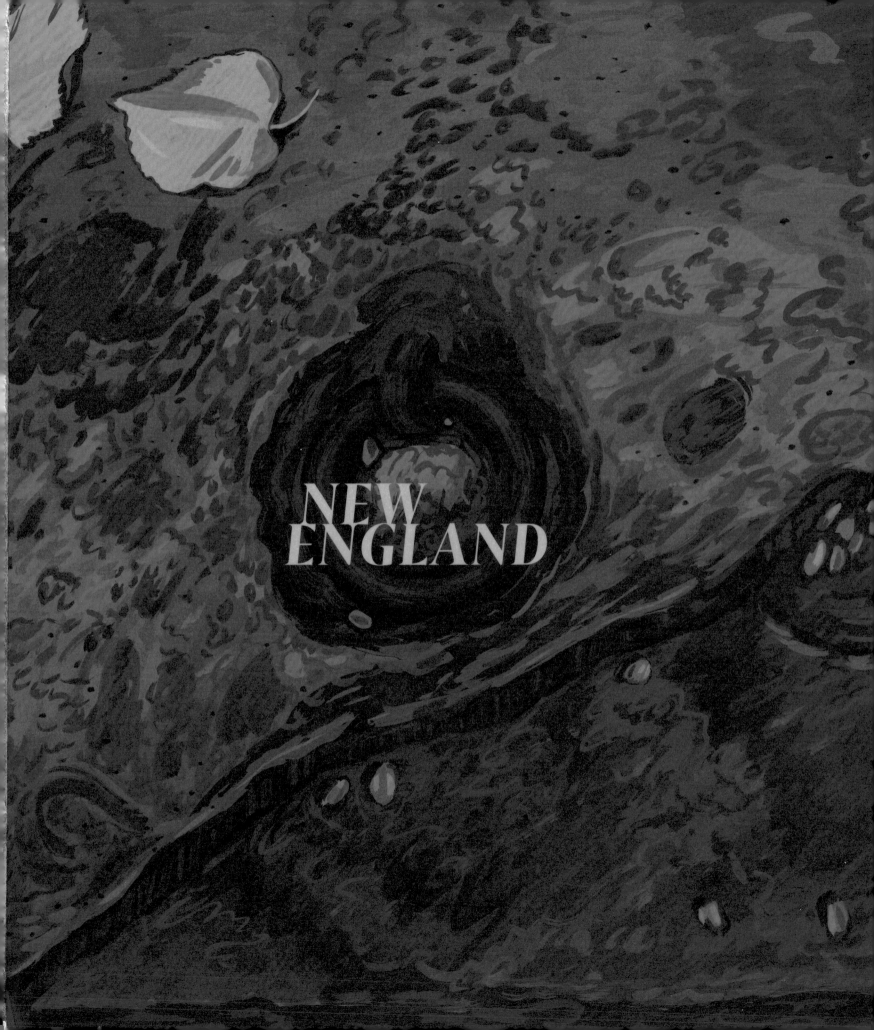

NEW
ENGLAND

NEW
ENGLAND

VISIONARY NEW ENGLAND

Edited by Sarah Montross

WITH CONTRIBUTIONS BY
Sam Adams
Anna Craycroft
Lisa Crossman
Richard Hardack
Scout Hutchinson
Paul Laffoley
Candice Lin
Sarah Montross

deCordova Sculpture Park and Museum
Lincoln, Massachusetts

The Trustees of Reservations
Boston, Massachusetts

The MIT Press
Cambridge, Massachusetts,
and London, England

Contents

Visionary New England is an innovative interdisciplinary exhibition that makes connections between the art, history, and culture surrounding deCordova Sculpture Park and Museum. DeCordova is set in the heartland of transcendentalism. Walden is just one pond over, and other sites of visionary enterprise are nearby—from the utopian Brook Farm Institute of Agriculture and Education to the spiritualist camp of Lake Pleasant. *Visionary New England* takes this history as a basis for exploring the continuing legacy of the utopian, spiritualist, and mystical practices in the region since the 1840s.

The exhibition features the work of ten contemporary artists—from self-trained to internationally renowned—who are involved in spiritually motivated practices or addressing ecological, political, and cultural concerns. Through painting, installation, photography, and the moving image, the exhibition tells some of the many stories of New England that have been overlooked. The inclusion of historical objects and artifacts adds another layer, offering our audiences an understanding of how past and present inform each other.

DeCordova has a strong tradition of presenting insightful modern and contemporary exhibitions that focus on the art of New England, often as a springboard to exploring ideas of national and international relevance. *Visionary New England* continues this trajectory, grounding its focus in the wealth of fascinating stories native to the region. These, in turn, offer compelling models of great relevance for today's fast and fractured society.

Some of the core ideas of this show were inspired by artists represented in deCordova's permanent collection, such as Latvian-born Boston artist Hyman Bloom, with his connections to mysticism and the occult, and Boston visionary artist and architect Paul Laffoley. In the lead-up to the exhibition, deCordova offered residencies to two of the contemporary artists whose works appear in *Visionary New England*, Anna Craycroft and Candice Lin. In creating her outdoor sculpture, Craycroft collaborated with faculty and students from Lincoln Nursery School on deCordova's campus—the first preschool embedded in a contemporary art museum. Lin spent time in the area over the summer of 2019 conducting research in archives and museums for her installation *La Charada China*. In addition, we are delighted to partner with the Fitchburg Art Museum and Fruitlands Museum—each presenting related exhibitions at the same time as *Visionary New England*. Promising collaborations with several area partners will round out the offering of educational programs.

We are grateful for the generosity of our major funders: the Henry Luce Foundation, the National Endowment for the Arts, and the Andy Warhol Foundation for the Visual Arts. The MIT Press, as our copublisher, has supported the catalogue distribution to ensure a wider readership. We are also indebted to the Trustees of Reservations, the venerable Massachusetts organization with whom deCordova has recently joined, for its support of this project.

It is my pleasure to also recognize the many deCordova staff involved in making this exhibition possible, most notably Senior Curator Sarah Montross, who, as ever, pursued an inspired idea with a scholarly approach and a generosity of spirit to create an exemplary, visionary exhibition and publication.

JOHN B. RAVENAL
Vice President of Arts and Culture, The Trustees of Reservations
Artistic Director, deCordova Sculpture Park and Museum

Acknowledgments

In 2015 I moved back to my home state, Massachusetts, for a curatorial position at deCordova Sculpture Park and Museum. Having not lived here for almost fifteen years, I found myself reengaging with the area's art, culture, and history in ways that were uncannily familiar yet totally new and strange. Prompted by a quest to understand the less commonly told stories of the region, I found myself making trips to places like Brook Farm in West Roxbury and Dogtown, near Gloucester. I also began having conversations with many people about defining New England's character by its seekers, reformers, and eccentrics, rather than its Puritanical work ethic, conformity, and thriftiness. I was fascinated by the legacy of utopian experiments and spiritualist practice of the mid-nineteenth century and how such beliefs and reforms have remained in this region over time. From these notions I started forming the ideas behind *Visionary New England*, a contemporary art exhibition and historical research project that continues to expand, even as I try to consolidate such efforts within this catalogue. Marrying aspects of ecology, faith, and pedagogy, this show argues for a regional artistic and cultural legacy that resonates in the work of many contemporary artists today.

First and foremost, I wish to thank the artists (and their representatives) for their collaboration and support: Gayleen Aiken, Caleb Charland, Anna Craycroft, Angela Dufresne, Sam Durant, Josephine Halvorson, Paul Laffoley, Candice Lin, Michael Madore, and Kim Weston. All have generously shared their artwork, ideas, and creativity to this collective, eclectic end. In particular, Anna Craycroft and Candice Lin devoted extensive time and energy as artists-in-residence to developing revelatory installations based on their research in area archives and collections. Their projects will continue to develop even as this publication is finalized in the months before the show's opening.

Visionary New England results from a collective body of knowledge generated from numerous contributors and collaborators. I am especially grateful to the MIT Press for its willingness to copublish this catalogue, allowing the exhibition's resources and propositions to live on past its display. Roger Conover, former executive editor, the MIT Press, believed in this project from its earliest stages, and I am grateful for his guidance through its realization. The book was designed and produced by Lucia|Marquand: thanks to Adrian Lucia, Meghann Ney, Melissa Duffes, Kestrel Rundle, and Leah Finger for their superb production. A particular debt is owed to designer Zach Hooker for his ability to synthesize such a visually diverse project. I am thankful to Kristin Swan, whose editing elevated our writing and deepened our ideas. I am also proud of the original contributions by Richard Hardack, Lisa Crossman, Anna Craycroft, and Candice Lin. Profound thanks are due to Scout Hutchinson, former curatorial assistant, for her exceptional contributions to this project, both during and after her time at deCordova.

The exhibition was made possible by many galleries, lenders, museums, and archives that willingly shared artwork and materials. Special thanks to Ananda Ashrama, La Crescenta, California; Oona Beauchard, Massachusetts Historical Society; Elyse and Lawrence B. Benenson Collections; Eve Brant, Harper's Magazine; Leone Cole, Watertown Free Public Library; Amanda Gustin, Vermont Historical Society; Alden Ludlow and Taylor Kalloch, Wellesley Historical Society; Anne L. Moore,

W. E. B. Du Bois Library at University of Massachusetts Amherst; Anna Mucchi, Reggio Children; Martha Oaks, Cape Ann Museum; Andy O'Brien, DownEast; Marie Panik, Historic Northampton; R. J. Phil, fine art photographer; Jessica Roscio, Danforth Art Museum; Kathy Stark, G.R.A.C.E.; Gan Uyeda, François Ghebaly Gallery; Douglas Walla, Kent Fine Art; Jessica Witkin, Blum & Poe, Los Angeles; and Rachel Arauz, Lorri Berenberg, Greg Mallozzi, Sister Murti Mata, Mary Mathias, Ed Shein, Ronni Simon, and Frank Williams.

I am deeply grateful to work at deCordova Sculpture Park and Museum and cannot imagine a more suitable setting for this exhibition than a place where art, nature, and education are central to its mission. More than that, I am lucky to work with colleagues who are smart, generous, collaborative, and (most importantly) warm spirited. Elizabeth Upenieks, curatorial assistant, was exceptional in organizing every aspect of the exhibition and catalogue. Sam Adams, Koch Curatorial Fellow, ably contributed to the catalogue and has been a whip-smart collaborator throughout. Christine Granat, registrar; Ross Normandin, head preparator; and Cody Mack, associate preparator, make our shows physically possible, and I cannot thank them enough for devoting themselves so fully to the logistical challenges of such a complex undertaking.

I greatly value the support and vision of John B. Ravenal, vice president of arts and culture, the Trustees of Reservations, and artistic director, deCordova Sculpture Park and Museum, who has fostered a unique environment at deCordova that makes projects like *Visionary New England* possible. I further appreciate deCordova's Advisory Board and the Collections and Exhibitions Committee for their steadfast support. My current and former colleagues in deCordova's Engagement Department, Julie Bernson, Emily Silet, Rachael Kelly, and Sarah Brockaway, are tremendous collaborators who always elevate the level of education and outreach around our exhibitions. Over the course of this show's planning, deCordova integrated with the Trustees of Reservations. In that time, new colleagues, including Kord Jablonski, deCordova's business director, have energized our institution. My gratitude extends to the Communication Department at the Trustees of Reservations, as well as to the visionary leadership of the organization, helmed by Barbara Erickson,

president and CEO. I am additionally grateful to my colleagues Christie Jackson, Sarah Hayes, and Allison Bassett, among many others across Trustees' properties. Extra-special thanks to grant writer Sarah Rothschild, who cowrote and helped navigate many grant applications with significant results. Thank you to our welcoming museum guides and the visitor services team who promote the interpretation and safe display of the work on view.

In preparing this exhibition, I benefited from two unique opportunities for research and discourse. The Clark Art Institute's Summer Collaborative Working Fellowship in 2018 offered me—along with two colleagues, Shana Dumont Garr, curator, Fruitlands Museum, and Lisa Crossman, curator, Fitchburg Art Museum—unparalleled time and resources in the stunning foothills of the Berkshires. I also organized an all-day working group at deCordova in early March 2019 with a group of artists and scholars, including Susan Aberth, Lisa Crossman, Tim Devin, Angela Dufresne, Shana Dumont Garr, Cat Holbrook, Diana Limbach Lempel, Alexis Turner, and Kim Weston. I thank them all for their enthusiastic participation and scholarship.

Shana Dumont Garr and Lisa Crossman have organized concurrent exhibitions with strong thematic ties to *Visionary New England* at their respective museums. I have valued their enriching conversations throughout this process and appreciate that we can strengthen ties among museums in the greater-Boston region through our collaboration. I also am deeply grateful to researcher-in-residence Diana Limbach Lempel.

My thanks extend to the many colleagues and friends, including: Dan Byers, Jeff DeBlois, Dina Deitsch, Daisy Nam, Rory O'Dea, Jenny Parsons, Martina Tanga, and Ellen Tani. Special thanks to my family and Jay Scheib for their support and love.

Lastly and most crucially, *Visionary New England* was made possible through major grants from the Henry Luce Foundation, the National Endowment for the Arts, and the Andy Warhol Foundation for the Visual Arts. I am profoundly grateful for such generous funders who continue to support artists and validate our role as curators.

SARAH MONTROSS
Senior Curator

D uring the early 1850s, the Boston painter Josiah Wolcott began attending sessions with mediums communing with spirits of the dead. Afterward, he described being overcome by a strong presence while creating new artwork:

> During the painting of these pictures I felt an unusual glow of enthusiasm and most thrilling pleasure. My hand seemed to move with unusual ease and freedom. . . . Something kept saying within "Paint! Paint! Paint these Pictures!" The spirits insist upon it that I must give up my present employment and paint the pictures they present me, that the world may have some visible representations of the glories of the future life.[1]

One of the works he created after these trance-induced sittings is *Invitation to the Spirit-Land* (fig. 1.1),

the 1840s to the merging of mysticism with experimental psychology at the turn of the twentieth century, the northeastern United States has long nurtured alternative ways of creating community along with societal and individual reform. These outlooks often merge a direct and divine communion with the natural world with a search for access to realms of higher powers. Grounded in this rich legacy, *Visionary New England* features the work of ten contemporary artists who have strong regional ties and/or have created artwork that concerns these topics: Gayleen Aiken, Caleb Charland, Anna Craycroft, Angela Dufresne, Sam Durant, Josephine Halvorson, Paul Laffoley, Candice Lin, Michael Madore, and Kim Weston. From painting to moving image, outdoor installation to photography, their works communicate a range of ideas about animism, mysticism, and utopian belief. Combined with these contemporary works, the exhibition and catalogue feature related

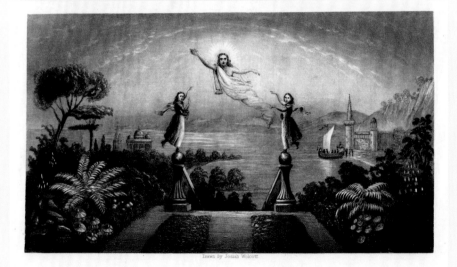

FIG. 1.1 Josiah Wolcott (1814–1885), *Invitation to the Spirit-Land*, 1853, frontispiece, in John W. Edmonds and George T. Dexter, *Spiritualism* (1853). Courtesy of the Boston Athenæum.

a scene of gauzy allegorical figures beckoning us into a paradisiacal landscape where a gondola readies passengers for a voyage across a vast, calm sea. Connecting his creative impulses to communication with the afterlife, Wolcott reveals a crucial, yet often unacknowledged, bond between spirituality and art that has long persisted in the Northeast.

Visionary New England is inspired by such mystical, spiritualist, and utopian activities in the region. From the formation of utopian agrarian communities in

art and artifacts from the 1840s onward, positing a reciprocal relationship between past and present creative forces.

From the trials of alleged witches in Massachusetts during the 1690s to the growth of Shaker communities and the Great Awakening across the Northeast and New York in the mid-1700s, episodes of esoteric faith-based practices course through the region's land and peoples. In an effort to bracket the already vast temporal scope of these subjects,

FIG. 1.2 Hyman Bloom (1913–2009), *The Harpies*, 1947, oil on canvas, 35¼ × 55½ in. Collection of deCordova Sculpture Park and Museum: Gift of the Estate of Dr. and Mrs. Abraham Pollen, by exchange; 2018.2.

Visionary New England begins in the mid-nineteenth century with the formation of utopian communities across New England (and the United States).[2] Among the best known of these experiments are the Brook Farm Institute of Agriculture and Education (West Roxbury, Massachusetts, c. 1841–1846), Fruitlands (Harvard, Massachusetts, 1843), and Northampton Association of Agriculture and Education (Florence, Massachusetts, 1842–1846).[3] These were founded by ardent advocates for social and labor reform amid a period of national upheaval in reaction to the dehumanizing effects of the Industrial Revolution. The communities devised innovative models for cooperative labor and communal living in which all members, including women, shared profits gained from agricultural pursuits.

As with many utopian pursuits, these communities were short lived, eccentric, and flawed. The ideals and energy required to support them were rarely sustainable, nor did they actually reach the levels of gender or racial equity that were publicly promoted. Some of the living conditions and restrictions placed on members proved untenable as the realities of hunger, exhaustion, and discord set in. Yet the aims of self-sufficiency, social reform, progressive education, and a spiritual communion with

nature have since persisted in the region, taking new forms and remaining relevant to this day.

Moving forward in time from these experimental settlements, this exhibition links together episodes of alternative belief systems, world building, and visionary enterprise with correlative artistic practice. In so doing, *Visionary New England* recognizes a kinship across space and time among artists and thinkers who may have been considered outliers to canonical art history. Some have likely been overlooked due to the spiritual or theological dimensions of their work, as such topics often rest uneasily in the context of modern society—even as some of its institutions, such as museums, are endowed with a secular spiritual status. For instance, the work of Latvian-born, Boston-based artist Hyman Bloom (fig. 1.2) has often been interpreted in terms of mid-twentieth-century debates in American art, particularly the rise of Abstract Expressionism. Yet in the context of this exhibition, new possibilities for interpretation and artistic connection arise. As recent scholarship has shown, Bloom was profoundly invested in mysticism and esoteric philosophies, attending meetings at the Theosophical Society and the Boston Society of Psychical Research in the late 1930s.[4] His focus on mortality and transcendence resonates with the

concerns of Ivan Albright, who lived in Chicago for most of his life but continued to unite the spiritual and material in works made after he moved to Vermont in 1965, such as a hallucinatory portrait of his aging neighbor (fig. 1.3).

Visionary New England advances a small yet significant swell of recent scholarly and curatorial efforts addressing spirituality in modern and contemporary art. Thomas Crow's *No Idols: The Missing Theology of Art* (2017) acknowledges how religion (specifically Christianity) has been largely ignored in the analysis of modernist and postmodernist art and visual culture. An earlier precedent, *The Spiritual in Art: Abstract Painting, 1890–1985*, was organized by Maurice Tuchman for the Los Angeles County Museum of Art in 1986. More-recent retrospectives, such as *Hilma af Klint: Paintings for the Future* (Guggenheim Museum, 2018) and *Agnes Pelton: Desert Transcendentalist* (Phoenix Art Museum, 2019), indicate a revival of such inquiries through the work of individual female artists. Yet few treatments have included figures from New England, even though the region was and still is a center for the mingling of spirituality, creativity, and intellectual life.[5] *Visionary New England* is further indebted to major undertakings such as Lynne Cooke's *Outliers and American Vanguard Art* (National Gallery of Art, 2018), which probed the intersecting categories of self-taught art, folk art, and modern and contemporary art. *Visionary New England* develops from this repositioning of cultural hierarchies (shaped by the market and museums) and integrates work by artists of distinct experiences and exposure, from self-taught artists to well-established figures in the contemporary art world.

What does *visionary* mean in the context of this exhibition? The term arguably carries clichéd connotations, suggesting one is "touched" by a divine, outside force. Here it applies to a broad range of creators: from those who devise innovative solutions to humanity's problems to artists who create highly personal reflections of their inner worlds. "Visionary" refers to the use of mind-altering substances, hypnosis, and experimental therapies by artists detailing communion with realms beyond our physical world (see plates: Paul Laffoley and Kim Weston). It also describes work that evokes an interconnected world in which organic and inorganic entities communicate and share equal degrees of agency (see plates: Anna Craycroft and Michael Madore). Relatedly, several artists derive their work from an intensely focused, unfiltered perception of nature that recalls Christopher Pearse Cranch's iconic caricature of Ralph Waldo Emerson as a "Transparent Eyeball" (fig. 1.4; see plates: Caleb Charland and

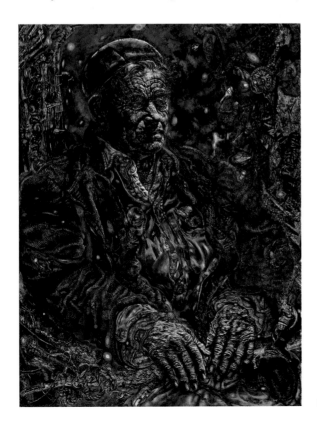

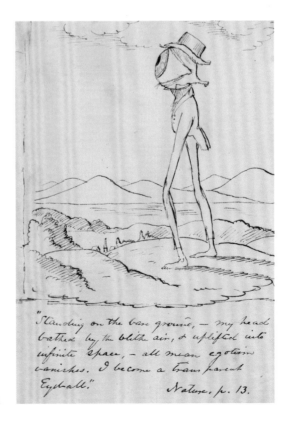

FIG. 1.3 Ivan Albright (1897–1983), *The Vermonter (If Life Were Life There Would Be No Death)*, 1966–77, oil on Masonite, 34¼ × 26½ in. Hood Museum of Art, Dartmouth: Gift of Josephine Patterson Albright, Class of 1978HW; P.985.31.

FIG. 1.4 Christopher Pearse Cranch (1813–1892), "Standing on the bare ground,—my head bathed by the blithe air, & uplifted into infinite space,—all mean egotism vanished. I Become a Transparent Eyeball," *Illustrations of the New Philosophy*, 1837–39, ink on buff paper, 7⅞ × 4¾ in. Houghton Library, Harvard University; MS Am 1506, (4).

Josephine Halvorson). Other artists bring to light the intersections of race, gender, and labor that are less visible in standard narratives of New England history (see plates: Sam Durant and Candice Lin). Still others picture or reference utopian gatherings of people who buck conformity and prioritize community and learning (see plates: Gayleen Aiken and Angela Dufresne).

Straddling the realms of belief and doubt, much of their work is not aligned with religious doctrine but conveys worldviews gained through forms of knowledge outside of official commercial, institutional, or governmental structures. For example, Candice Lin practices an embodied process of research and artistic creation for some of her work. She imbibes self-made tinctures with psychoactive substances like opium or datura and creates new work

FIG. 1.5 Candice Lin (b. 1979), *Yucca thompsoniana*, 2019, parasitic wasp and oak gall ink on blotting paper with plant remnants, 13½ × 11 in. Courtesy the artist and François Ghebaly, Los Angeles.

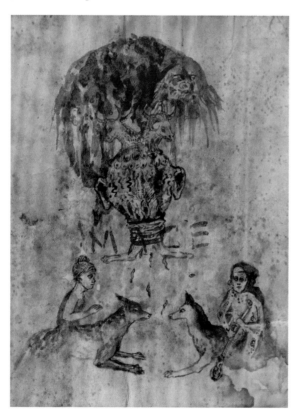

while under the influence (fig. 1.5). This method is less about inducing a hallucinatory state of mind and more directed at reaching a subjective understanding of substances—including those purveyed by New England merchants of the nineteenth century, such as opium—that have played a crucial role in the development of colonial economies.

For other artists in *Visionary New England*, art making is a container for spiritual practice and even

healing. Josephine Halvorson describes her experience of painting outdoors as "prayer-like," although she approaches terms like *faith* with a degree of caution.[6] Her paintings do not immediately suggest devotional subjects, but she ties her work to our collective questioning of truth in contemporary media. In that context, her observational compositions derive from a persistent, evidence-based seeking similar to Lin's. Through her intensely focused perceptual studies of nature and their translation into paint, Halvorson experiences a communion with nonhuman, nonliving entities and other elements that go beyond tangible perception. Out of a similar desire for transcendence, Kim Weston takes photographs at Native American powwows that she, her wife, and children witness and participate in. Her evocative, flowing images bridge the physical world, elevated by dance, prayer, and the rhythm of the drum. Yet this work is grounded by Weston's concern about crises within Native communities, where women suffer from astounding rates of violence with little recourse or recognition. Her photographic installations thus convey abhorrent realities while embodying the capacity of art and performance to elevate awareness and foster collective healing.

This exhibition stems from a desire to reevaluate a well-worn trajectory of modernism that German sociologist Max Weber described as the growing "disenchantment of the world." In this reading of modern life since the Enlightenment, the world has been increasingly drained of irrational or magical thinking, as once-mysterious phenomena have been explained and made terrestrial through the "triumph" of the scientific method. Historian Krister Dylan Knapp writes that these losses "include the crisis of faith in an increasingly secular world . . . an age of statistical expressions of knowledge claims and the decreasing role of subjectivity, personal experience, and intuition in a world of scientific experiment, empirical methodologies, and mathematical measurement of natural phenomena."[7] However, rational or data-driven thinking did not fully supplant intuitive or faith-based inquiry during the twentieth and twenty-first centuries. Rather than accept Weber's division of modern life into rigid binaries, this exhibition features artists, creatives, and thinkers whose work spans spiritual and material matters. These tendencies have endured for centuries in New England, as art

historian Charles Colbert writes in his revealing account *Haunted Visions: Spiritualism and American Art*: "Puritans shunned the practice of magic, and devotees of the Enlightenment cast a jaundiced eye on 'superstition' but, as populations spread after the Revolution into regions previously uninhabited, social restraints weakened and folkways flourished. Rural Yankees increasingly revived practices that had never quite disappeared."[8]

Broad questions have guided this tracing of visionary art practice: How does knowledge move through time? How is it taught to, inherited by, and adapted among younger generations in response to their own historical context? Why are we currently witnessing a surge in spiritual, mystical, and utopian practices in contemporary art? *Visionary New England* considers how, in reaction to technological overload, apocalyptic ecological devastation, increasing economic disparity, and corporate control, many of us are seeking reforms and ways of living that share principles established by utopian thinkers of the nineteenth century. At the same time, we are reckoning with the weight of these histories—particularly the enduring forms of oppression and inequity that were formed or embraced during this time period and have become codified in our present day.

The exhibition's strategy for display and interpretation is inspired partly by author and naturalist John Hanson Mitchell's concept of "ceremonial time," a theoretical and physical space in which past, present, and future can be perceived simultaneously. His book *Ceremonial Time: Fifteen Thousand Years in One Square Mile* is based on an intimate study of a small plot of land outside of Boston (just a few miles from deCordova Sculpture Park and Museum). It traces the passage of time since the last ice age, across many periods of human history, and includes the perspectives of Native Americans, colonists, witches, local farmers, and others. Mitchell makes the case that the character of a region embeds itself within a landscape and is passed down through written documents, oral traditions, and community-based rituals of diverse inhabitants and stakeholders. *Visionary New England* reminds us that artists, too, are linked to earlier figures through regional connections and shared spiritual sensibilities. As painter Marsden Hartley remarked about his predecessor Albert Pinkham Ryder:

When I learned he was from New England the same feeling came over me in the given degree as came out of Emerson's Essays when they were first given to me—I felt as if I had read a page of the Bible. All my essential Yankee qualities were brought forth out of this picture. . . . It had in it the stupendous solemnity of a Blake mystical picture and it had a sense of realism besides that bore such a force of nature as to leave me breathless.[9]

Three themes are central to *Visionary New England*: Teaching Utopia, Is Spiritualism True?, and The Animistic Landscape. In each section that follows, the contributions of artists, scientists, and creative thinkers, past and present, are knit together in order to speak to how visionary practices transform and translate across time. Expanding beyond standard art historical discourse, this analysis draws heavily from cultural and social episodes in which science and faith are entwined. The subsequent texts in the catalogue by curator Lisa Crossman, literary scholar Richard Hardack, and artists Anna Craycroft and Candice Lin offer more focused treatments of these topics through the lenses of literature, pedagogy, and scientific inquiry. Additional resources begin to map some of the many communities, organizations, and instances of spiritual and utopian culture in the region since the 1840s. While not comprehensive, the examples cited in this catalogue offer a sense of the diversity and continuity in the region, in the hope that future scholarship and exhibitions may build on these areas of research.

I. TEACHING UTOPIA

To its colonizers since the early 1800s (if not earlier), New England's rural spaces have represented a "New Eden" where abundant natural resources and expansive acreage could provide paradise on earth. The utopian experiments of the nineteenth century coincided with an era of apocalyptic prophecy that had been coursing through the country since the late 1700s. Groups such as the Millerites met at vast gatherings where preachers would detail the Earth's end and the Second Coming of Christ through visual aids that foretold how and when this would occur (fig. 1.6). Whether utopian or doomsday driven, these future-minded organizations were motivated by hope and desperation to escape or improve an

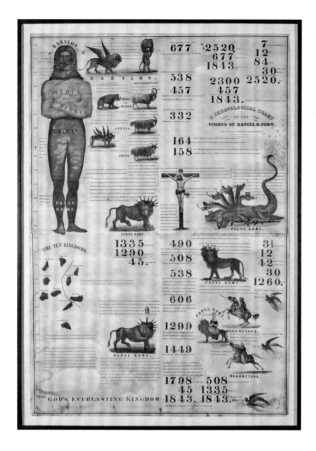

FIG. 1.6 After a design by Charles Fitch (1805–1844) and Apollos Hale (1807–1898), published by J.V. Himes, Boston, *A Chronological Chart of the Visions of Daniel & John*, 1842, hand-tinted lithograph on cloth, 55¾ × 39½ in. Fruitlands Museum Collection, The Trustees.

FIG. 1.7 J.P. Greaves (1777–1842) and Charles Lane (1800–1870), "Table of Circumstantial Law," 1840–44. Houghton Library, Harvard University: Amos Bronson Alcott papers, Autobiographical collections; MS Am 1130.11, (4).

THE CIRCUMSTANTIAL LAW.

The True Practical Socialist, being aware that Man is not a simple, but a compound, or, rather, a complex Being, whose threefold Character is formed by the threefold Law in the sympathetic, intellectual, and physical Circumstances, or Conditions, by which he is constantly surrounded, is desirous of presenting to such Law, in its several spheres, the circumstances most conducive to Man's harmonious development.

Though it be true that the CREATIVE POWER cannot properly be attributed to the CIRCUMSTANCES, because the latter term is used to designate the things which STAND ROUND something already created, yet, for as much as RESULTS can never be attained without circumstances, or conditions, or secondary causes, and it is only over these that Men individually, or socially, have any interfering power, the furnishing of suitable conditions, is a subject demanding the deepest consideration. While neither etymology, nor logic, nor truth, permits the assertion, that Circumstances form the Character; we may safely affirm that the END, or the CAUSE in CIRCUMSTANCES produces RESULTS.

The following Table is submitted as a Scheme, attempting to show the sort of conditions which should be offered in the Physical Sphere, according to the intention or desire for developing the higher or the highest natures. As a consequence it serves as a key to the interior state of any individual. Each one becomes in this manner a condition to others, for the evolution of the like nature, to that of which such conduct is an exhibition.

For the better understanding of the pure conditions, there is subjoined a hint of the present prevailing errors in each department.

Table No. 1. PHYSICAL CIRCUMSTANCES.

	AIR.	FOOD.	CLOTHING.	HABITATION	EMPLOYMENT	EDUCATION.	RELIGION.	MARRIAGE.
Best, for the Spirit Nature. Love Conditions.	Pure Balmy Atmosphere.	Ripe uncooked Saccharine Fruits.	Linen Robes	The Tent. An unfixed Locality.	The Orchard.	Progressive Gymnastic Exercises. Growth of Nerve.	Active Benevolence. Love for the unlovely.	Union of Spirit-selected pairs in sympathetic harmony.
Better, for the Soul, or Human Nature. Light Conditions.	Pure Temperate Atmosphere.	Green, or Succulent Vegetables.	Pervious and Flowing Cotton Garments; undyed.	The House: Social and scientific conveniences.	The Garden.	Progressive Gymnastic Exercises. Growth of Muscle.	Thoughtful benevolence. Thought for the thoughtless	Co-education, or betrothment of Spirit-selected pairs.
Good, for the Body. Life Conditions.	Pure Bracing Atmosphere.	Farinaceous Grain & Pulse.	Cotton or Hempen Dress, undyed.	The Public Hall. Accomodation, Rest and Amusement.	The Field.	Progressive Gymnastic Exercises. Growth of Bone.	Practical benevolence. Bread for the hungry.	Social intercourse of Families, Races and Nations.
Bad, for all Nature. Prevailing erroneous Conditions	Ill ventilated apartments; atmosphere corrupted in coal-dust, smoke, tobacco, &c.	Fermented and Cooked Fruits, Vegetables and Roots. Flesh of Animals. Fermented Liquors	Woollen fabrics, tight and impervious to perspiration; Animal skins; Metal decorations, &c.	Towns and Cities; dirty, dense & dark; Luxurious Mansions or dilapidated Cottages.	Exchange of Commodities, useful & useless. Factory & other Slave-Labour.	Treatment of the Being as a passive blank. Routine of discipline.	Physical representations and deadening Ceremonies.	Legal Bonds. Animal Lust.

Charles Lane

existence shaped by both the alienating effects of industrialization and the elevating belief that civilized perfection was attainable.

Some of these communities were linked to transcendentalism, the progressive philosophy and social movement that expanded outward from Boston during the 1820s and 1830s. George Ripley, a Unitarian minister and cofounder of the Brook Farm Institute of Agriculture and Education, announced his plans for the utopian settlement at a transcendentalist meeting in Boston in 1840. Philosopher and teacher Amos Bronson Alcott, cofounder of the Fruitlands community, was among the boldest advocates for living out transcendentalist ideals and was a close friend and intellectual partner of Ralph Waldo Emerson's and Henry David Thoreau's. Places like Brook Farm and Fruitlands were meant to be self-sustaining, deriving resources from the land worked through collective labor. Both imposed strict regimens for self-improvement; residents of Fruitlands were vegans, wore linen clothes, and were not allowed to use stock animals for farming. Fruitlands cofounder Charles Lane adapted a code of behavior called the "Circumstantial Law" (fig. 1.7); it detailed the most desirable conditions for living, which included residing in tents (rather than in permanently built, urban dwellings) and working in orchards (rather than in factories or any form of commercial enterprise that exploited slave labor). Most of the organizations strongly advocated for gender equity and abolitionism, although the demographics were far less equitable. David Ruggles, a militant abolitionist and fearless conductor of the Underground Railroad, was one of the few known African Americans who joined a New England utopian experiment, the Northampton Association of Education and Industry, in 1842/43.[10]

While these settlements were intensely creative in devising methods for living communally, relatively few visual artists were directly connected to them. Two of the only known paintings depicting Brook Farm are by Josiah Wolcott, who joined the community before his involvement with Spiritualism (fig. 1.8). Instead, some of the most substantial records related to utopian settlements are literary, often taking the form of memoir (some satirical and fictionalized), such as Nathaniel Hawthorne's *The Blithedale Romance* (1852) and Louisa May Alcott's *Transcendental Wild Oats* (1873). The former offers a darkly

humorous tale of a utopian agrarian community inspired by Hawthorne's experiences at Brook Farm, while Alcott's prose satire details the feckless leadership of the two leaders (modeled after the author's father, Amos Bronson Alcott, and his collaborator Charles Lane) of an experimental community based on her childhood experience living at Fruitlands. These accounts, "essentially a daydream, and yet a fact" (in Hawthorne's words),[11] affectionately critique the eccentric idealization of the founders, noting their blind arrogance and often unjust treatment of women. These written accounts coincided

farmhand to lawyer. Brook Farm was well known for its pioneering modern school, which sought to establish "a more natural union between intellectual and manual labor than now exists; to combine the thinker and the worker, as far as possible, in the same individual; to guarantee the highest mental freedom."[12] Before cofounding Fruitlands, Amos Bronson Alcott developed his educational methods, inspired by Swiss pedagogue J. H. Pestzalozzi, at his Temple School in Boston. There he modeled his instruction on a dialogic method, steering conversations with young pupils around virtues and

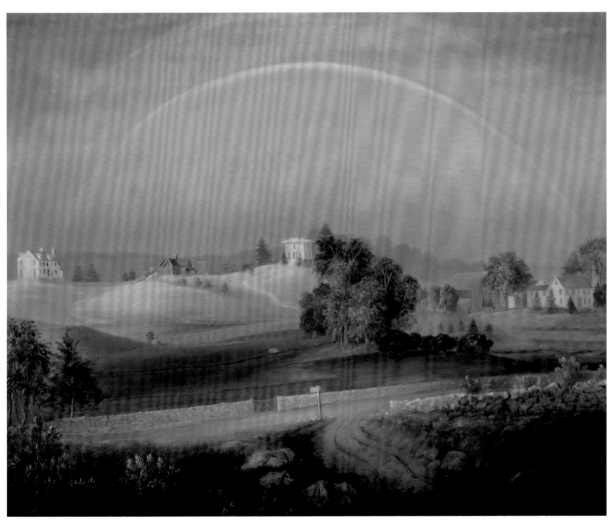

FIG. 1.8 Josiah Wolcott (1814–1855), *Brook Farm with Rainbow*, 1845, oil on canvas, 24⅛ × 29⅛ in. Collection of the Massachusetts Historical Society.

with a flourishing of utopian fiction, some of which was staunchly feminist, such as Charlotte Perkins Gilman's *Herland* (1915), which describes an isolated all-female society free of violence and corruption.

Despite the faults of agrarian communities of the nineteenth century, one of their most uplifting priorities was an emphasis on intellectual work and progressive education for all members, from

morals, the Gospel, and other advanced philosophical quandaries.

The primacy of education carried forward even as these social experiments ultimately failed and shuttered their doors. Certain methods of teaching inspired by utopian thinkers like Alcott were adopted by subsequent educators and became a conduit through which their ideals have passed on

through generations. Outside of the formal classroom setting, like-minded seekers of a syncretic spirituality also established seasonal gatherings focused on self-education beginning in the late nineteenth century. Because these groups met for shorter periods of time, typically in the summer, they did not require the same level of extreme self-sufficiency or separation from society as the earlier utopian settlements. Often these assemblies, whether rural or urban, were convened by women and privileged collective education and learning. For example, in 1894 the transcendentalist Sarah J. Farmer established Greenacre in Eliot, Maine, where progressive intellectuals, artists, and writers met each summer to discuss Eastern religions, theosophy, the arts, and the sciences (fig. 1.9). As cultural historian Leigh Eric Schmidt writes, "Greenacre was among the greatest sources of religious innovation anywhere in the country. It was the last great bastion of Transcendentalism, a school of philosophy and art for Emersonians and Whitmanites."[13] As a young man in 1907, painter Marsden Hartley worked at Greenacre, where he encountered mysticism for the first time, writing that "God has breathed on these acres . . . and we want the Godbreath to stay"[14] (fig. 1.10).

The presence of these and subsequent collectives may also connect to New England's receptivity to the numerous artist residencies and summer schools—such as the Cornish Art Colony in New Hampshire and Haystack Mountain School of Crafts in Maine—that were founded from the late nineteenth and through the twentieth century. These self-sustaining art environments in remote natural settings were catalysts for vibrant cross-disciplinary experiments in design, craft, and art. While not strictly utopian in their mission, they still channeled progressive ways of shared living and creating that "participated in a long tradition of craft-based idealism grounded in the union of art and life."[15] New residencies and summer collectives formed amid the return of social experiments across New England (and the nation) during the rise of countercultural movements in the mid-to-late twentieth century. From communes in rural Vermont (fig. 1.11) to urban collectives and educational centers like the Fayerweather Street School in Cambridge, Massachusetts, these latter-day utopian projects constituted a reflourishing of communalism not present since the 1840s.[16]

From past to present, many of these groups practiced experimental and experiential learning that echoes the philosophies of radical nineteenth-century pedagogues, such as Alcott and Elizabeth Peabody (who worked at Alcott's Temple School and opened the first kindergarten in the United States).

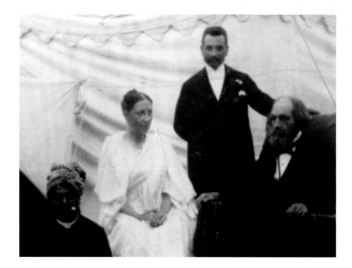

FIG. 1.9 Dignitaries at Greenacre, 1894, photo-transparency, 15⅞ × 10⅜ in. Collection of Eliot Baha'i Archives.

FIG. 1.10 Marsden Hartley (1877–1943), *Raptus*, c. 1913, oil on canvas, 39⅜ × 32 in. Currier Museum of Art, Manchester, New Hampshire: Gift of Paul and Hazel Strand in Memory of Elizabeth McCausland; 1965.4.

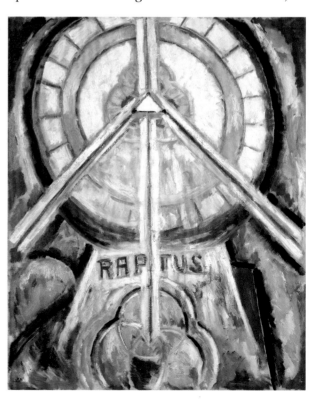

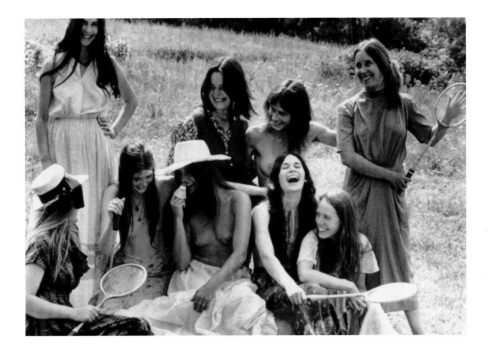

Artist Anna Craycroft's project *Common Conscience* for *Visionary New England* stems from her research into the legacy of Alcott's methods of childhood education, which she details in her essay in this catalogue (see also plates: Craycroft). Rejecting repressive techniques of harsh discipline and rote memorization, Alcott believed the divine existed in children and that in an open, discursive environment, students would better understand and share social mores.[17] Craycroft connects this outlook of a collective student body to the behavior of New England flora, especially mosses, that communicate underground in ways that recall the oral traditions of Alcott's methodologies.

Fellow artists in *Visionary New England* engage with kinship formation that decenters the primacy of the nuclear family or imagine it as a much-expanded form, as was often the case in past and present utopian experiments. Twentieth-century folk artist Gayleen Aiken of Vermont created drawings, puppets, and diaries that chronicle episodes of learning and play with her imagined family, the Raimbilli cousins (see plates: Aiken). She created an entirely idealized, harmonious world based on her fictional memories of the sweeping Vermont countryside, nearby granite factories, and her family home. Familial gatherings and intergenerational dynamics of learning and play are also powerful motivators in the work of Angela Dufresne (see plates: Dufresne). Her unflinching paintings show furtive acts of instruction taking place in remote,

luminous landscapes that recall nineteenth-century paintings of the Hudson River School. In her work, human bodies are porous and even grotesque—some figures are also interspecies or ambiguously gendered. The unmistakable intimacy of these gatherings, which are further charged by the nudity of many figures, expresses a commitment to what Dufresne calls "feminist audacity," a utopian privileging of female desire that in modern society seems delusional or doomed to fail.[18] By presenting a world that dissolves hierarchies, where bodies fuse with their environments, Dufresne's pastoral gatherings prioritize mutability and impurity.

II. IS SPIRITUALISM TRUE?

There is a wide realm lying between the known physical and the comparatively unknown spiritual—a realm as yet almost entirely unexplored.

—WILLIAM AND ELIZABETH M. F. DENTON,
Is Spiritualism True?, 1874[19]

In 1871 William and Elizabeth Denton of Wellesley, Massachusetts, published a treatise titled *Is Spiritualism True?* in which they defined Spiritualism as a "belief in the communication of intelligence from the spirit of the departed, commonly obtained through a person of susceptibility, called a 'medium.'"[20] The book unfolds as William Denton details countless accounts of his wife's and sisters'

communication with the afterlife, accumulating into a dossier in support of Spiritualism based on detailed witnessing of phenomena. The Dentons were among many observers of Spiritualist activities in the region, a movement that emerged in the 1850s and that involves mediumship, clairvoyance, trance states, and séances. Offering a space for self-expression, mediumship was primarily the domain of women, as Lisa Crossman explores more fully in her essay in this volume. Some of its most famous practitioners, such as Mina Crandon (known as the "Boston Medium"), were based in New England.

As the question mark in the Dentons' title implies, spiritualist practices were constantly questioned or investigated as fraudulent. Debates around the verification of immaterial realms were often connected to vision and tactility, as parapsychological

belief systems to progressive values, such as abolitionism, temperance, vegetarianism, and equality in marriage and property rights.[22] In this regard, the pursuit of spirit communication was aligned with the desire to elevate the individual and society.

Acceptance of Spiritualism shifted around the turn of the century, as debates around this and related psychical phenomena are tied to the emergence of psychology and related social sciences as academic fields. Prominent social scientists, doctors, and philosophers, such as James H. Hyslop and William James, supported claims that psychical phenomena should be investigated through scientific methods. They and other psychologists and scientists were active members of the American Society for Psychical Research (with an office on Beacon Hill in Boston), which was dedicated to inquiry into

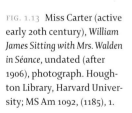

FIG. 1.12 William H. Mumler (1832–1884), *Mrs. Tinkham*, 1862–75, albumen silver print, 3¾ × 2¼ in. The J. Paul Getty Museum, Los Angeles; 84.XD.760.1.7.

FIG. 1.13 Miss Carter (active early 20th century), *William James Sitting with Mrs. Walden in Séance*, undated (after 1906), photograph. Houghton Library, Harvard University; MS Am 1092, (1185), 1.

events were proved through sight and touch. Photographs became a prominent form of evidence of contact with the afterlife. As it became more publicly accessible in the 1850s, photography was taken up by figures such as the Boston-based William H. Mumler, who created double portraits of subjects beside spectral images of their deceased loved ones via a wet-collodion process (fig. 1.12). Despite how easily we now recognize the visual trickery of spirit photography, these images were born from profound concerns about the mysteries of mortality and the desire to transcend worlds beyond our own.[21] Further, many Spiritualists connected their

paranormal activities. Hyslop attended sessions with the Boston medium Leonora Piper in the late 1880s and later reported communicating with deceased family members in his book *Science and a Future Life* (1905). James's life and work were equally infused by psychical research, attending séances, and publishing widely on the subject while he was based at Harvard University (fig. 1.13).

Despite a commitment to understanding psychical phenomena, James was not a true believer in or practitioner of Spiritualism.[23] Psychical phenomena appealed to James as part of his broader commitment to debunking all manner of dualisms, including

"natural versus supernatural and the normal versus paranormal."[24] As the modern research laboratory and methods for scientific demonstration codified in the early twentieth century, some of James's contemporaries strongly contested his open-minded approach to extrasensory perception. These debates were both crucial to the formation of the field of psychology and indicative of growing discomfort with and anxiety about the presence of alternative belief systems and faith-based approaches within the academy (and modern institutions as a whole). As historian Krister Dylan Knapp writes, "It was the common appeal to facts that eventually made an empirical science out of psychology and allowed it to separate itself from speculative metaphysics and religion."[25]

Among James's most vocal opponents was Hugo Münsterberg, a German American psychologist

condition, and his laboratory studies at Harvard contributed to the development of film theory and neuroaesthetics. In that regard, some of his work operates as a hinge between the use of trancelike techniques and visual effects familiar in Spiritualist practices and their application in the study of human perception. He performed studies with an array of scientific instruments—some designed by his forerunners in the field—such as the hypnoscope, used to induce a hypnotic state, and the antirrheoscope, a device that created the "waterfall illusion" (figs. 1.14 and 1.15). The latter, a standing, striped (and footed) object, was managed by a crank that, when activated, would rotate an inner striped panel. When the motion stopped, the subject continued to perceive movement, with the stripes often appearing to be turning in the opposite direction. These and other perceptual experiments prefigure movements of

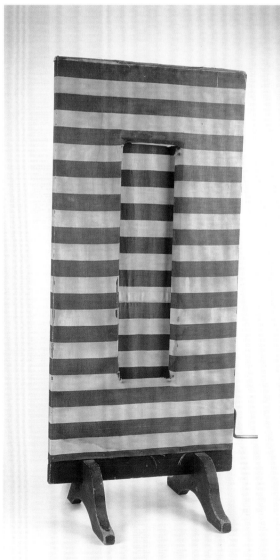

FIG. 1.14 Style of Jules Bernard Luys (1828–1897), hypnoscope, 1890, wood, glass, steel, 7 1/16 × 9 × 5 5/8 cm. Collection of Historical Scientific Instruments, Harvard University; Inv. #WJ0053.

FIG. 1.15 William James (1842–1910), waterfall illusion, 1890, wood, cloth, brass, steel, 34 11/16 × 19 1/8 × 12 3/8 in. Collection of Historical Scientific Instruments, Harvard University; Inv. #WJ0216.

whom James had invited to Harvard to run the experimental psychology lab. In journals and other public venues, Münsterberg routinely debunked psychical phenomena, writing, "Mysticism and mediums were one thing, psychology was quite another. Experimental psychology and psychic hocus-pocus did not mix."[26] These debates speak to broader epistemological shifts—particularly in the United States—that involved "hastening the process of religious unbelief in America" in an increasingly secular world.[27]

Münsterberg represented a more secular approach to the study of perception and the human

the 1960s and 1970s such as Op Art that focus on the dualism of inner perception and outer experience.

A backlash to this period of positivism in the early twentieth century was a severe nationwide crisis of belief and anxiety. As scientific naturalism supplanted traditional religious practice, many were left "yearning for psychic harmony and a new kind of authentic spiritual experience."[28] One reaction to this was the rise and formalization of therapeutic practices and psychiatry during the mid-twentieth century that offered individuals levels of self-fulfillment and self-improvement once secured through religious communities. One of the more "visionary" instances of midcentury therapy developed in and around Harvard University through the work of Max Rinkel. A German exile, Rinkel was the first psychiatrist in the United States to issue LSD to patients, beginning with a study at the Boston Psychopathic Institute in 1949.[29] His studies and public lectures on this and other hallucinogens described their effect on artistic creativity. The artist Hyman Bloom was among his earliest subjects and participated in sessions in which Bloom created a series of drawings that reflect the hypnotic impact of the drug (figs. 1.16 and 1.17). While both Bloom and Rinkel later agreed that the drug did not enhance his technical fine art skills, these sessions importantly coincided with a period of Bloom's heightened interest in the occult and the astral plane (fig. 1.18).[30] The growth of psychedelic studies in New England

thereafter, most infamously through Richard Alpert and Timothy Leary's Harvard Psilocybin Project, sometimes harked back to transcendentalist language as it called for the dissolution of one's ego. While living in a communal home in Newton, Massachusetts, Leary came to his studies as "a continuation of the work of Thoreau, Emerson, and Margaret Fuller, the American writer and protofeminist who participated in the Brook Farm experiment."[31]

Elsewhere in the Northeast, experimental therapeutic practices and centers for the study of extrasensory perception found hospitable ground. Wilhelm Reich, a radical psychiatrist and student of Sigmund Freud, fled Germany and came to the United States in the 1930s and built an expansive laboratory he called "Orgonon" in Rangeley, Maine, in the 1940s. There he pursued the study of "orgone," a libido-like energy force that he believed could be harnessed to affect weather and biological systems. In this rural setting, he built instruments known as "cloudbusters" and "orgone accumulators" (fig. 1.19), but Reich was eventually investigated by the FDA for claims he was illegally marketing and distributing these devices.

Reich's and Rinkel's were among many unusual midcentury approaches that probed the limits of the human mind and body. Artists then and now, such as painter Alex Grey and *Visionary New England* artist Paul Laffoley, have similarly explored the boundaries of science, esoteric philosophies, and visionary

FIG. 1.16 Lantern slide from Max Rinkel's lecture on hallucinogens and LSD, showing a drawing by Hyman Bloom made under the influence of LSD on April 24, 1954. Countway Library of Medicine: Max Rinkel Papers; LS 139.

FIG. 1.17 Lantern slide from Max Rinkel's lecture on hallucinogens and LSD, showing a drawing by Hyman Bloom made under the influence of LSD on April 24, 1954. Countway Library of Medicine: Max Rinkel Papers; LS 145.

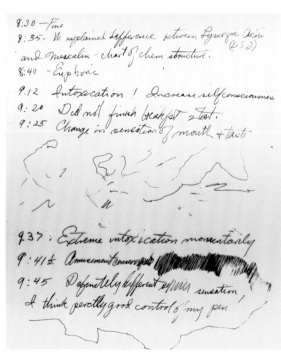

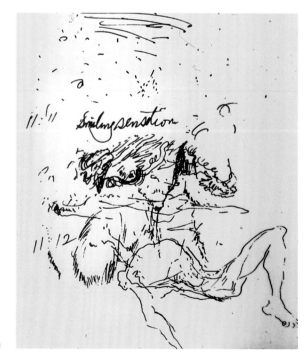

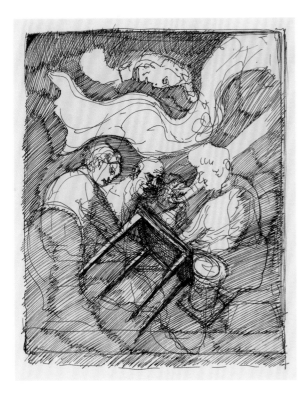

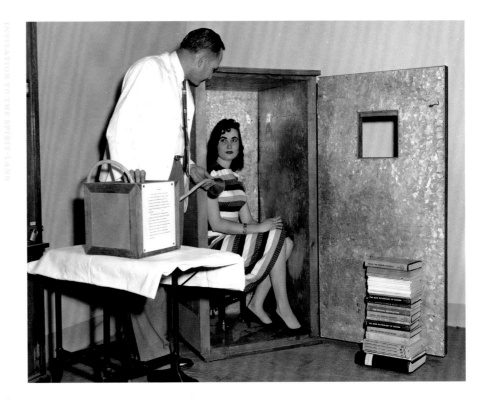

perception (see plates: Laffoley). Grey attended the School of the Museum of Fine Arts, Boston, in the early 1970s, where he experimented with LSD and other induced mystical experiences and healing practices in collaboration with his lifelong partner, artist Allyson Rymland Grey. Around this time, he worked as a medical illustrator in the Anatomy Department at Harvard Medical School, and the work he created thereafter often features hypercolored, intricate depictions of bodily interiors that express his conviction of the sacred and esoteric symbolism of the body and the forces that define its vibrant field of energy (fig. 1.20).

The Cambridge-born artist Paul Laffoley developed an expansive synthesis of spiritual and intellectual inquiry that fused topics ranging from time travel and psychotronic devices to lucid dreaming. His diagrammatic paintings and extensive writings frequently reference visionary architectural structures and an immense catalogue of intellectual forebears from William Reich and Rudolf Steiner to Dante and Plato.[32] In a handwritten document titled *The New England Center for Comparative Utopias*, Laffoley presents a reading list with texts by many New England–based utopian writers, including Nathaniel Hawthorne's *The Blithesdale Romance*, Clara Endicott Sears's book on Fruitlands, and Edward Bellamy's *Looking Backward*. Laffoley's approach to

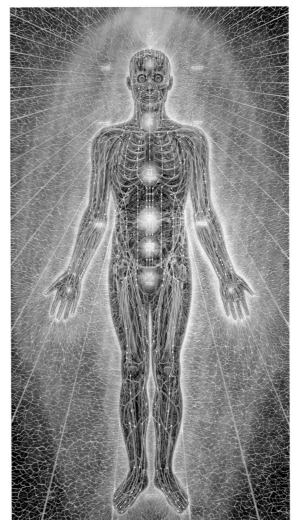

FIG. 1.18 Hyman Bloom (1913–2009), *Untitled (Séance)*, c. 1950s, pen and ink on paper, 10⅜ × 8¾ in. Collection of deCordova Sculpture Park and Museum: Gift of Eleanor Saunders in memory of Sidney Saunders and in honor of Gertrude Saunders; 2005.98.

FIG. 1.19 A patient in one of Wilhelm Reich's orgone accumulators. Courtesy of the US Food and Drug Administration: Healing Devices (FDA 138).

FIG. 1.20 Alex Grey (b. 1953), *Psychic Energy System*, 1980, acrylic on linen, 84 × 46 in. Courtesy of the artist.

FIG. 1.21 Paul Laffoley (1935–2015), *The Thanaton III*, 1989, oil, acrylic, ink, and vinyl lettering on canvas; painted wooden frame, 73½ × 73½ in. Private Collection, Courtesy of Kent Fine Art, New York. (See Appendix.)

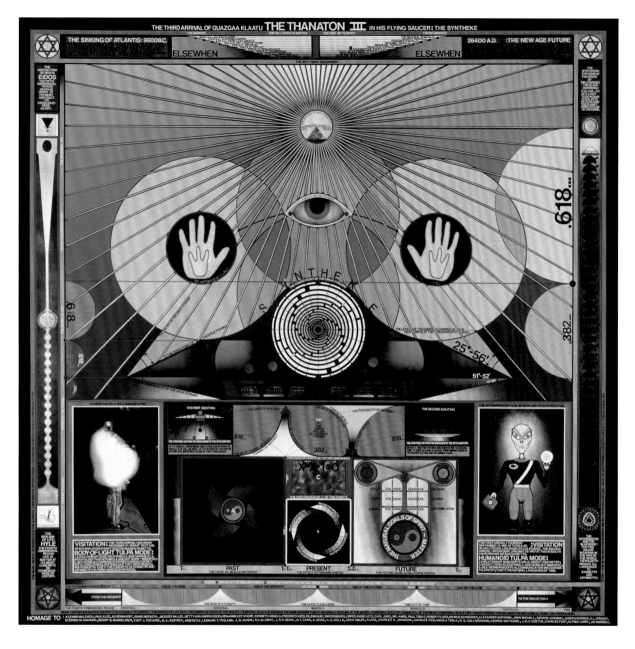

FIG. 1.21 Paul Laffoley (1935–2015), *The Thanaton III*, 1989, oil, acrylic, ink, and vinyl lettering on canvas; painted wooden frame, 73½ × 73½ in. Private Collection, Courtesy of Kent Fine Art, New York. (See Appendix.)

painting continued the nineteenth-century practices of psychometry and mediumship. Some of his works, such as *The Thanaton III* (fig. 1.21), draw on Laffoley's experiences of telepathic communication with an alien who "manifested as a body of light" and left the artist with knowledge about time and multidimensional travel. His paintings were meant to offer similar experiences of transcendence for viewers; *The Thanaton III* was to be activated "by approaching . . . , stretching out your arms, touching the upright hands, and staring into the eye. When you do this, new information will come to you through the active use of the divine proportion, which is the proportion of life connecting to death."[33]

III. THE ANIMISTIC LANDSCAPE

We are never prepared to believe that our ancestors lifted large stones or built thick walls. . . . How can their work be so visible and permanent and themselves so transient? When I see a stone which it must have taken many yoke of oxen to move, lying in a bank wall . . . I am curiously surprised, because it suggests an energy and force of which we have no memorials.

—Henry David Thoreau, *Journal*, 1850[34]

A collection of gray rocks rests on a contemporary art gallery floor, a humble and easily overlooked gathering. Closer inspection reveals that these rocks are not granite or marble but precise bronze replicas

of fieldstones, the kind that overpopulate the New England landscape and which were used to build the many miles of stone walls and subterranean cellars across the region. Synonymous with the imposed borders and property lines of New England's colonial terrain, the stones also convey the austerity of the country's founding years. Such geological formations have similarly long held spiritual significance for the land's stakeholders. Well before European colonizers arrived, Native Americans constructed ceremonial stone effigies that can still be found today.

Titled *Fieldstones (after Robin Coste Lewis's Erasures)*, Sam Durant's 2016 stone sculpture is part of a larger project called *The Meeting House* that centered on the Old Manse in Concord, Massachusetts, a site closely associated with the start of the American Revolution and later home to transcendentalists, including Ralph Waldo Emerson and Nathaniel Hawthorne (see plates: Durant). Extending Durant's long-standing focus on the legacy of slavery and continuing forms of racism, *The Meeting House* explored the "the inseparability of African American cultural pioneers from the canonical transcendentalists and American identity itself."[35] In this context, *Fieldstones* points to the enslaved people who played a role in building New England, yet whose presence is largely obscured in historical accounts—like the buried foundations that populate the region.

During the mid-nineteenth century, the visibility of fieldstones intensified across New England. They emerged from the soil in countless numbers after decades of intense clear-cutting for farmland, frustrating farmers' efforts to plow and plant. As journalist John-Manuel Andriote writes, "Widespread deforestation exposed New England's soils to winter cold—scientists estimate winter was 1 to 1.5 degrees Celsius colder on average during the Little Ice Age than it is today—causing them to freeze deeper than they had before. This accelerated frost heaving, and gradually lifted billions of stones up through the layers of soil toward the surface."[36] It was as if the stones were asserting themselves, disrupting the colonialist enterprise of mastering nature for survival and economic gain. Such an understanding hinges on the stones' animism, a term coined by the English anthropologist E. B. Taylor to define the force or energy that governs all materials: animal, vegetable, and objects.

As Richard Hardack writes in his catalogue essay, animism was a common theme in transcendentalist writings on nature—partly as an outgrowth of white male identity politics and colonial outlooks on the ownership of land and people. As transcendentalist writers promoted an ecstatic, solitary communion with nature, they were also reinforcing certain racial codes, borrowing tropes of pantheism from Native American and African peoples whom they aligned as naturalized, nonhuman "others," simultaneously idealizing and objectifying them.[37] As Hardack writes in *"Not Altogether Human": Pantheism and the Dark Nature of the American Renaissance*, "Late 18th-century Romantic notions that the world is a living organism—and Romantic interest in folklore, folktales, folk music, and the natural savage—were generated by the intersection of European and colonized cultures; they in turn informed the ways the United States tried to reclaim its own pre-Christian animism through the cultures it colonized."[38]

Rocks are among the most physically obdurate and seemingly least sentient objects of the natural world. Yet, during the nineteenth century, they were endowed with an immaterial, almost sacred, presence and also became a fixation of those studying paranormal occurrences. For example, Spiritualist promoters William and Elizabeth Denton's *The Soul of Things* (fig. 1.22) describes their experiments with

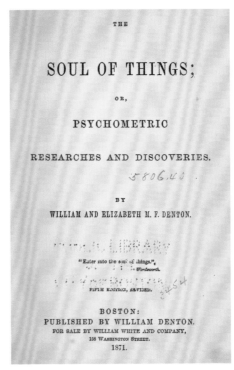

FIG. 1.22 Title page, William and Elizabeth M. F. Denton (1823–1883 and 1826–1916), *The Soul of Things; or, Psychometric Researches and Discoveries*, 1871, 5th ed., rev., Francis A. Countway Library of Medicine, Harvard University.

psychometry (a form of extrasensory perception). When individuals placed their hands on rocks and fossils (or brought these objects to their foreheads), they would fall into a trancelike state through which they could determine the distant geographic origins and vast life span of each geological specimen.[39]

During that century of increasing deforestation alongside the rise of animistic appreciation, New England's geological terrain also captured the attention of many visual artists. Martin Johnson Heade's *Rocks in New England* (fig. 1.23), represents the altered landscape where livestock—a cow and several sheep—populate a denuded hillside. Decades later, artist Marsden Hartley pictured the similarly austere, eerie terrain of Dogtown, near Gloucester,

MacIver, highlight its most transient qualities, creating abstracted, luminous views of natural phenomena, such as the fleeting effects of light and water. Between 1931 and 1941, MacIver spent time in Truro, Massachusetts, captivated by the windswept beaches and seaside atmosphere. Her aerial view of the seaside shack where she lived with her husband (fig. 1.26) is a microcosmic world unto itself (and was the first painting by a female artist collected by the Museum of Modern Art, New York, in 1938).

The animistic New England landscape resurfaces in contemporary art, with artists creating work that similarly underscores the vitalism permeating the environment and cultural artifacts. Artist Candice Lin filters this outlook through a critical lens that

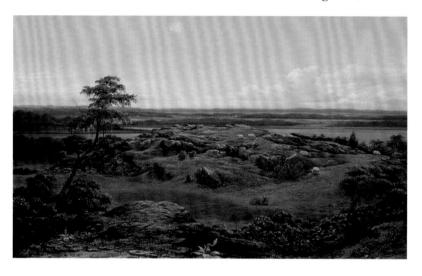

FIG 1.23 Martin Johnson Heade (1819–1904), *Rocks in New England*, 1855, oil on canvas, 17⅛ × 27¼ in. Museum of Fine Arts, Boston: Gift of Maxim Karolik for the M. and M. Karolik Collection of American Paintings; 1815–1865, 47.1171.

FIG. 1.24 Marsden Hartley (1877–1943), *Rock Doxology*, 1931, oil on canvas, 25 × 31 in. Collection of Cape Ann Museum: Gift of Robert L. and Elizabeth French; 2009.51.28.

Massachusetts (fig. 1.24). These forlorn, elemental compositions of heavy brushwork and rich auburn tones extend the innovations of Cézanne into a metaphysical terrain. By then, Dogtown was an abandoned settlement, noted for its massive boulders (some as large as small houses) and landscape pitted with the stone cellars of former homes. Described by Hartley as "a cross between Easter Island and Stonehenge," Dogtown had been a settlement for outliers—widows and social outcasts, even so-called witches, who found refuge there until the late nineteenth century (fig. 1.25). Hartley's studies of Dogtown coincided with his return to a mystical understanding of the landscape, as he wrote at the time: "While my pictures are small, they are more intense than ever before, and I have for once [again] immersed myself in the mysticism of nature."[40]

In contrast to the solidity of Hartley's Dogtown pictures, some midcentury artists, including Loren

focuses on complex exchanges and traumas between the colonized and colonizers, and she examines the ways in which Westerners have adopted animistic viewpoints. In past projects, she devised alchemical installations that featured colonial trade items, such as tea, cochineal, and sugar, pumped through a system of vessels and tubes. She also places within these environments plants and insects, from poppies to silkworms, that featured in colonial enterprise. In so doing, she aims to "highlight the liveliness and vibrancy of supposedly inanimate things—the sexuality of stones, the quantum possibilities of smell, or the racialized and gendered language around plants."[41] Her outdoor installation *La Charada China* for *Visionary New England* considers the connections between the New England transcendentalists and the Opium Wars of the nineteenth century, foregrounding the global identity of the region as trade with China satisfied New Englanders' addictive

hunger for imported foods, luxury goods, and medicinal treatments (see pages 37–39; plates: Lin).[42]

In the intimately scaled paintings of Josephine Halvorson, small rock formations, stray leaves, and chipped bark also radiate with an innate vitality (see plates: Halvorson). Within the woods around her home and studio in western Massachusetts, Halvorson paints *en plein air*. Directing her almost trance-like focus on patches of soil and trees, she engages with the liveliness of the world around her through the medium of paint. For Halvorson, meditating upon the natural world is not enough; she needs the brush, pigment, and support to establish full mediumistic connection to that which surrounds her. A number of these works call attention

deteriorating natural environment. While some of the artworks in this exhibition may not be overtly mystical, they often convey utopian values or a reciprocal relationship with the natural world in ways that extend beyond the empirical realm. Layered and imprinted within the New England region for centuries, such tenets are continually revived and given new forms by successive generations of artists and seekers. In this process of transformation, history and myth have intertwined. Also inherited are past traumas and inequities that maintain a specter-like presence in landscapes and within bodies. Often unacknowledged or even suppressed by those in power, these imbalances compel artists and other creatives to speculate on alternative

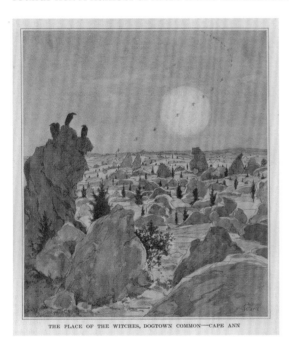

THE PLACE OF THE WITCHES, DOGTOWN COMMON—CAPE ANN

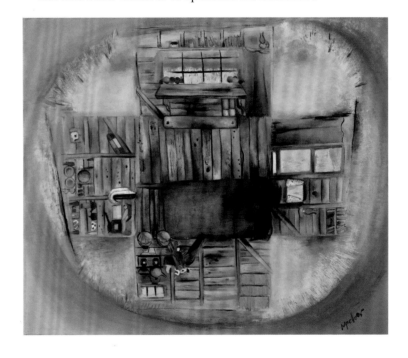

to boundaries, property lines, and the liminal states of present materiality and past existence. The painting *Ghost* offers a close view of a tree trunk to which a sign, likely a property marker or "no trespassing" sign, was once stapled. This work subtly shifts our attention to humans' attempts to possess nature and to the persistent imprints of possession on the New England landscape, like stone walls, even as they degrade with time.

Halvorson's work and that of her contemporaries make us sensitive to the presence of unseen forces that govern our world. We are now witnessing a stronger embrace of such outlooks at a time of continued anxiety about potential isolation from human fellowship and disconnection from our

futures and imagine spaces for healing, greater sovereignty, and even irrationality. *Visionary New England* brings together practitioners from past and present, with works ranging from contemporary folk art to avant-garde artistry, bridging long-established hierarchies within the art world (that are often defined by the market or museums). By integrating episodes of literature, history, and the sciences into its interpretive structure, this exhibition models an art historical approach in which disciplinary distinctions are less rigidly applied. Considered together as integral to the eccentric formation of New England culture, these diverse visionary outlooks inform a fruitful and broad embrace of art, past and present.

FIG. 1.25 The place of the witches, Dogtown Common, Cape Ann, Massachusetts, illustration published in *Harper's Magazine* 140, c. 1919–20.

FIG. 1.26 Loren MacIver (1909–1998), *Shack*, 1934, oil on canvas, 20⅛ × 24 in. Museum of Modern Art, New York: Gift of Abby Aldrich Rockefeller; 399.1938.

1

Josiah Wolcott, in John W. Dexter and George T. Edmonds, *Spiritualism* (New York: Partridge and Brittan,1853), 486. See also Nancy Osgood, "Josiah Wolcott: Artist and Abolitionist," *Old Time New England*, Spring/Summer 1998, 5–34.

2

Chris Jennings notes that at least one hundred experimental communities formed in this country during the nineteenth century. See Chris Jennings, *Paradise Now: The Story of American Utopianism* (New York: Random House, 2017), 1.

3

Brook Farm experienced two phases of existence. From roughly 1841 to 1844, the community followed principles of shared labor and collective ownership as led by the social reformer and transcendentalist minister George Ripley. By 1844 its members were committed to the precepts of the French socialist and utopian philosopher Charles Fourier. See "The Fourierist Phalanxes," in Jennings, *Paradise Now* for a highly readable account of Fourier and his influence on American utopian settlements in the 1840s.

4

See Henry Adams and Marcia Brennan, *Modern Mystic: The Art of Hyman Bloom* (New York: Distributed Art Publishers, 2019), which includes a thoroughly researched essay by Brennan on the importance of mysticism in Bloom's work. Additionally, the Museum of Fine Arts, Boston, opened a long-awaited survey exhibition of Bloom's work in July 2019 that emphasized Bloom's prioritization of transcendence and spiritual matters. See Erica Hirshler, ed., *Hyman Bloom: Matters of Life and Death*, exh. cat. (Boston:

Museum of Fine Arts, Boston, 2019).

5

For books that discuss a number of related New England–based artists, see Abraham A. Davidson, *The Eccentrics and Other American Visionary Painters* (New York: E. P. Dutton, 1978); Ann Braude, *Radical Spirits: Spiritualism and Women's Rights in Nineteenth-Century America* (Bloomington: Indiana University Press, 1989); and Leigh Eric Schmidt, *Restless Souls: The Making of American Spirituality* (New York: Harper Collins, 2005).

6

Josephine Halvorson, phone conversation with the author, July 3, 2019.

7

Krister Dylan Knapp, *William James: Psychical Research and the Challenge of Modernity* (Chapel Hill: University of North Carolina Press, 2017), 15–16.

8

Charles Colbert, *Haunted Visions: Spiritualism and American Art* (Philadelphia: University of Pennsylvania Press, 2011), 79.

9

Marsden Hartley, quoted in *Feininger/Hartley*, exh. cat. (New York: Museum of Modern Art, 1944), 61.

10

See Bruce Laurie, *Rebels in Paradise: Sketches of Northampton Abolitionists* (Amherst: University of Massachusetts Press, 2015). See also Frederick Douglass, "What I Found at the Northampton Association," in *The History of Florence, Massachusetts, Including a Complete Account of the Northampton Association of Education and Industry*, ed. Charles A. Sheffeld (Florence, MA: Charles A. Sheffeld, 1895), 129–32.

11

Nathaniel Hawthorne, *The Blithesdale Romance* (Concord, MA: Ticknor and Fields, 1852), 2.

12

George Ripley to Ralph Waldo Emerson, printed in Lindsay Swift, *Brook Farm: Its Members, Scholars, and Visitors* (New York: Macmillan, 1900), 16.

13

Schmidt, *Restless Souls*, 185.

14

Marsden Hartley, quoted in Schmidt, *Restless Souls*, 203.

15

M. Rachael Arauz, "The Best Ideals of Socially Useful Living: Haystack, 1950–60," in *In the Vanguard: Haystack Mountain School of Crafts, 1950–1969*, ed. M. Rachael Arauz and Diana Jocelyn Greenwold (Berkeley: University of California Press, 2019), 63.

16

See the three volumes by Tim Devin titled *Mapping Out Utopia* (Somerville, MA: Free the Future, 2017) that chart countercultural community organizations of the 1970s in Cambridge, Boston, and the surrounding communities of Somerville, Brookline, and Newton.

17

"One time as he [Alcott] was reading to his class, they began playfully tussling. He simply put his book down and asked them to tell him why he had stopped. They replied, 'Because we are all making such noise,' whereupon they settled down and he continued the story. This was his way of appealing to the child's 'common conscience,' encouraging him to release his normal drives but also to remember his is a social being with community obligations." Marjorie Stiem, "Beginnings of Modern Education: Bronson Alcott Peabody," *Journal of Education* 38, no. 1 (July 1960): 8.

18

Angela Dufresne, from a presentation at the Visionary New England Working

Group, March 4, 2019, deCordova Sculpture Park and Museum.

19

William Denton, *Is Spiritualism True?* (Boston: William Denton, 1874), iii.

20

Denton, *Is Spiritualism True?*, 4.

21

Tom Gunning, "Haunting Images: Ghosts, Photography, and the Modern Body," in *The Disembodied Spirit*, exh. cat., ed. Alison Ferris (Brunswick, ME: Bowdoin College Museum of Art, 2003), 14.

22

Colbert, *Haunted Visions*, 10.

23

Knapp, *William James*, 4.

24

Knapp, 6.

25

"The schism eventually led to two fields of discourse—experimental psychology, practiced at most research universities, and parapsychology (a word not invented until 1925) practiced, for the most part, outside of academic institutions." Knapp, 11.

26

D. W. Bjork, *The Compromised Scientist: William James in the Development of American Psychology* (New York: Columbia University Press, 1983), 63–64.

27

Knapp, *William James*, 11.

28

Knapp, 11.

29

His partner, Robert Hyde, continued these experiments, which were often administered to unwitting patients, at other sites in New England, including at a CIA center in Rhode Island and the Vermont State Hospital.

30

Henry Adams, "The First Abstract Expressionist? Hyman Bloom's Mystical

Quest," in Adams and Brennan, *Modern Mystic*, 33.

31
Don Lattin, *The Harvard Psychedelic Club: How Timothy Leary, Ram Dass, Huston Smith, and Andrew Weil Killed the Fifties and Ushered in a New Age for America* (New York: Harper, 2011), 36.

32
Laffoley's New England Center for Comparative Utopias was to be built at the site of a defunct roller coaster in Revere Beach, Massachusetts.

33
Laffoley on *The Thanaton III*, quoted in *The Essential Paul Laffoley: Works from the Boston Visionary Cell*, ed. Douglas Walla (Chicago: University of Chicago Press, 2016), 192. See also pages 142–44 of this volume for a selection of Laffoley's "Thought-Forms" written to accompany the works on view in *Visionary New England*, including the complete *Thanaton III* text.

34
Henry David Thoreau, *The Writings of Henry David Thoreau, Journal II: 1850–September 15, 1851*, ed. Bradford Torrey (Boston: Houghton Mifflin, 1906), 16–17.

35
Sam Durant, *Build Therefore Your Own World* exhibition proposal to Blum & Poe, 2016, reprinted in Sam Durant, *Build Therefore Your Own World* (Los Angeles: Blum & Poe and Black Dog, 2017), 11.

36
John-Manuel Andriote, "The History, Science and Poetry of New England's Stone Walls," *Earth*, May 19, 2014.

37
Richard Hardack, *"Not Altogether Human": Pantheism and the Dark Nature of the American Renaissance* (Amherst: University of Massachusetts Press, 2012), 78.

38
Hardack, *"Not Altogether Human,"* 64.

39
William Denton and Elizabeth M. F. Denton, *The Soul of Things; Or, Psychometric Researches and Discoveries* (Boston: Walker, Wise and Co., 1863), 36. "I accordingly commenced, some ten years ago, a series of experiments with mineral and fossil specimens and archeological remains, and was delighted to find that without possessing any previous knowledge of the specimen, or even seeing it, the history of its time passed before the gaze of the seer like a grand panoramic view; sometimes almost with the rapidity of lightning, and at other times so slowly and distinctly that it could be described as readily as an ordinary scene. The specimen to be examined was generally, placed upon the forehead, and held there during the examination; but this was not absolutely necessary, some psychometers being able to see when holding a specimen in the hand."

40
Marsden Hartley to Adelaide/Kunz, October 22, 1931, Beineke Rare Book and Manuscript Library, Yale University, reprinted in *Marsden Hartley: American Modernist*, ed. Elizabeth Mankin Kornhauser with contributions from Patricia McDonnell (New Haven: Yale University Press, 2002), 308.

41
Candice Lin, "Artist Statement," Headlands Center for the Arts website, 2016, http://www.headlands.org/artist/candice-lin/.

42
Martha Berbinger, "How Profits from Opium Shaped 19th-Century Boston," July 31, 2017, https://www.wbur.org/commonhealth /2017/07/31/opium-boston -history, and "The Opium Trade Boomed in the 1800s, Boston Doctors Raised Addiction Concerns," August 1, 2017, https://www .wbur.org/commonhealth /2017/08/01/opium-history -addiction.

To Summon and Witness the Apparitions of Our Pasts

LISA CROSSMAN

the Apparitions of Our Pasts

To Summon and Witness

LISA CROSSMAN

When loved ones, called away from earth,
Awake in heaven to purer birth.
But that they come in love,
To point the Weary heart above . . .
To light with hope the weary eye,
And teach the soul it cannot die

—ACHSA W. SPRAGUE,
Spiritualist trance speaker from Vermont,
published posthumously in 1864

S piritualism infamously originated in Hydesville, New York, when the young Fox sisters made claims of the possibility of spirit communication in 1848. It quickly spread nationally thanks to the help of those like Amy and Isaac Post (abolitionist and feminist Quakers) and Andrew Jackson Davis (credited with defining Modern Spiritualism) who had been awaiting such a sign.[1] That Spiritualism spread internationally and endures today (although with fewer followers) is a testament to its adaptability and the human longing for the means to materialize the intangible experience of loss. Its rootedness in individuality, religious reform, women's rights, and abolitionism in early decades was increasingly overshadowed by the sensationalist demands for and displays of objective proof of communication with the dead that arose after the 1880s.

Yet, while Spiritualism declined in the United States after the 1920s, it continues to fascinate the general public and art enthusiasts—as indicated, for instance, by the popularity of the Guggenheim Museum's recent exhibition *Hilma af Klint: Paintings for the Future*. The history of Spiritualism's practice in New England demonstrates ways in which it has been shrewd and visionary. Spiritualism's attention to human yearnings to communicate and transcend the restrictions of one's station, like its rituals that facilitate connection, remains relevant today as we seek new interpretations of the past, contend with the losses of the present, and imagine how the world could be.

The appeal of Spiritualism—a science, religion, and philosophy—was in part (and perhaps still is) in its capacity to transgress borders, helped by desire for spiritual agency and relief from the grief of personal and collective loss. Women in particular found empowerment through Spiritualism,

especially in its early decades. Its egalitarian principles and non-centralized structure offered women a platform as mediums. Women did not stick to a script of personal messages from the beyond, however. Instead, their oration extended to discussions of rights for women and a variety of areas of reform, including marriage and health.[2]

Spiritualism's enduring belief that the living could communicate with the dead and that the soul would continue to evolve beyond the grave not only was cause for comfort, entertainment, or both, but also suggested a pliable divide between material and immaterial worlds, presence and absence, past and present—as detailed in the purportedly spirit-authored text *The Philosophy of Creation* (fig. 2.1).[3] Spiritualism's confounding of binaries and responsiveness to technology and the centrality of objects in its practice in the United States will be explored in the following pages through a few New England examples. These historical vignettes are an illuminating

FIG. 2.1 Horace Gay Wood (1831–1893), "Illustration from Thomas Paine (through the hand of Horace G. Wood, medium)," *The Philosophy of Creation: Unfolding the Laws of the Progressive Development of Nature, and Embracing the Philosophy of Man, Spirit, and the Spirit World* (Boston: B. Marsh, 1854). Collection of Bennington Museum, Bennington, Vermont.

Spiritualist camp meeting movement and spirit photography. Together, they demonstrate Spiritualism's affinity for synthesizing new technology, popular culture, and philosophy.

Spiritualist camp meetings were inspired by and supported the rural cemetery movement and designs such as that of Mount Auburn Cemetery (dedicated in 1831), which allowed visitors to contemplate death while enjoying nature.[5] The Spiritualists, affirming the transcendentalists, believed that spiritual truth could be found in nature.[6] The Spiritualist camp meetings informally began at sites such as Melrose, Massachusetts, in 1866. A circuit of annual meetings spread to locations including Lake Pleasant and Montague, Massachusetts, in 1874. The meetings were regularized in 1879 under the New England Spiritualist Camp Meeting Association (fig. 2.2).[7] Lake Pleasant, which had initially been developed as a resort in 1872, was transformed into a Spiritualist camp that allowed for the mixing of nature with comfort, worship with entertainment. A fire at Lake Pleasant in 1907 led to its decline, although it became the home of the National Spiritualist Alliance after the organization's founding in 1913 and remains the oldest continuously operating Spiritualist center in the United States.[8]

William H. Mumler is recognized for commercializing spirit photography in the 1860s in Boston.[9] Mumler's photographs follow the conventions of a standard portrait, but diverge in their revealing of one or more spirits floating behind the sitter. The "spirit" is differentiated from the sitter in its ephemeral quality and sometimes disembodied state. While by an unknown photographer, an early image of the famed medium and levitator Daniel Dunglas Home, who made his start in New England, serves as a noteworthy example (fig. 2.3). In the photograph, a woman's face merges with Home's shoulder, and two heads float above his opposite side. Spirit photographs typically were commissioned as a means of recording a convening with a deceased loved one or as tangible proof of the spirit world, however contested. The Home photo additionally seems to offer testament to the medium's connection to the spirit world, while proving the camera's capabilities to reveal the invisible.

Spirit photography generated critical examination as an art form in the exhibitions *The Disembodied Spirit* (Bowdoin College Museum of Art,

FIG. 2.2 New England Spiritualists Camp Meeting Association 15th Annual Convocation flier, 1888. Special Collections and University Archives, UMass Amherst Libraries: Louise Shattuck Papers; MS 563.

point of departure for considering a bridge between visionary spiritual practices of the nineteenth century and recent artworks that explore either Spiritualism or related themes of inheritance, loss, and spirit.

Spiritualism thrived in New England, finding cohesion with aspects of other contemporaneous trends and belief systems. As archivist and historian Robert S. Cox has noted, "Spiritualism was like a pop-culture amoeba, distilling a mixture of high culture and low, absorbing the language of scientific empiricism, occultism, and social reform in the course of emerging as the fastest growing religion in mid-nineteenth century America."[4] New England notably holds claim to the origins of both the

2003), *Concerning the Spiritual in Photography* (Photographic Resource Center, 2004), and *The Perfect Medium: Photography and the Occult* (The Metropolitan Museum of Art, 2005). While each took a different tack, these exhibitions explored the inherent properties of photography as a medium that can serve as both evidence and artifice. These exhibitions point to a lasting fixation upon the visual culture of Spiritualist practice and its capacity to inspire creative acts. Today, contemporary artists, such as Maria Molteni and *Visionary New England* artist Kim Weston, similarly explore the potential of photography as a tool for documentation and for revealing more than what the eye alone can see. Yet each artist works beyond the photographic medium with objects and ritual to capture the experiential aspect of Spiritualism and/or mourning, spirit, and identity.

A multimedia artist and organizer, Molteni has created projects that directly link to the history of Spiritualism in New England, evoking its foundation in reform and the liberation of ritual. She merges her Spiritualist practice, which includes participation in medium circles at Lake Pleasant, with her vision of the artist's role as "like that of a Saint—someone who stood out from the rest of society, sacrificing for what they believed in, Seekers working to access the un-seeable."[10]

Her collaborative project *Ectoplasm Selfies: DIY Ritual in the Age of Social Mediums*, developed with spirit photographer Lacey Prpić Hedtke for communities in the artists' respective cities, included performance-workshops in Boston, 2016, and Minneapolis, 2017, along with a zine published that year.[11] Ectoplasm is an invisible substance thought to emanate from a medium's orifices in order to materialize a spirit; it could be captured by photography, although it was also repelled by a camera's flash. Participants in the two interactive performances, which began with communal séances, were encouraged to make their own ectoplasm and to shape it into forms that could be used as props in a spirit selfie. The zine both documents that experience and roots the project in history, honoring Scottish medium and Spiritualist Helen Duncan, who was imprisoned under the Witchcraft Act of 1735. Molteni and Prpić Hedtke also called to French medium Eva Carrière (née Marthe Béraud) at the Boston performance. This project, like Spiritualism,

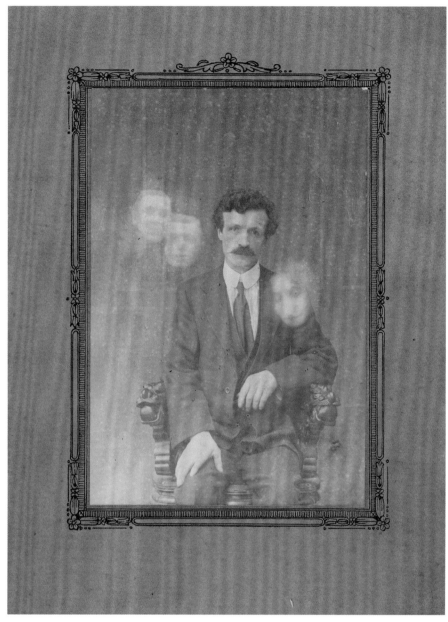

finds transformative power in the communal act of séance and validation in photography as well as the utility of print culture.[12] Spiritualism was democratic in the direct, experiential contact with the supernatural that it offered to the ordinary citizen, as well as in the physical contact with other living participants it entailed.[13] Molteni and Prpić Hedtke leverage this trait in their work.

Ectoplasm Selfies exploits homemade ectoplasm as a performative device. The artists instructed workshop participants to craft ectoplasm using the provided household materials such as cheesecloth, flour, and egg; they were also given instant (or, occasionally, cell phone) cameras for capturing the selfies. Their individual ectoplasm recipes

FIG. 2.3 Artist unknown, *Spirit Photo of D. D. Home*, c. 1860s, albumen print on original mount, image: 5¾ × 4 in.; with mount: 10 × 7 in. Fitchburg Art Museum, Clapp Family Collection Fund; 2019.142.

and photos were later published in the project zine (fig. 2.4). The overt fabrication of ectoplasm in the workshop preempts the conversation about the "truth" of its substance and instead emphasizes the power of ritual. This play could inspire participants to consider their self-definition, exploring the intangible spirit as the basis for the creation of a material performance of self. In the artists' assessment, the amorphous substance of ectoplasm further allows the exploration of nonbinary queer identities. The premise locates commonality in the language of Spiritualism, which offered the possibility of breaching the bounds of material and immaterial while transgressing social limits through ritual.

that swirl from images of botanicals and human faces to text.

Other mediums, however, would draw likenesses of clients' spirits or naturalistic imagery. Louise Shattuck (fig. 2.5) was a descendant of two generations of mediums, and a devoted Spiritualist—although never a professional medium—based in Massachusetts in the mid-to-late twentieth century. Shattuck maintained a strong connection to Lake Pleasant throughout her life, thanks to her family, and was an artist, dog breeder, teacher, and writer.[15] Her spirit guide, Charles Memling, aided her artistic practice, sending such messages as "Charles Memling. I am here now. . . . Your drawing today was

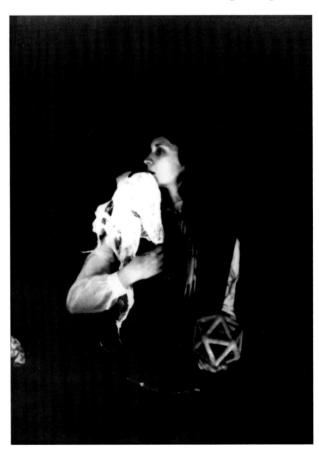

FIG. 2.4 Maria Molteni (b. 1983) and Lacey Prpić Hedtke (b.1981), *Maria, Ectoplasm Selfies: DIY Ritual in the Age of Social Mediums*, 2016, gold-toned albumen print on watercolor paper from Fuji instant photograph, 8.5 × 11 in. Courtesy of the artists.

FIG. 2.5 Photographer unknown, Louise Shattuck sculpting *Arab Rider*, c. 1945. Special Collections and University Archives, UMass Amherst Libraries: Louise Shattuck Papers; MS 563.

Spiritualist practitioners have been not only the subjects of art but at times also its creators. Swedish painter Hilma af Klint and British draftswoman Georgiana Houghton are just two artists known for the visionary works they created, guided by spirits.[14] In the United States, Helen Butler Wells is another example; interestingly, she is known to have communicated with Ralph Waldo Emerson, among others. After 1919 a spirit artist named Eswald guided Wells to create graphite or colored-pencil drawings

pretty good but not quite in proportion through the upper part of the head. . . . You will improve, so don't worry about it now." Years of automatic writing and documentation of spirit messages reveal how banal many communications were. The messages also show how the spirits served as support for individual betterment. Spiritualism is profound in its epistemological challenge to the world's divisions and places the power of communication (however ordinary the messages might be) in the hands of a broad

range of individuals. Shattuck was a local artist with a spirit guide tied to her artistic training. Molteni, with an expanding engagement with Spiritualism and Lake Pleasant, makes fluid her own identification as artist and "seer," affirming the power of ritual as a visionary act in itself.

Kim Weston began to root her practice in an exploration of inheritance and her spiritual heritage after a near-death experience in 2013. She studied several religions while growing up, but Native American practices, in particular, resonated with her and now enter her photography. Weston's work bridges everyday and ceremonial experiences, past losses and current ones, and ancestors and future generations. Her series *Seen, Unseen* (2014) documents her deceased grandmother's home in Cheraw, South Carolina. The photos capture the literal, material experience of death, as seen in an image of her grandmother's body resting in a coffin. Exhibited on embossed white wallpaper, the photographs honor a personal loss while also exploring larger themes related to memory and place, identity, and the effects of discrimination that persist on landscapes that bear the residue of the Civil War. The photographs show the way spirit and memory resonate in one's belongings, the home, and the surrounding land. Others expose light that reads either as an apparition or as a manifestation of the "spirit" that Weston's relatives felt in the house while she photographed, capturing the slippage between absence and presence (fig. 2.6).

Weston's reflection on the life of her grandmother, who was part of the Cherokee tribe despite rarely speaking of it, complements the artist's exploration of Native American culture and threats faced by women in other works. Her installation in *Visionary New England* is partly a memorial to Native American women who have disappeared, honoring their lives and making visible a crisis that has largely been ignored.[16] Red silk bundles, each filled with tobacco, are arranged in a circle as a call for support and prayer. The red symbolizes the spiritual: blood, loss, pain, body, and cross-generational connections (fig. 2.7). Photographs of dancers at powwows in *Layers of the Soul* link past and present. Powwows, organized as a circuit throughout the country, including in New England, continue Native traditions and provide a platform for connection and education, not dissimilar in principle to a Spiritualist camp meeting.

Weston's large-scale photographs freeze movement and a play of light and color that allows the viewer to "see" that which is otherwise unseen. The images create an effect of blurred time and defy a fixed state of identification.

Spiritualism crossed racial, ethnic, and class boundaries, especially as it dispersed across geographic boundaries.[17] Anglo-American Spiritualists in New England at times called forth indigenous spirits, perhaps recognizing the need for reconciliation at a time when Native Americans were subjected to violence and resettlement or perhaps for "perceived access to a world of spirituality and truth" in the nineteenth century.[18] These mediums, unwittingly or not, masked the diverse living traditions of indigenous people by principally imagining Native Americans' presence through the spiritual or in a limited romanticized visage. Weston's work gives voice to her own exploration of part of her lineage with the intent to communicate with those both within and outside of the traditions she explores, using photography and ritual as means of connecting across time and other social divisions.

While the momentous loss of life in the United States during the Civil War (1861–65) fueled a rise in Spiritualism and altered bereavement practices, the social disputes that preceded and followed this conflict did not die. In the North, the idea of present and future in the national narrative was not modeled after the antipatriarchal, egalitarian ideals of Spiritualism, nor did it fully evolve beyond the racial and cultural divisions that festered after the war.

Recently, much attention has been devoted to publicly debating the validity of some Civil War monuments—in particular, Confederate ones that were principally built in the early and mid-twentieth century—and to broadly rethinking monuments in

FIG. 2.6 Kim Weston (b. 1969), *Untitled (Grandma's Chair)* from the series *Seen, Unseen*, 2014, photograph printed on archival paper. Courtesy of the artist.

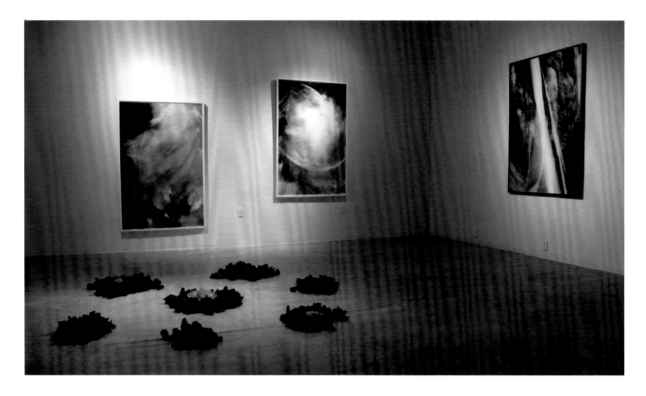

FIG. 2.7 Kim Weston (b. 1969), installation view of *Seen, Unseen, Where Reality Meets Spirit*, 2014, thesis exhibition, International Center of Photography, Bard Program in Advanced Photographic Studies.

the civic arena altogether. Contemporary artists have been an active part of questioning and proposing new models of confronting the past, memory, and mourning. Memorials by artists such as Weston call for us to see the parts of the present that are denied widespread visibility—to witness others' grief and imagine a future that is not restricted to the likenesses of the specters that haunt us personally. Artists like Weston and Molteni create space for us to

consider absence, offering new models of presence, transgression, and unfixed representation that both allow for the losses and traumas of our past to be mourned and recognize the violence of our present. Within the context of art, objects and experiential contact with something beyond our tangible world perhaps allow for people to *see* loss, to materialize nonbinary identities, and to harness the apparitions of the past in hope of transformation.

NOTES

Epigraph

Ann Braude, *Radical Spirits: Spiritualism and Women's Rights in Nineteenth-Century America* (Bloomington: Indiana University Press, [1989] 2001), 105. Originally published in Achsa W. Sprague, *The Poet and Other Poems* (Boston: William White & Co., 1864), 299–300. Sprague was a trance lecturer in Plymouth Notch, Vermont, from 1854 until her death in 1862.

1

Davis's book *The Principles of Nature: Her Divine Revelations*

and a Voice to Mankind, published in 1847, outlined the foundations of Modern Spiritualism. His diary of March 31, 1848, supposedly alludes to the Fox sisters incident: "About daylight this morning a warm breathing passed over my face and I heard a voice, tender and strong, saying 'Brother, the good work has begun—behold, a living demonstration is born.' I was left wondering what could be meant by such a message." Andrew Jackson Davis, quoted in Simeon

Steanidakis, "Forerunners to Modern Spiritualism: Andrew Jackson Davis (1826–1910)," First Spiritual Temple, accessed June 25, 2019, http://fst.org/spirit3 .htm).

2

Braude's *Radical Spirits* in particular deftly outlines how some women who found empowerment in the early decades of Spiritualism separated from it later as it became more sensational and was perceived as a liability to women who sought to be taken

seriously. For more on the perception of women as "moral guardians" in the nineteenth century, see Braude, *Radical Spirits*, 38–39.

3

This text was believed to have been written by the spirit Thomas Paine, as channeled by the Vermont medium Horace G. Wood. The illustration in fig. 2.1 refers to the seven divisions of Spirit Land, where individuals enter levels (circles) based on moral and intellectual status and

have the opportunity to continue evolving in the spirit realm. The seventh circle is conceived of as "a new world" of "harmonized souls of all planets and nations" (100). While Spiritualism was progressive in many ways for its day, it still maintained that the Spirit Land was divided into "societies" on all levels except the seventh. These social divisions, which reflect Paine/Wood's assumptions about the "moral and intellectual powers of the Spirit when on Earth" (85) in various individuals, expose the author's underlying prejudice.

4

Robert S. Cox, "Spiritualism," in *Introduction to New and Alternative Religions in America*, vol. 3, *Metaphysical, New Age, and Neopagan Movements*, ed. Eugene V. Gallagher and Michael Ash-Craft (Westport, CT: Greenwood, 2006), 2.

5

William D. Moore, "'To Hold Communion with Nature and the Spirit-World': New England's Spiritualist Camp Meetings, 1865–1910," *Perspectives in Vernacular Architecture 7, Exploring Everyday Landscapes* (1997): 241.

6

Braude, *Radical Spirits*, 44–46.

7

Moore, "'To Hold Communion,'" 230, 232. By the 1880s, ten significant summer meetings were held in New England.

8

Although the New England Spiritualist Camp Meeting Association disbanded in 1976, the National Spiritualist Alliance's presence at Lake Pleasant since 1913 makes this site the longest-running spiritualist center in the nation, according to the National Spiritual Alliance website, http://spiritualallianceusa.org/.

9

Some accounts of spirit photography from the 1850s are documented. Most examples date to between 1870 and 1930. The form spread to Europe in the 1870s.

10

Maria Molteni, "About the Artists: Maria Molteni," in *Ectoplasm Selfies: DIY Ritual in the Age of Social Mediums*, Lacey Prpić Hedtke and Maria Molteni (Galveston, TX: Super Hit, 2017).

11

Mills Gallery, *Queer Threads: Crafting Identity and Community*, April 29–July 10, 2016, in partnership with the LGBTIAQ Artist Alliance (BLAA), of which Molteni is a member. While Lacey Prpić Hedtke is from, and now based in, Minneapolis, she lived in Boston for many years and attended the First Spiritualist Church of Salem.

12

Banner of Light (published in Boston for national circulation, 1857–1907) and *The Spiritual Telegraph* (published in New York, 1852–60) were prominent Spiritualist newspapers. As Spiritualism lacked a centralized structure, these publications allowed for broad communication of events, lectures, and meetings, as well as pertinent articles. *Banner of Light* had its own resident medium, Mrs. Conant, and communiqués from the departed were documented in a message board, thus sharing the ritual of spirit communication in print.

13

Charles Colbert, *Haunted Visions: Spiritualism and American Art* (Philadelphia: University of Pennsylvania Press, 2011), 2, 6. Colbert's text offers an insightful examination of aesthetic parallels between Spiritualism and American art.

14

Spiritualism arrived in Britain in 1852. Houghton was inspired to seek Spiritualism because of the loss of her siblings. Her art, like that of af Klint, has been heralded as visionary in more recent years. Simon Grant and Marco Pasi, "Works of Art without Parallel in the World," in *Georgiana Houghton: Spirit Drawings* (London: Courtland Gallery, 2016).

15

For documentation on her life, see the Louise Shattuck Papers, 1881–2006, MS 563, UMass Amherst Special Collections and University Archives.

16

For more information about the disappearance of Native American women, see "Cortez Masto, Murkowski, Tester Introduce Legislation to Address Crisis of Missing, Murdered and Trafficked Native Women," April 3, 2019, press release, https://www.murkowski.senate.gov/press/release/cortez-masto-murkowski-tester-introduce-legislation-to-address-crisis-of-missing-murdered-and-trafficked-native-women; "Ending Violence against Native Women," Indian Law Resource Center website, https://indianlaw.org/issue/ending-violence-against-native-women; MMIW Database, Sovereign Bodies Institute website, https://www.sovereign-bodies.org/mmiw-database; Jaime Black, *The REDress Project*, http://www.redressproject.org/; "Dozens of Native American Women Have Disappeared in Montana," https://www.youtube.com/watch?v=btBNBUmaPp8&feature=youtu.be.

17

Among the movement's nonwhite practitioners were William Cooper Nell, an African American abolitionist from Boston who

was a known Spiritualist, and Sojourner Truth, an African American Spiritualist, abolitionist, and women's rights activist. See Braude, *Radical Spirits*, 60–61. For a thorough study of the Afro-Creole Spiritualist group Cercle Harmonique, see Emily Suzanne Clark, *A Luminous Brotherhood: Afro-Creole Spiritualism in Nineteenth-Century New Orleans* (Chapel Hill: University of North Carolina Press, 2016).

18

For reflections on the channeling of Native American spirits, see Bridget Bennett, "Sacred Theaters: Shakers, Spiritualists, Theatricality, and the Indian in the 1830s and 1840s," *The Drama Review* 49, no. 3 (Fall 2005): 114–34; Braude, *Radical Spirits*, 120.

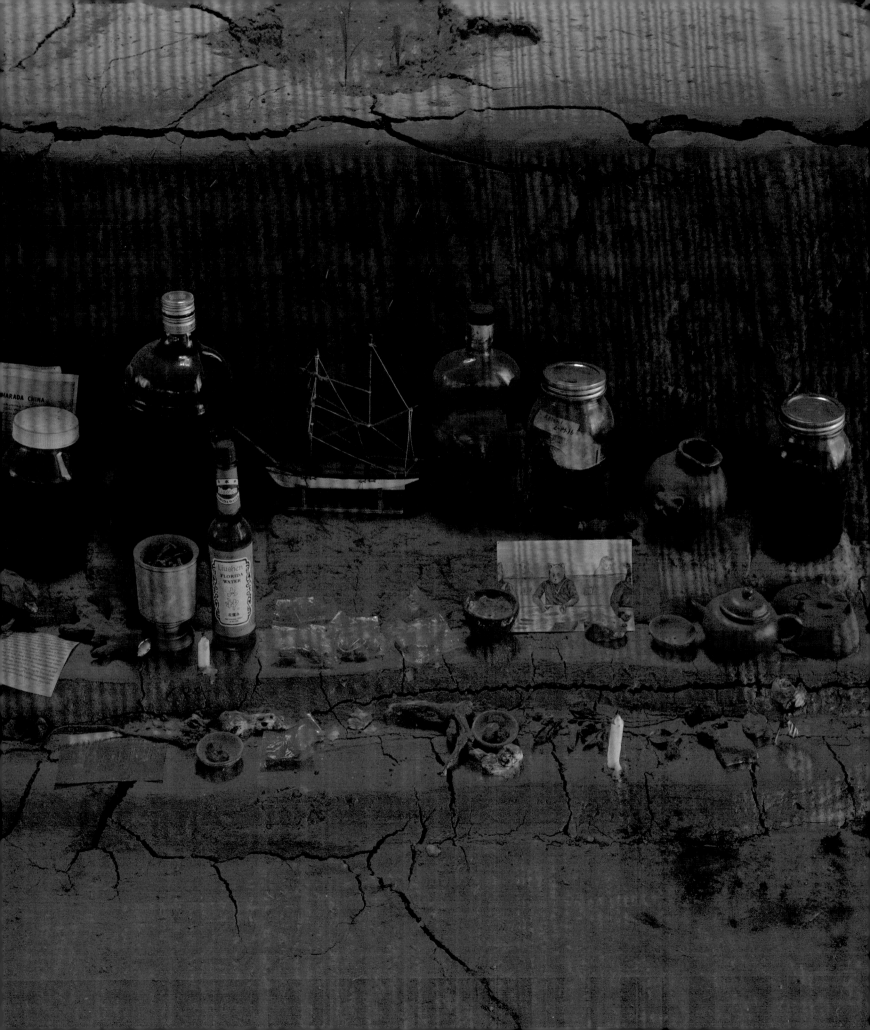

La Charada China

(a home)

CANDICE LIN

In my past life, I was a horse before I was a house. Not an iron horse that belched steam and ran from east to west, grinding the bones of the Irish and the Chinese. Just an ordinary horse in a green field in Concord, Massachusetts, the sunshine on my back, the moist soil indented by my strong hooves. Papa was embarrassed when the other gentlemen educators came to see our model family and Marmie made a joke, "this one's not a little girl, she's a horse." I flashed my dark eyes and tossed my thick mane in defiance. I will become my Papa. I will trot on his fields and make his Fruitlands into my Plumfields. I will never pull the plow. Instead of apples, my crop will be boys; I am a specialist in masculinity, since I am placed outside of it. Our lives are intertwined. I die two days after my father. I marry him in my most famous book. I am a horse.

Hope, Harriet, Empress, Experiment, Frolic, Glide, Canton, and the *Grand Turk.* These were the names of our ships.[1] From the ships came the scent of mahogany, rhubarb, cassia, and clove, the clink of blue and white porcelain that balanced the keel, the blue silk crepe fabric that my older sister made into a dress. Before I was a horse I was a house being shipped across the ocean. I remember the gentle rocking that was more than an infant's cradle. I remember the hot foul air in my belly, and the people packed into it, crying in sickness and mutiny. I remember the sweet smell of smoke that mingled with the undisguisable stench of feces and urine.

As a house, a Chinese house, I was small but well built. I was disassembled and put on board the *Frolic.* The *Frolic* had had a long run as an opium clipper ship in the firm of Augustine Heard & Company. But now I was folded into compact bundles, to be refabricated and sold in California. Alongside my lumber arms and elbows, there were rosewood and lacquered cabinets and dressers, porcelain, and silk shawls. In size, I might have compared to the cabin that Henry David Thoreau built on Walden Pond, reusing the timbers from a railroad worker's shanty. In other words, I was modest in size, but I must have been beautiful. Beautiful enough to ship my bones across the sea. Perhaps I had wooden doorways carved into a perforated lace of dragons and good luck symbols and windows made of translucent shells. They would not have shipped me if I were merely good wood. We shipwrecked in Mendocino, right next to a whole parcel of fine redwood trees, the beginning of a logging industry. The Pomo Indians were seen later wearing silk shawls and eating out of blue and white crockery.[2] No one knew what happened to me.

I went down under the sea, where Commissioner Lin had dumped the thousand long tons of illegal British opium, giving them the excuse to declare the first Opium War. He hoped the sea would swallow it all without offense at such pollution, and made offerings of hog's bristles, sheep's wool, and dainty pastries and cakes.[3] The sea does not forget, and a thousand tons was not enough to cloud its memory. It remembers all of the enslaved Africans and, later, the Indian and Asian workers who were dragged across the oceans in ships like the one that took me. Some of them jumped overboard in suicide; some of them were thrown in alive because they were too rebellious, too sick, or just worth more in insurance value.[4] Their bodies remain in the ocean, literally. Christina Sharpe writes in her book *In the Wake* of the scientific concept of residence time, the time it takes for a body to enter and leave the ocean. She writes, "Human blood is salty, and sodium [. . .] has a residence time of 260 million years."[5]

Over two hundred thousand Chinese workers were brought to the United States and the Caribbean from 1847 to 1874 to harvest sugarcane, tobacco, and guano; to make bricks and dams out of clay and cement; to mine mercury and silver. The so-called "coolie trade" was both a continuation of coerced labor and a "solution" to the impending abolition of slavery. Like the African and indigenous slaves, the Chinese also resorted to suicide when they found themselves regularly abused, in virtual enslavement despite their supposedly "free" status due to broken and never-ending labor contracts, corporal punishment, and substandard living conditions. There was no way to earn a living, to save and return home a wealthy man—or to return home at all—as the contracts had promised. In 1862 half of the 346 deaths reported on the island of Cuba were Chinese. The most luxurious form of suicide was eating opium, the very same drug that politically paved the way for

the exploitation of Chinese labor. But more often than not, the workers simply hanged themselves from the eaves of their ramshackle homes or from nearby trees.[6]

After I grew up in Concord, I was no longer a horse or a house, and I grew into a fine young woman. I wanted to serve my country so I enlisted as a nurse during the Civil War. I am still haunted by the faces of those young men, and my body still bears the effects of the calomel I took when the fever hit me hard. The mercury took the best of my beauty; my dark chestnut hair fell out in clumps and turned gray and brittle; I was constantly nauseous and in pain. Father said it was nothing an apple and a glass of water wouldn't cure, but I was not the workhorse I used to be. I was the caregiver and I did not have time to die, so I took hashish and morphine, the cleaner, less addictive opiates, so I could go on writing and working.[7] I was not proud of this, but in May I had earned enough to buy a fine set of china for the family and a gray soapstone sink for Marmie. She cried and loved it well. It would have cost Papa a year's salary.

To dissuade the Chinese workers from suicide, the overseers would sometimes mutilate their corpses, dissecting and disemboweling their bodies. Even when they were not mutilated, they were not given a proper burial but were often cast in the side of a ditch or piled with the bodies of livestock. The desecration of the bodies of these dead ensured, by Chinese burial customs, that, even in death, these workers would never return home but would forever wander the earth.

Chinese workers addressed officials in the 1873 Chin Lan Pin Commission sent by the Chinese Imperial court to ascertain the poor working conditions in Cuba. One worker wrote: "We are old and weak and it is only uncertain whether we shall die in a depot or in a fresh place of service, or cast out as useless by the roadside; but it is certain that for us there will be neither coffin nor grave, and that our bodies will be tossed into a pit, to be burnt with those of horses and oxen and to be afterwards used to refine sugar . . . to produce an even purer whiteness."[8] Noting the high rates of suicide among Chinese workers in the field and even on the ships before arriving at the plantations, British and American officials attributed this to the general debilitated and emaciated state of such workers who,

they claimed, were all opium addicts, prone to sickness and death.

In 1885, when my dear Lulu was just five years old and three years before I died, I wrote a story of a little girl, just like her, who goes to candy country. In this world,

> the people all lived on sugar, and never quarreled. . . . The way they grew old was to get thinner and thinner till there was danger of their vanishing. Then the friends of the old person put him in a neat coffin, and carried him to the great golden urn which stood in their largest temple, always full of a certain fine syrup; and here he was dipped and dipped till he was stout and strong again, and went home to enjoy himself for a long time as good as new.[9]

In the Caribbean, porcelain domestic objects were prized as they were in New England. With the increasing ease and reach of transatlantic commercial trade in the nineteenth century, delicate shipments of family china became less rare, and cheaper imitations of porcelain became more accessible across class lines. In Cuba, the Santería practice emerged where the treasured china cabinet became a ritual altar, and the soup tureen, or *sopera*, became a place to house the spirit of a god.[10] Lydia Cabrera writes that "far from being limited to the replacement of earthenware pots beside Santería altars with 'China,' that is, with vases made of Chinese porcelain, 'Chinese magic' rapidly acquired a reputation among African slaves and their Spanish masters as 'the worst and most powerful of all.'"[11] La charada china is a syncretic gambling game that was invented in the Caribbean and drew from a host of symbolic systems—Spanish Lotería cards, Chinese astrology, African Yoruban gods, and indigenous folklore of local plants and animals. It mapped these symbols onto a stereotyped figure of a Chinese man in elfin slippers with a long braided queue of hair, holding an opium pipe in his left hand. In the nineteenth century, the Chinese laborers gathered together around gambling games like charada china, in communities of hope and chance, though these later developed the problems of organized crime and racketeering. While no single laborer had a chance at earning enough money in the system of debt-peonage that was stacked against them, la charada china gathered a pool of money together from

everyone's earnings and redistributed it to one lucky winner, enabling that person to return to China or to stay in the United States or Caribbean, open a store, make a home, and settle down.

NOTES

1
These are the names of some of the first clipper ships to be built and launched by American merchants from New England.

2
Thomas Layton, *The Voyage of the* Frolic: *New England Merchants and the Opium Trade* (Palo Alto, CA: Stanford University Press, 1997).

3
Arthur Waley, *The Opium War through Chinese Eyes* (New York: Routledge, 1958/2005).

4
M. NourbeSe Philip, *Zong!* (Middletown, CT: Wesleyan University Press, 2008).

5
Christina Sharpe, *In the Wake: On Blackness and Being* (Durham, NC: Duke University Press, 2016).

6
Kathleen López, *Chinese Cubans: A Transnational History* (Chapel Hill: University of North Carolina Press, 2013); and Moon-Ho Jung, *Coolies and Cane: Race, Labor, and Sugar in the Age of Emancipation* (Baltimore, MD: Johns Hopkins University Press, 2008).

7
Stephen Gertz, "Sisters in Opium: Elizabeth Barrett Browning and Louisa May Alcott," *Seattle PI*, January 14, 2010, https://blog.seattlepi.com/bookpatrol/2010/01/14/sisters-in-opium-elizabeth-barrett-browning-and-louisa-may-alcott/. See also Susan Cheever, *American Bloomsbury: Louisa May Alcott, Ralph Waldo Emerson, Nathaniel Hawthorne, and Henry David Thoreau* (New York: Simon and Schuster), 2006.

8
The Cuba Commission Report: A Hidden History of the Chinese in Cuba: The Original English-Language Text of 1876, Johns Hopkins Studies in Atlantic History and Culture (Baltimore, MD: Johns Hopkins University Press, 1993), 80.

9
Louisa May Alcott, *Candy Country* (Boston: Little Brown and Co. / S. J. Parkhill and Co., 1885/1900), 8.

10
"White Cubans remember the sopera as a cherished object of Cuban middle- and upper-class domestic life. The sopera . . . [was] saturated with the meanings of domestic well-being and social class status. . . . With the increasing diversity and reach of transatlantic commercial nineteenth-century trade, imitations, often of less elaborate materials and design, were disseminated widely across class lines." David Brown, *Santería Enthroned: Art, Ritual, and Innovation in an Afro-Cuban Religion* (Chicago: University of Chicago Press, 2003), 253.

11
Lydia Cabrera, "Editorial Letras Cubanas," in *El Monte* (Havana, Cuba: 1985), 33; English translation: Patrick Taylor and Frederick Case, eds., *The Encyclopedia of Caribbean Religions, Volume 1: A–L* (Urbana: University of Illinois Press, 2013), 161. It is likely that the Chinese also brought their long tradition of medicine, knowledge of plants, and poisons along with their history, myths, and religious beliefs.

"Alive to Its Axis"

The Animate Landscape of Transcendentalism and Its Legacy in US Culture

RICHARD HARDACK

"Alive to Its Axis"

The Animate Landscape of Transcendentalism and Its Legacy in US Culture

RICHARD HARDACK

Mid-nineteenth-century New England transcendentalists sought to transcend themselves—that is, their white male subjectivities—by seeking communion with a sacralized form of nature, which they believed offered an antidote to the perceived constraints and pathologies of their society. While aspects of transcendentalism might seem archaic to contemporary readers, some of its postulates foreshadow recent post-humanist theory, which rejects hierarchical and anthropocentric views of life. For example, some transcendentalists believed that all things are alive, sentient, and conscious in some way. This facet of transcendental thought—an animistic attribution of spirit to nature—draws on Native American, African American, and aboriginal sources, which transcendentalists sometimes acknowledged. Indeed, its syncretic nature in some ways makes transcendentalism distinctly American.[1]

Many of those in antebellum New England who affiliated themselves with transcendentalism tended to view society with suspicion but also to situate nature as their Other—everything that was outside themselves. Their animism usually fetishized a primitive and racialized nature, alienation from which lay at the heart of some post-colonial constructions of whiteness. A progressive and sometimes utopian vision for reforming society was connected to the visionary part of transcendentalism: the desire to transcend the ego to become one with nature, and to link the isolated individual to an imagined prelapsarian culture. But the nature they sought represented a retroactive fantasy of a state of being that never existed, and in this formulation white identity emerges as a belated, boot-strapped construct dependent on the nonexistence of its imagined alterities. Attaining transcendence therefore often proved difficult.

In Joseph McElroy's 1974 novel *Lookout Cartridge*, an unnamed intellectual alleges that "Americans confused the natural resources of their continent with their own ability to exploit those resources, and even mingled those minerals and plants with the illusion of philosophical ideas."[2] This conflation summarizes an ontological strain of American pantheism, an animistic distillation of transcendentalism that resurfaces in a series of counter–Great Awakenings (movements that seek spiritual revival or ego-transcendence not through Christianity but through nature or some form of counterculture, religion, or psychedelic drugs). This pantheism is predicated on the deification of impersonal nature or universal natural law and, ultimately, of any great, impersonal collective force.

Herman Melville was both a great expositor and a critic of animism. A contemporary of Ralph Waldo Emerson's and friend of Nathaniel Hawthorne's, he frequently dramatized transcendental ideas in his fiction, at first playfully, but with increasing alarm at his own susceptibility to them and their implications. Melville's alienation from pantheism likely reflects disappointment with how an already corporatized antebellum United States constructed nature, rather than an alienation from his own experience of nature. He debated whether communion with nature could be an end in itself, in part because he surmised it could not replace a practical politics.

From *Typee* (1846) to *Pierre* (1852), Melville's protagonists are often men who seek to rejuvenate themselves by fleeing society and merging with a racialized and female nature.[3] When they first encounter such presences, they experience oneness and mystical ecstasy. In the arc of his work, however, Melville grew wary of these fantasies and revealed them as symptoms of the corporatized society they were meant to oppose. In popular culture, the fantasies Melville addressed still tend to be taken at face value. To explain how they function, I start with a brief history of transcendentalism and pantheism in the United States and then focus on the works of Melville and Emerson, which offer the best expositions of this narrow but still influential genre of natural philosophy. I then trace the legacies of transcendentalist animism as they recur in certain contemporary texts.

Visionary in their prophetic traditions and progressive social agenda, many transcendentalists advocated greater equality for women and minorities and the reform of labor practices, marriage laws, diet (including vegetarianism), modes of consumption, religious dogmatism, and education. Transcendentalists helped generate a series of liberationist and utopian projects that rejected the materialism of US culture and sought spiritual meaning in the natural environment. Transcendentalism was also visionary because many of its exponents were obsessed with the ways in which looking at the world shaped it. Emerson, especially, emphasized

the connection between seeing and being, and he mystically, ontologically, and even etymologically associated orbs/eyes with male production, reproduction, and aesthetics. (Emerson believed that the eye, the male orb, was another kind of testis—it created what it viewed, which helps explain why some transcendentalists were interested in an occult ocularity and were ekphrastic in representing nature.)[4] Transcendentalism simultaneously espoused both a kind of Gnostic mysticism and what was seen as irreligious natural science.

Uncertainty about whether nature is alive or a thing to be exploited attaches to a long line of speculation by writers such as Emerson, Melville, D. H. Lawrence (in his works addressing US culture), Annie Dillard, and Thomas Pynchon, who ask if rocks and trees and finally worlds are sentient, and whether they can communicate with us. One of the transcendentalists' imperatives was to treat living creatures as part of the community in which we exist rather than in utilitarian terms. If we are not sovereigns over, but enmeshed with, the world, all relations and communication must become bilateral—or, more realistically, multilateral. In ways that continue to inspire artists, transcendentalists presupposed reciprocity with nature. As Thoreau asked in *Walden* (1854), "What shall I learn of beans or beans of me?"[5] Or as Emerson contends, an occult relation exists between man and nature, an idea that dissolves boundaries between human and animal, and culture and nature; he wrote, in the original journal entry that would inform the 1836 essay "Nature," of how he loved "the mighty PAN. . . . [I]n the fields I am not alone or unacknowledged, they nod to me and I to them."[6] These nods signal telepathic transmissions, to which only initiates, mystics, the mad, the alert, the drugged, and pantheists generally have access.

In the United States, nature also has served as a disguise for the artifice of the corporation. Essentialized nature is cast as the polar opposite of the corporation, which represents the most artificial and in some ways complex of human inventions, a form of artificial nature or intelligence hostile to the nature it exploits. *Moby-Dick* (1851) chronicles a form of this colonization of nature—a New England whaling venture backed by a joint-stock investment.[7] Hunting whales already threatened with extinction, Ishmael tells us the universality

of nature is being superseded by the universality of the corporate enterprise. Many of Melville's characters who seek to encounter animated nature (a collective mass that is alternately benign and terrifying) unexpectedly encounter an animated corporation. Transcendentalists often reacted to this incipient corporatization. For Emerson, "Society is a jointstock company. . . . Self-reliance is its aversion."[8] By self, however, Emerson meant an archetypal, not individual, self—he wanted men to rely on universal nature, and never personal subjectivity.[9] For Melville, that self could be merged with both society and nature. As we learn throughout *Moby-Dick*, "It's a mutual, joint stock world, in all meridians": "my own individuality was now merged in a joint stock company of two."[10] (In the latter example, Ishmael acknowledges his relationship with the Pacific Islander Queequeg.) Such passages intimate the way Melville's characters tried to merge with other men and with nature but sometimes realized they had merged with the corporation. The corporate form, which in the nineteenth century primarily took the guise of the joint-stock company, was developed to colonize the New World and subjugate nature. Its tactic, from whaling to slavery, was to extract natural resources and co-opt the cultures of the aboriginal societies it dispossessed in ways that ultimately justified the corporate endeavor itself.

We witness a putative contest between emblematic views of nature in *Moby-Dick*, voiced first by the narrator Ishmael, who exults in the possibility of being merged into the sublime All but is also terrified by his susceptibility to losing himself in it; and then by the tragic obsessive Ahab, who personifies all malignant nature in the white whale that amputated his leg. Ishmael worries that "seductive seas" lure men into a rapprochement with nature they cannot survive: so lulled into an "unconscious reverie is this absent-minded youth that at last he loses his identity."[11] For the pantheist, nature, or a natural high, alleviates the isolation of individuality by merging and submerging the self; loss of identity is also its transcendence. In contrast, Ishmael tells us that "few thoughts of Pan stirred Ahab's brain."[12] Motivated by a hypertrophied hostility to nature, such individualists are sometimes dismembered by, rather than merged with, that nature.

Nature in antebellum New England was often imagined as a collective cure for the ills of uncivil

society. Ishmael describes even the multicultural crew of *Moby-Dick* as "Isolatoes," each "living on a separate continent of his own."[13] Emerson consonantly concluded in his lecture "The Heart" that "man is insular and cannot be touched. Every man is an infinitely repellent orb, and holds his individual being on that condition."[14] Transcendentalism emerges against this backdrop. In 1840 the French proto-sociologist Alexis de Tocqueville predicted that collectivizing religions would be popular in the United States because they allowed its atomized citizens to immerse their identities in a unified whole: a "philosophical system which teaches that all things . . . [are only] the several parts of an immense Being, who alone remains eternal amidst [ceaseless transformation] . . . such a system [of pantheism], although it destroy the individuality of man, or rather because it destroys that individuality, will have secret charms for men living in democracies."[15] Whether sympathetic, hostile, or indifferent to humankind, nature is a giant animated collective that men seek to merge into, and whether it is sympathetic, hostile, or indifferent to humankind, Tocqueville concludes that "pantheism [is among the philosophies] most fitted to seduce the human mind in democratic times."[16]

Based partly on Emerson, Melville's character Babbalanja in *Mardi* (1849) conjures the immense Being of a pantheistic world:

> There are more things alive than those that crawl, or fly, or swim. Think you, my lord, there is no sensation in being a tree? Feeling the sap in one's boughs, the breeze in one's foliage? Think you it is nothing to be a world? . . . what are our own tokens of animation? That we move, make a noise, have organs, pulses, and are compounded of fluids and solids. And all these are in this Mardi as a unit. . . . Its rivers are its veins; . . . it shouts in the thunder and weeps in the shower; . . . Mardi is alive to its axis.[17]

Mardi is a proto-Gaean living network of nature. Melville was intrigued and amused by such animism, whose advocates sought kinship with a living world, but he grew increasingly concerned that this living world might be a malevolent corporate feint.

The first premise of Emerson's transcendentalism is that one must transcend the body, ego, and self-consciousness by merging into nature. In "Nature," Emerson asserts that within the words, or plantations of God, he is "bathed by the blithe air and uplifted into infinite space,—all mean egotism vanishes. I become a transparent eyeball. I am nothing; I see all; the currents of the Universal Being circulate through me"[18] (see fig. 1.4). Borrowing from Indian religions, transcendentalists proposed that we must lose consciousness of self to gain consciousness of nature. One can transcend self-consciousness only by being nowhere (transcending the subject's position), which equates to seeing All. Emerson becomes the transparent eyeball as he merges into the All of Nature, which he situates as the Other, or "not me," of whiteness; he avers that "all that is separate from us, all which philosophy distinguishes as the NOT ME . . . must be ranked under this name, NATURE."[19] To transcend his subjectivity, Emerson must merge into a racialized nature, which supposedly will liberate him from the vitiation and isolation of individuality.

Throughout his work, Emerson associated the "not me" of nature along lines of racial distinction. Emerson orated that the "free negro" stands "in nature below the series of thought, and in the plane of vegetable and animal existence."[20] The early Emerson also asserted that "the brute instinct rallies and centres in the black man. He is created on a lower plane than the white, and eats men."[21] Though he became a fervent abolitionist, Emerson never relinquished his racial ontology, which was predicated on his inchoate belief that whiteness represented a dematerialized transparency and a spiritual universality that, in turn, were dependent on the materiality and particularity of racialized and feminized nature. For the transcendentalist, the price and benefit of merging into nature was the self—the form of particularity Emerson associated with being wrong, because rightness transcended the specific and became representative. Emerson wanted to regain access to what he termed the "aboriginal Self," an archetypal identity that predates and supersedes personal subjectivity.[22]

Scholar John Carlos Rowe demonstrates that the later Emerson appealed "for New England transcendentalism to be changed significantly by its exposure" to African American religion.[23] But aside from gleaning elements of actual African American beliefs, Emerson primarily "ontologized" race—he situated nature, Pan, natural instinct, and aboriginality as

innately nonwhite. More specifically, Emerson connotes Pan/natural instinct as black, a process beginning before Harriet Beecher Stowe provided him with the following reference from her novel *Uncle Tom's Cabin* (1852): Pan is "aboriginal, old as Nature, and saying, like poor Topsy [the slave girl who never knew her parents], 'Never was born; growed.' . . . The mythology cleaves close to Nature."[24] Contemporary African American writers, however, had little interest in linking blackness to nature, or in transcending a self they were told they did not fully possess. While Frederick Douglass, for example, could appreciate transcendental philosophy, he never embraced its theosophy of nature.[25]

While they are associated with "animated nature," African Americans were simultaneously rendered "inanimate" property in antebellum society. As the narrator of Ishmael Reed's 1976 novel *Flight to Canada* declaims, paraphrasing Frederick Douglass, "Isn't it strange? Whitman desires to fuse with nature, and here I am, involuntarily, the comrade of the inanimate. . . . I am property. I am a thing."[26] Whitman—whom Reed somewhat unfairly sets up as a straw/white man—wants to transcend his identity by merging into a racialized nature. Following the lead of D. H. Lawrence, who castigated Whitman as "the first white aboriginal,"[27] Reed playfully mocks transcendental vagaries and chides "those awful Whitmanites always running around hugging things."[28] In fact, this rebuke might apply to Melville, the first avowed tree-hugger, who ushered a group that included Hawthorne to a special spot to show them "some superb trees. He [admitted] that he spent much time there patting them upon the back."[29] Such descriptions remind us of the spiritual connection transcendentalists felt with landscape, often emblematized by trees.

Transcendentalists imagined the living world was designed according to organic principles. Thoreau traced how archetypal leaves and lobes (orbs/eyes) were linguistically and taxonomically connected. Like Emerson and Whitman, Thoreau suggested that just as all vertebrate bodies develop from spines and all plant bodies from leaves (based on the proto-Darwinian theory of development), nature and culture animistically coincide in books, which also "develop" from spines and leaves. Or as Timothy Gould postulates, Thoreau dedicated himself to finding the "continuity between natural law and linguistic significance," or the ways the natural world speaks to and through us.[30]

The continued animistic ascription of meaning to nature evinces the legacy of transcendental animism in US literature of the late twentieth and twenty-first centuries, particularly in works that reject the presumption that humans occupy a privileged space within nature. Many of these texts correct misreadings of transcendentalism that overly venerate the individual and instead situate individuals within environmental as well as social communities. That process usually begins with some epiphanic encounter with nature. In Pynchon's postmodern epic *Gravity's Rainbow* (1973), for example, we meet "the presences we are not supposed to be seeing—wind gods, hilltop gods, sunset gods—that we train ourselves away from to keep from looking further. . . . Suddenly, Pan—leaping—too beautiful to bear."[31] Invoking a familiar reciprocity in the essay "Pan in America," Lawrence attests that nature has "helped him vitally": energy crosses to him "from the tree, and I become a degree more like unto the tree, more bristling and turpentiney, in Pan. And the tree gets a certain shade and alertness of my life."[32] In *Gravity's Rainbow*, Pynchon's primary protagonist, the justifiably paranoid and increasingly AWOL American intelligence officer Tyrone Slothrop, becomes "treed at last!" and "alert to trees, finally." Like Melville, he will

> spend time touching them . . . [realizing] each tree is a creature . . . aware of what's happening around it, not just some hunk of wood to be cut down. Slothrop's family actually made its money killing trees . . . grinding them to pulp, bleaching that to paper and getting paid for this with more paper. "That's really insane." . . . [The trees] know he's there. They probably also know what he's thinking. . . . [A pine] nods its top and suggests, "Next time you come across a logging [tractor] . . . take its oil filter."[33]

Madness isn't talking to trees—it's not hearing them when they nod.

In the transcendental realm, nothing is more collectively social than a tree. In Richard Powers's novel *The Overstory* (2018), the botanist Patricia Westerford determines "trees are social creatures [that] evolved ways to synchronize" and "form one great symbiotic consciousness"; redwoods represent "an immortal,

collective ecosystem," another immense eternal Being. "Linked together on an airborne network," these trees "send out alarms": "Life is talking to itself. . . . The biochemical behavior of trees may make sense only if we see them as members of a community."[34] One of Emerson's central ideas is that life enables the universe to talk to itself, and Powers's trees nod to us as pitifully few of us nod to them. Nature also provides Powers's socially isolated characters with community. Powers espouses the sentimental pantheism that Whitman propounded, reifying nature as benign: men stubbornly refused to "believe that plants were really *alive*. . . . Now we know that plants communicate and remember. . . . Link enough trees together, and a forest grows *aware*. . . . The environment is alive—a fluid changing web."[35]

Conceiving of identity that transcends individuality, pantheists often render people as collectivized plants. In *The Overstory*, Powers asserts that nature erases delusions of "Isolato-ism": when Douglas fir roots "run into each other underground, they fuse. . . . Networked together . . . There aren't even separate species. . . . There are no individuals in a forest."[36] But in Powers's novel, the creation of a full-scale, networked digital world proceeds in correlation with the destruction of the natural world. (The book's title evokes Emerson's Over-Soul but also implies the story might be over, that nature has been lost.) *The Overstory* addresses the interconnections of ecosystems from under the shadow of the expanding virtual, with the sense that the more the "second nature" of the virtual/corporate world extends, the further nature diminishes. What perhaps has changed most in such recent narratives is the presumption that humans have precipitated the Anthropocene, an era defined by how people have affected the planetary environment. In that context, the world that is alive to its axis is trying to communicate something we remain unwilling to hear.

1

An unexpected correlative of transcendental animism now supports some of the critical tenets of corporate personhood. In literature and in society, we are still debating what is alive, what has rights and agency and what can speak. As Jane Bennett summarizes, vital materialism has affinities with "nonmodern (and often discredited) modes of thought, including animism, the Romantic quest for nature, and vitalism," and rejects binaries that separate nature from culture, living/sentient from nonliving, and matter from being. Jane Bennett, *Vibrant Matter: A Political Ecology of Things* (Durham, NC: Duke University Press, 2010), xviii. According to Catherine Albanese, the naturalist John Muir's "environmental religion of nature" incorporated the "romantic transcendentalism" he learned from Emerson and Thoreau, which mingled "pantheistic-vitalistic strains." Catherine Albanese, *Nature Religion in America: From the Algonkian Indians to the New Age* (Chicago: University of Chicago Press, 1990), 95, 93.

2

Joseph McElroy, *Lookout Cartridge* (New York: Knopf, 1974), 16.

3

See, for example, Herman Melville, *Pierre*, ed. Harrison Hayford, Hershel Parker, and G. Thomas Tanselle (Evanston, IL: Northwestern University Press, 1968).

4

Emerson depicts the eye as a biological and taxonomic archetype that encapsulates all aspects of creation: "Eyes are better on the whole than telescopes or microscopes. . . . Goethe suggested the leading ideas of modern botany, that . . . the eye of a leaf is the unit of botany, and that every part of a plant is only a transformed leaf." Ralph Waldo Emerson, "Goethe," in *The Complete Works of Ralph Waldo Emerson*, 1–12 (Boston: Houghton Mifflin, 1904), 4:275. Emerson treats the eye, in its circular form and actual and figurative functions, as the symbol of a harmonious nature: "The eye is the first circle; the horizon which it forms is the second; and throughout nature this primary figure is repeated without end. . . . St. Augustine described the nature of God as a circle whose centre was everywhere and its circumference nowhere" ("Circles," in *Complete Works*, 2:299–301). When he is still in his (literally) optimistic mood, Emerson believes that the "plastic power of the human eye" reflects the plastic power of nature: nature's unity "seems partly owing to the eye itself" ("Nature," in *Complete Works*, 1:15).

5

Henry David Thoreau, *Walden: A Fully Annotated Edition*, ed. Jeffrey S. Cramer (New Haven, CT: Yale University Press, 2004), 150.

6

Ralph Waldo Emerson, *The Journals and Miscellaneous Notebooks of Ralph Waldo Emerson*, 1–16, ed. William Gilman et al. (Cambridge, MA: Harvard University Press, 1960–82), 5:179.

7

As Ishmael remarks, Nantucketers "invest their money in whaling vessels, the same way that you do yours in approved state stocks." Herman Melville, *Moby-Dick*, ed. Harrison Hayford, Hershel Parker, G. Thomas Tanselle (Evanston, IL: Northwestern University Press, 1988), 73.

8

Emerson, "Self-Reliance," in *Complete Works*, 2:49–50. Of course, some transcendentalists formed communal farming enclaves such as Brook Farm and Fruitlands, but their sociality was tied to a back-to-the-land ethos and had little traction in urban settings.

9

Emerson's notion of self-reliance has been misinterpreted in popular culture in problematic ways, as I argue in*"Not Altogether Human": Pantheism and the Dark Nature of the American Renaissance;* "'Infinitely Repellent Orbs': Visions of the Self in the American Renaissance," in *Languages of Visuality: Crossings between Science, Art, Politics, and Literature*, ed. Beate Allert (Detroit: Wayne State University Press, 1996), 89–110; and "Dream a Little Dream of Not Me: The Natures of Emerson's Demonology," *symplokē* 26, no. 1–2 (2018): 329–60. Though individualism, too, has its secret charms, few informed writers would take utopian individualism seriously, which is why Ayn Rand, who thought billboards improved nature, was its preeminent promoter.

10

Melville, *Moby-Dick*, 56, 320.

11

Melville, 158–59.

12

Melville, 456.

13

Melville, 121.

14

Ralph Waldo Emerson, *The Early Lectures of Ralph Waldo Emerson*, 1–3, ed. Robert Spiller and Wallace Williams (Cambridge, MA: Harvard University Press, 1959, 1964, 1972), 2:280.

15

Alexis de Tocqueville, *Democracy in America* 1–2, The Henry Reeve Text, rev. Francis Bowen, ed. Phillips Bradley (New York: Knopf, 1953), 2:31–32.

16

Tocqueville, *Democracy in America*, 2:32.

17

Herman Melville, *Mardi*, ed. Harrison Hayford, Hershel Parker, and G. Thomas Tanselle (Evanston, IL: Northwestern University Press, 1970), 458.

18

Emerson, "Nature," in *Complete Works*, 1:10–11.

19

Emerson, "Nature," in *Complete Works*, 1:4–5.

20

Emerson is quoted in James Elliot Cabot, *A Memoir of Ralph Waldo Emerson*, 1–2 (Boston: Houghton Mifflin, 1888), 2:429.

21

Cabot, *A Memoir of Ralph Waldo Emerson*, 2:429.

22

Emerson, "Self-Reliance," in *Complete Works*, 2:63.

23

John Carlos Rowe, *At Emerson's Tomb: The Politics of Classic American Literature* (New York: Columbia University Press, 1997), 19.

24

Emerson, "Natural History of the Intellect," in *Complete Works*, 12:35–36.

25

Douglas Jones contends that "transcendentalism provided abolitionists such as Douglass a system of philosophical conceits" with which to "revitalize American abolitionism"; Douglass's notion of the "All-Wise" echoes "what Emerson termed the 'Over-Soul'—that is, the impersonal that animates" nature. Douglas A. Jones, "Douglass' Impersonal," *ESQ A Journal of the American Renaissance* 61, no. 1 (2015): 3.

26

Ishmael Reed, *Flight to Canada* (New York: Avon, 1976), 75.

27

D. H. Lawrence, *Studies in Classic American Literature*

(New York: Viking, 1964), 182.

28

Reed, *Flight to Canada*, 37.

29

Herman Melville, *The Melville Log: A Documentary Life of Herman Melville, 1819–1891, 1–2*, ed. Jay Leyda (New York: Harcourt, Brace, 1951), 2:506.

30

Timothy Gould, *Hearing Things: Voice and Method in the Writing of Stanley Cavell* (Chicago: University of Chicago Press, 1998), 182.

31

Thomas Pynchon, *Gravity's Rainbow* (New York: Penguin, 1995), 720–21.

32

D. H. Lawrence, "Pan in America," in *Phoenix*, ed. Edward McDonald (New York: Viking, 1936), 25–26.

33

Pynchon, *Gravity's Rainbow*, 199, 269, 552–53.

34

Richard Powers, *The Overstory* (New York: Norton, 2018), 122, 141, 197, 126.

35

Powers, *The Overstory*, 451–54.

36

Powers, 142, 264, 280.

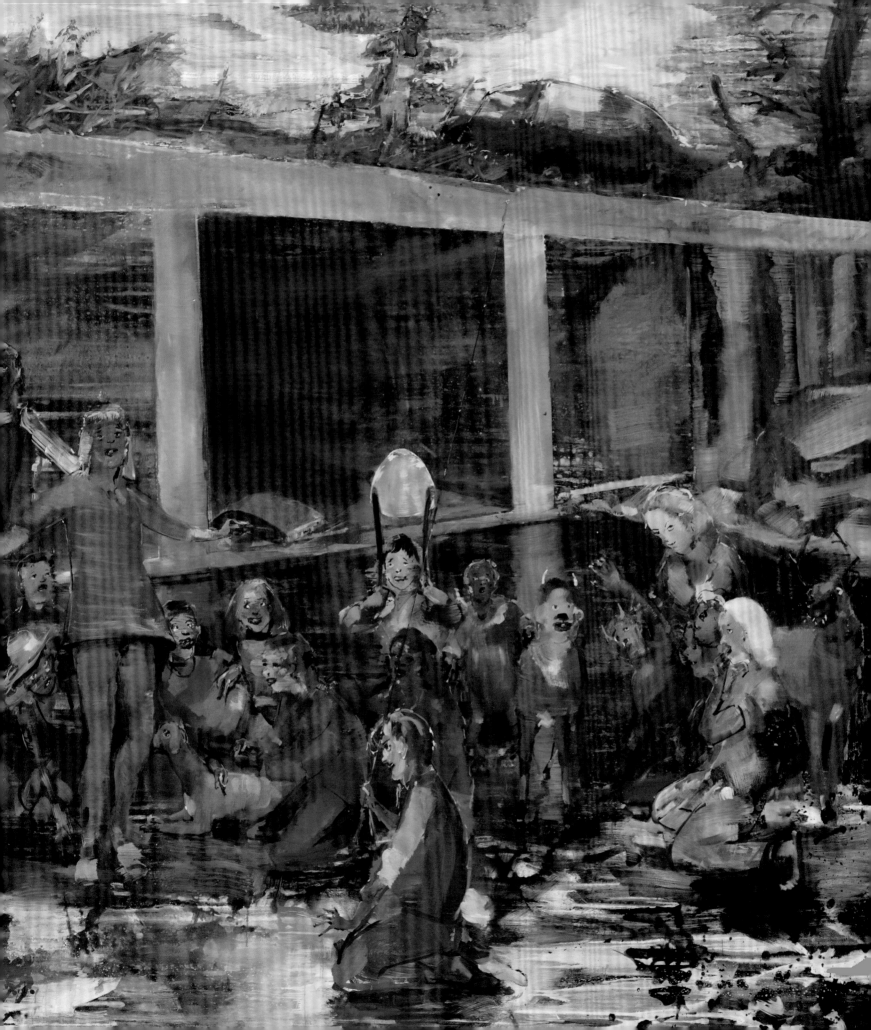

Childhood Shall

Be My Voice

to the Nation

ANNA CRAYCROFT

A mos Bronson Alcott's classroom revolved around the needs and desires of his young students. Today, such a characterization is unremarkable. However, Alcott opened his Temple School in Boston in the early nineteenth century. This was the predawn of progressive education, when a shift in focus from teacher to student was still a radical notion.

The ethos of Alcott's early-child pedagogy heralded slogans common in education today. It was *child centered*, used *object lessons*, welcomed *open dialogue*, encouraged students to be *self-directed*, and engaged the *whole child*. Each of these methodologies form the backbone of countless schools and educational philosophies that have been widely influential in the two hundred years following the brief life of Alcott's Temple School. Nonetheless, Alcott is rarely acknowledged as a significant voice in the canon of progressive education.

Some have argued that Alcott was too eccentric or fervently religious to be considered a substantive influence on the evolution of progressive pedagogies. But single-minded urgency was a driving force for educational reformers. The popularization of progressive education over the past century has diluted its more esoteric origins. This homogenization is paradoxical. Radical pedagogy is, by definition, a cultural and societal anomaly. With this in mind, we will consider Alcott's teachings alongside those of like-minded colleagues in order to lay bare his quintessentially American vision.

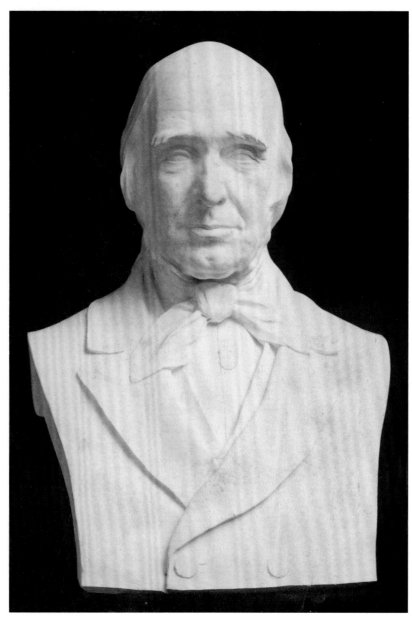

Child-Centered

At Amos Bronson Alcott's Temple School, thirty to forty students between the ages of three and twelve learned to cultivate what Alcott termed a "Common Conscience." This binding-yet-unspoken social contract was Alcott's pedagogical life force. Its catalyst was discourse. Each day, students sat in a semicircle around their teacher and analyzed various texts. All parties were given an equal platform for speaking their minds. Through this open dialogue, they would learn how to build a community that was compassionate, thoughtful, self-governing, and just.

These classroom conversations gained notoriety after Alcott published a book transcribing them. Fervent critics accused Alcott of using a forceful hand to lead the discourse, thus manipulating the opinions of his students. There is no way to measure the power of Alcott's persuasion retrospectively. In his insistence that the children spoke for themselves, Alcott suggests a political agenda embedded in his pedagogy.

Alcott concluded a journal entry in 1836 about his forthcoming book on Temple School with an evocative statement: "Childhood shall be my voice to the Nation." In this predictive proclamation, Alcott did not imagine himself speaking through children per se. Rather, *childhood itself* would be his avatar. By making a distinction between people (children) and a state of being (childhood), Alcott underscored the ideological core of his pedagogy.

The question of whether the students spoke entirely for themselves misses the broader aspirations of Alcott's agenda. Their audibility was essential regardless of volition because it substantiated Alcott's ambitions. Temple School presented a bold model for American democracy in what were still the early days of the United States as an independent nation. Alcott's students were the populace of his classroom, personifying his ideology of childhood through child-centered curricula. The chorus of their voices could be carried "to the Nation" only by the harmonizing force of the pedagogy that brought them together.

ANNA CRAYCROFT

Montessori

In Maria Montessori's pedagogy, developed in early twentieth-century Italy, the dance between child and teacher is one in which the child must always feel like the leader. Montessori wrote, "It is necessary for the teacher to guide the child without letting him feel her presence too much, show that she may always be ready to supply the desired help, but may never be the obstacle between the child and his experience."[1]

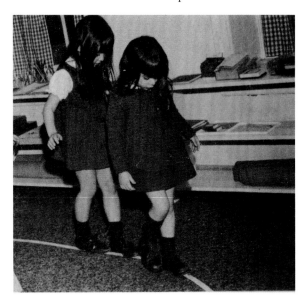

Kindergarten

The motto of Friedrich Froebel's early nineteenth-century German kindergartens, "*Kommt last uns unsern Kindern leben!*," has been translated as "Come, Let us Live *with* our Children,"[2] and as "Come Let us Live *for* our Children."[3] But perhaps the clearest articulation of how this child-centered thinking worked was "Come; let us live in an exemplary fashion for the benefit of our children!"[4] The role of the adult was to be the consummate model while allowing the children to lead themselves.

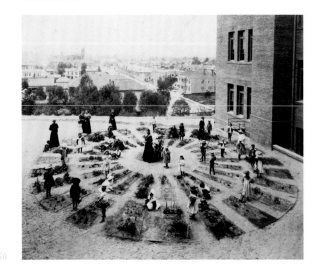

QUARTER CARD OF DISCIPLINE AND STUDIES IN MR. ALCOTT'S SCHOOL FOR THE SUMMER TERM CURRENT 1836.							
THE TUITION AND DISCIPLINE ARE ADDRESSED IN DUE PROPORTION TO THE THREEFOLD NATURE OF CHILDHOOD.							
THE SPIRITUAL FACULTY.		THE IMAGINATIVE FACULTY.		THE RATIONAL FACULTY.			
MEANS OF ITS DIRECT CULTURE.		MEANS OF ITS DIRECT CULTURE.		MEANS OF ITS DIRECT CULTURE.			
1. Listening to Sacred Readings on Sunday Morning. 2. Conversations on the GOSPELS. 4. Self-Analysis and Self-Discipline. 5. Listening to Readings from Works of Genius. 6. Motives to Study and Action. 7. Government of the School.		1. Spelling and Reading. 2. Writing and Sketching from Nature. 3. Picturesque Geography. 4. Writing Journals and Epistles. 5. Illustrating Words. 6. Listening to Readings. 7. Conversations and Amusements.		1. Defining Words. 2. Analysing Speech. 3. Self-Inspection and Self-Analysis. 4. Demonstrations in Arithmetic. 5. Study of the HUMAN BODY. 6. Reasonings on Conduct, and Discipline. 7. Explanations of Conduct and Study.			
The Subjects of Study and Means of Discipline are disposed through the Week in the following general Order.							
TIME.	SUNDAY.	MONDAY.	TUESDAY.	WEDNESDAY.	THURSDAY.	FRIDAY.	SATURDAY.

(table continues)

TIME.	SUNDAY.	MONDAY.	TUESDAY.	WEDNESDAY.	THURSDAY.	FRIDAY.	SATURDAY.
IX	SACRED READINGS	STUDYING SPELLING DEFINING and Writing the Lesson in Journals.	STUDYING GEOGRAPHY with Sketching Maps in Journals.	STUDYING THE GOSPEL LESSON for the day and Writing it in Journals.	STUDYING PARSING LESSON and Writing it in Journals.	STUDYING ARITHMETIC writing the Demonstrations in Journals.	PREPARING JOURNALS AND BOOKS for Examination.
X	with Conversations on the	SPELLING with Illustrative Conversations on the Meaning & Use of WORDS.	RECITATIONS in GEOGRAPHY. with Conversations and Illustrations.	CONVERSATIONS on SPIRIT DIVINE AND HUMAN as revealed in the LIFE of JESUS CHRIST.	ANALYSING SPEECH Written and Vocal with Conversations on the Principles of GRAMMAR.	RECITATIONS in ARITHMETIC with Demonstrations Written and Mental.	READINGS from Class-Books with Conversations on the Sense of the Text.
XI	TEXT and Singing						
	(BEFORE CHURCH.)	RECREATION ON THE COMMON OR IN THE ANTE ROOM.					
XII	with Readings	READINGS by the TEACHER from Works of Genius.	DRAWING from NATURE with Mr. Graeter.	CONVERSATIONS on the HUMAN BODY and the Means of Health.	WRITING EPISTLES and copying them in Journals.	READINGS by the TEACHER from Works of Genius.	REVIEW of Studies, and Week's Deportment.
	and Conversations	INTERMISSION FOR REFRESHMENT AND RECREATION.					
III	at Home.	STUDYING LATIN LESSON and writing it in Journals.	STUDYING LATIN with Recitations.	RECREATIONS and DUTIES At Home.	STUDYING LATIN with Recitations.	STUDYING LATIN LESSON and Writing it in Journals.	RECREATIONS and DUTIES At Home.
IV							

Printed by S. N. Dickinson, TEMPLE No. 7, MAY 1836. No. 52, Washington St. Boston.

Pestalozzi

Johan Heinrich Pestalozzi created an alphabet for his schools in eighteenth-century Switzerland: the *ABC der AUNSCHUUANG* (ABCs of sensory intuition). Consisting of a sequence of straight and curved lines of varying lengths, his geometric letters appear more systematic than intuitive. But in exercising each student's ability to look and draw, Pestalozzi's ABCs were designed to reinforce the learners' individual sensory experiences.

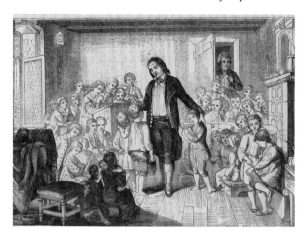

Summerhill

Since its inception in the first quarter of the twentieth century, England's Summerhill School has encouraged its students to study what and how they like. Skeptics have called its method "go as you please" pedagogy. Founder A. S. Neill embraced this nickname, as he believed that giving children the freedom to follow their impulses and desires allowed students to feel more deeply invested in and passionate about learning.

Reggio Emilia

There were no set curricula at the Reggio Emilia school, which originated in post–World War II Italy. All subjects of study grew out of the collective interests of the children, arrived at through group discussions among students and teachers. These daily class assemblies have been called the *assemblea del che fare* (the assembly of what to do).[5] As the school's influence reached far beyond its Italian hometown, Reggio-inspired schools have termed this collective discovery "emergent curricula."

Object Lessons

The spacious main room of Amos Bronson Alcott's Temple School was bathed in the colorful light of a massive stained-glass window. The decor was warm and domestic. Filled with furniture "as only an upholster can appreciate,"[6] it stood in radical contrast to the rigid benches in classrooms of the day. Alcott designed the space and its furniture to "address and cultivate the imagination and heart,"[7] believing this would inspire students to follow their true nature.

The room was arranged to ensure both self-contained contemplation and engagement with others. If students worked alone, they sat at desks along the walls with easy access to books and chalkboards. When students participated in group activities, chairs were arranged in a circle at the center of the room. These were placed close enough for intimate conversation, but with just enough distance so students need not disturb one another.

At regular intervals throughout the space, Alcott installed sculptures chosen to convey an array of symbolic meanings. These included busts of philosophers such as Socrates and authors like Shakespeare and Milton. There were also models of character: a child "aspiring," a child reading, a child drawing. Each was located so as to associatively connect to whatever—or whoever—was nearby. Harpocrates, the god of silence, stood on a table before the stained-glass window. Plato was poised on the large bookcase. Bacchus was placed underneath the water pitcher.

In class lessons, Alcott used objects and imagery to give ideas a physical form. He believed in teaching with emblems and allegory so that students could have a direct experience with the subject. His drawing lessons were sometimes called "the art of learning to see,"[8] emphasizing that it was the experience of the student that mattered most of all.

VIEW OF THE INTERIOR OF MR. ALCOTT'S SCHOOL-ROOM.

Waldorf

Rudolf Steiner's belief that "forms stimulate thoughts"[9] was evident in the physical environment as well as the teaching methods of the Waldorf schools he developed in Germany shortly after World War I. The shapes of its classrooms changed according to the cognitive and emotional development of the growing child. When Waldorf students were first learning to write letters, each unique shape was introduced as a multisensory experience, anthropomorphized visually and narratively: the *B* is a dancing bear; *M* follows the shape of an upper lip vibrating "mmmmm."[10]

Pestalozzi

Johan Heinrich Pestalozzi's motto was "Things before Words, Concrete before Abstract." Ideas were first introduced to students through material understanding. These hands-on lessons were not confined to the classroom but extended out into the farm and woods, incorporating the worlds that students occupied outside the school.

Kindergarten

Friedrich Froebel designed a developmentally specific set of teaching materials and activities called "Gifts and Occupations." As the children grew older, the materials designed for them grew more complex. Teachers would use this finite set of blocks, sticks, paper, and clay to give lessons in a vast range of subjects, which Froebel classified as Forms of Beauty (abstract pattern and design), Forms of Knowledge (mathematics and science), and Forms of Life (direct experience).

Summerhill

The lush grounds of Summerhill included buildings and traditional classrooms among trees and green fields. Learning took place wherever students determined for themselves that they needed to be.

Reggio Emilia

Reggio Emilia incorporated an *atelier* or *atelierista* into the structure of its architecture and curricula. These elements brought creative experimentation into all activities at the schools. Reggio students were encouraged to explore their ideas through a range of hands-on material expressions.

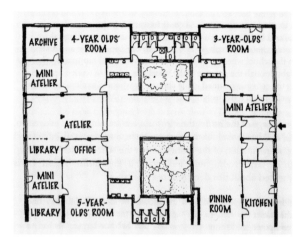

Montessori

A Montessori classroom was filled with child-sized furniture and divided by shelves holding baskets and boxes filled with toys for hands-on learning. Each set was designed for a specific subject of study, characterized by Maria Montessori as motor education, sensory education, and language.[11] Children carried the various teaching tools to child-sized tables or floor mats where they could play either alone or with fellow students.

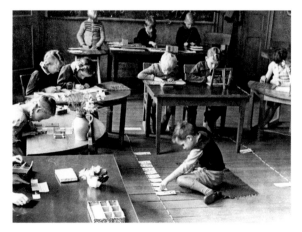

Amos Bronson Alcott was eager to broadcast the successes of his pedagogy to the world and planned a series of books that would describe daily life at Temple School.[12] The two that were ultimately published include Elizabeth Palmer Peabody's *Record of a School* (1835) and Alcott's *Conversations with Children on the Gospels* (1836). Both books are filled with excerpts of class conversations as transcribed by Peabody.

Peabody's role as a documentarian also created an opportunity to encourage students to self-reflect. At the end of the school day, Peabody would share her records with each student. Students were thus given a unique space in which to consider the value of their participation in the classroom conversations.

Students also recorded their own thoughts daily in their journals. These books were included in the curriculum so that students could cultivate their inner dialogue. The journals served as lesson books as well as personal diaries. In them, students recorded their classwork in drawings, maps, and vocabulary exercises, alongside narratives about their daily activities at home or when playing outside with one another.

Language at Temple School was a form to be analyzed and explored. Whenever Alcott read aloud to students, he would stop periodically to ask for their interpretations. In an activity that one Alcott scholar has identified as "syonymizing,"[13] a given sentence of the text would be parsed exhaustively to explore the myriad of other ways the same idea could be articulated. Alcott wanted students to feel a command of the language as though these stories were their own.

WE	LIVE	TO LEARN	TO BE GOOD	AND HAPPY
People	are born	know how	amiable	joyful
The pupils	come into	get knowledge	obedient	gleeful
School-fellows	the world	find out	not naughty	agreeable
Men & women	begin to	think	do right	
Lads—folks	awaken	see	not like	
All people	exist		Cain	
Everybody			like Abel	
All things			affectionate	
Animals				
Birds				

An exercise from the *ABC der Aunschauung* reads as follows: "The teacher draws his line and says to the children: I draw a horizontal line. The children do the same and say all together: I draw a horizontal line. The teacher: Have you done it? The children answer: Yes! Teacher: What have you done? Children: I have drawn a horizontal line."[14] Occasionally the teacher would deliberately make a mistake, inciting children to gleefully protest. In Johan Heinrich Pestalozzi's classroom, drawing was a discursive act.

Montessori

In the Montessori classroom, language was taught through texture, color, and abstract forms. Students traced the individual letters with their fingers, following the twists and turns of each unique shape. When assembling words into sentences, students created correlating sequences of Maria Montessori's grammar symbols. The stature of a large black triangle is a noun. The potential energy of a large red circle is a verb.

article verb interjection

noun adverb pronoun

adjective preposition conjunction

Waldorf

Language in the Waldorf school was drawn as well as danced. Waldorf students recorded their studies in a main lesson book that they filled with colorful drawings. They also learned physical gestures for spoken sounds called "Eurythmy." This technique of sound and movement translated language into choreography. As a silent act, Eurythmy was also a practice of listening. Moving in unison, students formed a collectively communicative body.

Reggio Emilia

Reggio Emilia's teachers kept copious documentation of each student's daily explorations and discoveries. The comments that the students made aloud as they played were recorded alongside sketches and photographs taken by the teachers. Excerpts of these notes were then typed up and printed out to decorate the walls of each classroom. This poetic interplay between images and text framed the activities of a Reggio classroom as an ongoing process. Inquiries were open ended. Language was unfixed.

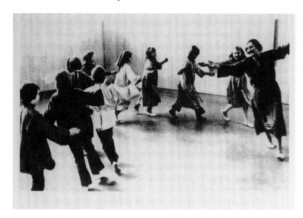

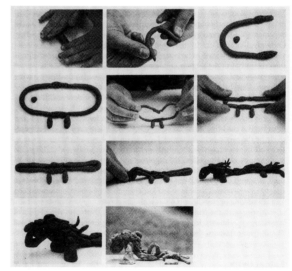

Summerhill

No words were off limits at Summerhill. The taboo of cursing could be defused by not being forced into the shadows. A. S. Neill considered Summerhill's policy on swearing as another opportunity for children to be open about who they are. "The difference between Summerhill and a prep. school is that in the one the children swear openly, in the other secretively."[15] Students were welcome to speak freely within the grounds of the school but were advised to take care not to offend others when out among the general public.

Self-Directed

Amos Bronson Alcott's personal politics laid the foundation for an inclusive community at Temple School. He developed and ran Temple with collaboration from multiple women, each highly accomplished in her own right, including Elizabeth Palmer Peabody, Margaret Fuller, and Sophia Peabody Hawthorne. In his classroom, he taught boys and girls equally, side by side.

Like his transcendentalist counterparts, Alcott was an abolitionist. When he enrolled Susan Robinson as his first African American student in 1839, many of the white parents protested and withdrew their children from the school. Alcott was steadfast in his belief that Robinson held the same rights to education that her white counterparts did. Robinson remained a student at Temple until the school's last day.

When it came to teaching good behavior, Alcott wanted students to learn self-discipline. This was a radical restructuring, as teachers of his day used whipping and other physical violence to stigmatize troublemakers. In some instances, Alcott would stop the whole class when one student acted out. On other occasions, he asked the misbehaving students to inflict the injury on Alcott himself. These methods were intended to make students aware of how their own bad behavior was damaging to others.

In *Conversations*, Alcott transcribes a discussion on suffering. He asks the children, "Do you see any good in suffering or in punishment now? Who makes you suffer?" A student named Charles responds, "Ourselves."[16] Understanding oneself through one's relationship with others is at the heart of Alcott's Common Conscience. If students took responsibility for their own behavior, they would, in turn, take responsibility for the behavior of others.

Summerhill

Freedom and self-government were the political core of Summerhill. Each Sunday everyone participated in the weekly meeting to address all issues affecting the community. Everyone had one vote. Children outnumbered the adults. A. S. Neill wrote, "The sense of justice that children have never ceases to make me marvel. And their administrative ability is great. As education self-government is of infinite value."[17]

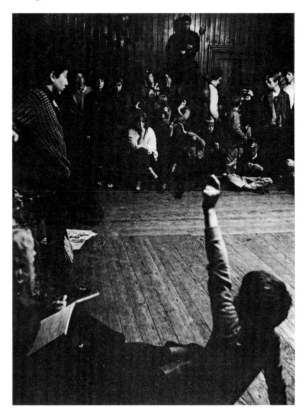

Montessori

Maria Montessori created her first school specifically to teach children who had been identified as unteachable because of alleged disabilities. Her curriculum disproved these damaging assessments. Her self-explanatory teaching toys and child-sized practical tools encouraged children to be at ease with their own pace, to learn skills, and to take responsibility for caring for themselves and one another.

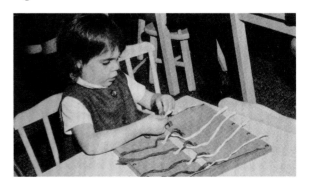

Laboratory Schools

John Dewey saw his Laboratory Schools as miniature societies. He believed that students "must be educated for leadership as well as obedience." Dewey sought to instill in students "the power of self-direction and power of directing others, powers of administration, ability to assume positions of responsibility."[18]

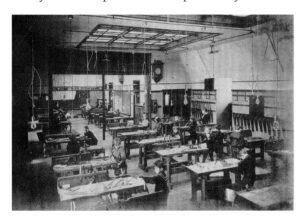

Pestalozzi

Johan Heinrich Pestalozzi began teaching while running a colony for impoverished adults and children on his family farm. Valuing education as a means of creating opportunity for neglected citizens, Pestalozzi eventually opened a school for poor, orphaned, and refugee children.

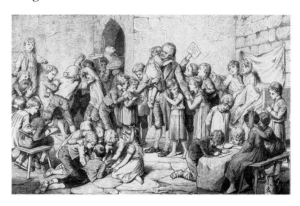

Citizenship Schools

Septima Poinsette Clark was an elementary school teacher in the Jim Crow South until a series of racist laws barred African American teachers from their jobs. In Clark's subsequent political activism, she adapted her reading and writing curriculum to create Citizenship Schools for adults that became essential in the civil rights movement. Clark's curriculum provided African Americans with the tactical skills to successfully navigate the chicanery of the Southern "literacy laws" designed to undermine their eligibility to vote.

Mrs. Septima Clark, Director of Education, Highlander

Ethical Culture

The Ethical Culture School, originally called the Workingman's School, created opportunities for children of all races and religions who could not afford tuition. In late nineteenth-century New York City, these students would otherwise have had to work long hours in factories. The school's founder, Felix Adler, lobbied throughout his life to end child labor. With the democratic aim of integrating social classes, the school eventually also included children whose families paid tuition.

WORKINGMEN'S SCHOOL, SOCIETY FOR ETHICAL CULTURE, 109 WEST 54TH STREET.

Whole Child

When schools today advocate for educating the "whole child," the focus is on tangible aspects of students' well-being to help prepare them for their future. Amos Bronson Alcott believed that wholeness was an intrinsic quality that children were born with. He equated it with a spiritual purity. Alcott discussed the subject with his students.

> Mr. Alcott: Of all the people . . . who best deserve crowns of rays?
> Josiah: Little babies . . . with pretty little body, and hands, and feet.
> Mr. Alcott: And is what comes to the eye emblematic of the Spirit within?
> Ellen: If babies are so good, what does the Bible mean where it says we "go astray from the womb speaking lies"?
> Mr. Alcott: What do you think it means?
> Ellen: That nature is bad.
> Mr. Alcott: Some people think it is so, and others think that it is the example of those grown up, which makes children speak lies early in life.[19]

As a transcendentalist, Alcott believed all individuals had an unmediated and personal relationship with their god. Children had the greatest access to this inner dialogue but were vulnerable to the corrupting forces at play in the world of adults. But because of his belief in their inherent goodness, Alcott was more interested in "preserving" than "teaching" his students. The goal was also to help students learn to defend their true nature against the culture that sought to corrupt and minimize it.

The social and physical environments of Temple School were designed to encourage self-preservation. Teaching to the whole child was a collective act in which the students were asked to lead the way. Analyzing literature, folklore, and the Bible in open-ended group discussions provided a means for students to interrogate their own moral character and hone an ethical understanding of responsible citizenship.

Alcott hailed childhood as an ideal state. His pedagogy advocated dialogue among adults and children as equals. The aspirational path of this utopic vision was one to which all citizens might aspire, regardless of age.

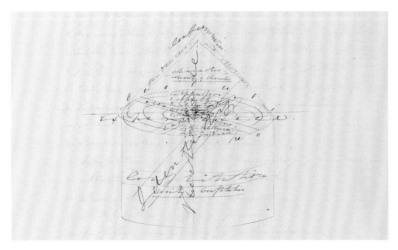

Kindergarten

Friedrich Froebel believed that the child was modeled on the unity of Nature. His early work as a crystallographer mapped a blueprint for this and formed the aesthetic basis of all the teaching tools used in the Kindergarten classroom.

Waldorf

Rudolf Steiner wrote: "Waldorf School Education is not a pedagogical system but an Art—the Art of awakening what is actually there within the human being. Fundamentally, the Waldorf School does not want to educate, but to awaken."[20]

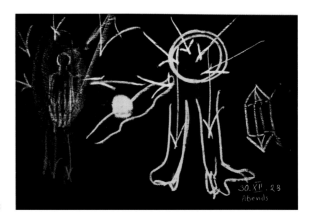

Reggio Emilia

Reggio Emilia pedagogy asserts that children innately navigate the world through "a hundred languages." This abundance of skills for interrogating, interpreting, and articulating their experiences is inherent in their nature as children. Traditional education undermines this faculty, while the Reggio approach celebrates it. A poem by Reggio founder Loris Malaguzzi reads:

> The Child has
> a hundred languages
> a hundred hands
> a hundred thoughts
> a hundred ways of thinking
> of playing
> of speaking . . .
> The child has a hundred languages (and a hundred
> hundred hundred more) but they steal
> ninety-nine
> The school and the culture separate the head from
> the body . . . They tell the child
> to discover the world already there and of the hundred
> they steal ninety-nine.[21]

Ethical Culture

Though originally trained as a rabbi, Felix Adler developed a curriculum for the Ethical Culture School that included literature from all world religions. Adler believed that in the diversity of these teachings, students learned to develop an ethical conscience. Teachers would read the stories aloud to students so the morals were imparted, not as abstract concepts, but as lessons passed from one person to another.

Montessori

Maria Montessori had trained as a physician and wrote about her pedagogy as a form of scientific education. Nonetheless, the reach of her approach was expansive. The range of physical engagement through the activities that take place in a Montessori classroom can bring students in touch with much more than the mere objects surrounding them. Montessori wrote of her pedagogy that "children are able with our methods to arrive at a splendid physical development, and, in addition to this, there unfolds within them, in all its perfection, the soul, which distinguishes the human being."[22]

1

Maria Montessori, *Dr. Montessori's Own Handbook* (New York: Schocken Books, 1969 [1914]), 131.

2

Friedrich Froebel, *Pedagogics of the Kindergarten* (New York: D. Appleton, 1899), 5.

3

Irene M. Lilley, ed., *Friedrich Fröebel: A Selection from His Writings* (Cambridge: Cambridge University Press, 1967), 93.

4

Norman Brosterman, *Inventing Kindergarten* (New York: Abrams Books, 1997), 27.

5

Catalogue of the Exhibit: Hundred Languages of Children (Reggio Emilia, Italy: Reggio Children, 2013), 131.

6

Elizabeth Palmer Peabody et al., *Record of a School: Exemplifying the General Principles of Spiritual Culture* (Boston: James Munroe and Company, 1835), 1.

7

Peabody, *Record of a School*, 1.

8

Peabody, 4.

9

Rudolf Steiner, *Architecture as a Synthesis of the Arts*, trans. J. Couis, D. Osmond, R. Raab, and J. Schmid-Bailey (London: Rudolf Steiner Press, 1999), 45.

10

Rudolf Steiner, "Practical Advice to Teachers," lecture 5, https://www.rsarchive .org/Download/Practical _Advice_to_Teachers -Rudolf_Steiner-294.pdf.

11

Montessori, *Dr. Montessori's Own Handbook*, 49–50.

12

See Amos Bronson Alcott journals, 1832–38, The Trustees Archives and Research Center, Series I: (Amos) Bronson Alcott Papers, 1814–1907, n.d., 1, box A.2 and box A.3.

13

Dorothy McCusky, *Bronson Alcott, Teacher* (New York: Macmillan Company, 1940), 53.

14

Johann Heinrich Pestalozzi, *ABC der Aunschuuan: Oder Anschauugs-Lehre der Mass-verhältnisse* (Zurich: Gessnerschen Buchhand, 1803), 60–61. Translation in Clive Ashwin, *Drawing and Education in German-Speaking Europe 1800–1900* (Ann Arbor, MI: UMI Research Press, 1981), 15.

15

A. S. Neill, *Summerhill: A Radical Approach to Child Rearing* (London: Hart, 1960), 235.

16

Amos Bronson Alcott, *Conversations with Children on the Gospels* (Boston: James Munroe, 1837), 109.

17

A. S. Neil, *Summerhill School: A New View of Childhood*, rev. ed. (New York: St. Martin's Press, 1995), 23.

18

John Dewey, "Ethical Principles Underlying Education," in *Third Yearbook of the National Herbart Society* (Chicago: University of Chicago Press, 1903), 11.

19

Alcott, *Conversations with Children*, 100.

20

Rudolf Steiner, *The Younger Generation: Educational and Spiritual Impulses for Life in the Twentieth Century* (New York: Anthroposophic Press, 1967), thirteen lectures given October 3–15, 1922.

21

Loris Malaguzzi, "No Way. The Hundred Is There," trans. Lella Gandini (1990), in *Classroom Conversations: A Collection of Classics for Parents and Teachers*, ed. Alexandra Miletta and Maureen McCann Miletta (New York: New Press, 2008).

22

Maria Montessori, *The Montessori Method: Scientific Pedagogy as Applied to Child Education in "The Children's Houses" with Additions and Revisions by the Author*, trans. Anne E. George (New York: Frederick A. Stokes, 1912), 239.

Plates

Plates

Gayleen Aiken

BORN 1934, BARRE, VERMONT

DIED 2005, BARRE, VERMONT

Growing up in rural Vermont as a mostly home-schooled only child, Gayleen Aiken longed for the companionship of siblings. At a young age, she dreamed up a bustling extended family she called the "Raimbilli cousins." Creating twenty-four life-size puppets out of cardboard, she gave each cousin his or her own name and distinct traits and recorded their imaginary escapades in countless paintings and comics. These scenes show Aiken and the Raimbillis putting on impromptu musical concerts, playing pranks, dancing in the moonlight, and cavorting through the Vermont countryside. Aiken's preferred materials of pen and crayon lend her work a storybook quality, yet her keen sensitivity to light and shadow, perspective, and color produces sophisticated and lively landscapes and interiors.

Though the world of the Raimbilli cousins is an imagined and fanciful one, their story is tied to the real landscape of Aiken's native Vermont. Their adventures take place among the rolling hills, snow-covered fields, and nearby granite plants and mills of Barre, the artist's hometown. The predominant setting is Aiken's beloved childhood home, a rambling Victorian-era farmhouse where she lived with her parents until the 1950s. In the lower-right corner of each of her comics, Aiken inscribed a variation on the following "homesick poem or prose" that mourns the loss of this home: "I miss and liked our old fancy chandeliers, old woodwork, pretty old wallpaper, porches, attics, old country hills and old familier [sic] views." Written over and over, the declaration becomes a kind of chant, the same bottled message cast repeatedly into the void.

This mantra-like quality is also present in the moments Aiken chose to illustrate. Signs of time's passing are certainly evident—in seasonal shifts, the setting sun, and the electric neon clock that lights their porch—but her narrative comics do not move the viewer forward through a linear plot. Instead, they return us to the same scenes, as in a recurring dream. Her imaginary cousins never age but remain rambunctious schoolchildren, and they continue to dwell in the adored "old big heirloom country house" of Aiken's memory. Her artistic practice ultimately offered her a way to transcend time, and rather than projecting a visionary future, Aiken chose to inhabit a reenvisioned past.

SCOUT HUTCHINSON

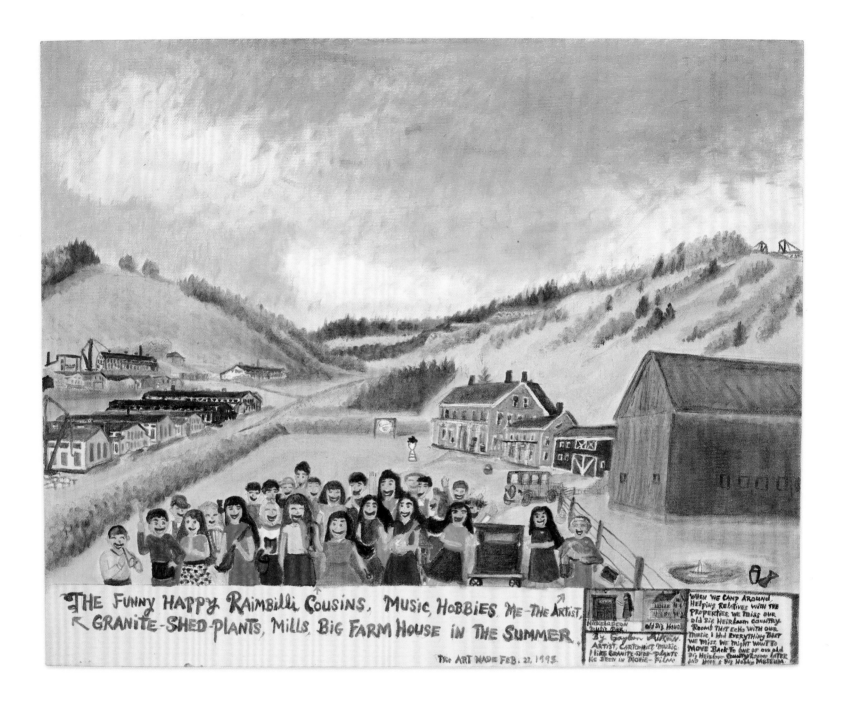

GAYLEEN AIKEN
(1934–2005)

*The Funny Happy Raimbilli Cousins, Music, Hobbies, Me—
the Artist, Granite-Shed-Plants, Mills, Big Farm House
in the Summer*

1995 mixed media on canvas board 16 × 20 in. Collection of Grass
Roots Art and Community Effort, Rutland, Vermont

A DUST-COLLECTER
AND SUCTION-PUMP-HOSE.
THIS GRAND MACHINERY IS A LUNG-SAVER BECAUSE IT TAKES STONE DUST OUT OF AIR.

A NICKELODEON MUSIC MACHINE

A GRANITE PLANT. AN OLD HOUSE.

By Gayleen Aiken.
ARTIST, MUSICIAN CAMPER
MUSIC — COMPOSER. I like
old player piano. Xylophone —
NICKELODEONS.
Big Tall COUNTRY HOUSES.
I COLLECT PICTURES OF GRANITE
PLANS AND SAWS. AND NICKELODEONS.

MY HOME SICK PROSE POEM STORY.
WHEN WE CAMP AROUND HELPING RELATIVES
WITH CAMPS, FARMS, APT. PROPERTIES
WE MISS OUR VERY old WALLPAPER
old FANCY CHANDELIERS. ATTICS old PORCHES
Long HALLS old COUNTRY HILLS, Woods
old FAMILIAR SCENES. MUSIC ECHO BETTER
WE MIGHT MOVE BACK TO ONE OF OUR old
LARGE TALL COUNTRY HEIRLOOM HOUSES LATER.
WE ONCE THOUGHT THAT WE WANTED A BIG HOBBY
MUSEUM IN OUR old ART STUDIO. BUT WE BIGGER. CAMP.

GAYLEEN AIKEN (1934–2005) *A Dust-Collecter and Suction-Pump-Hose.* 1989 mixed media on paper 14 × 17 in. Collection of Grass Roots
Art and Community Effort, Rutland, Vermont

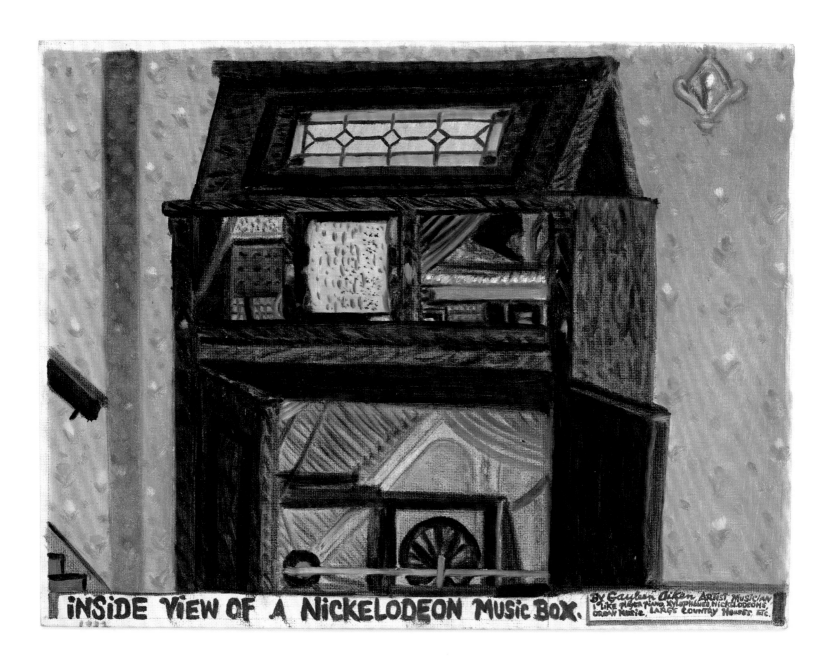

INSIDE VIEW OF A NICKELODEON MUSIC BOX.

BY Gayleen Aiken ARTIST MUSICIAN
I LIKE PLAYER PIANO XYLOPHONES NICKELODEONS
ORGAN MUSIC, LARGE COUNTRY HOUSES, ETC.

GAYLEEN AIKEN (1934–2005) *Inside View of a Nickelodeon Music Box.* 1982 mixed media on canvas board 12 × 16 in. Collection of Grass Roots Art and Community Effort, Rutland, Vermont

GAYLEEN AIKEN
(1934–2005)

*A Nickelodeon & House,
Comic in the Yard*

2000 mixed media on paper
14 × 17 in. Collection of Grass
Roots Art and Community
Effort, Rutland, Vermont

BORN 1980,
BANGOR, MAINE

LIVES AND WORKS IN
BREWER, MAINE

Caleb Charland

As a child growing up in rural Maine, Caleb Charland honed a self-sufficient curiosity about the natural world. That sense of wonder now pervades his photographs that picture and elevate everyday natural phenomena and principles of physics, from the swing of a pendulum to the refraction of light on water. Studying photography at Massachusetts College of Art and Design as an undergraduate, and then in graduate school at the University of Chicago, Charland immersed himself in the history and techniques of the medium, finding affinities with foundational figures, such as Edward Marey and Harold Edgerton, who innovated photographic processes to capture motions and patterns not available to the naked eye.

Since returning to Maine, Charland's meditative inquiries into nature and the photographic medium have both supported his pathways of aesthetic and perceptual study. For his nighttime *Solar Plexus* series of 2015, he captured traces of star trails through his large-format bellowed camera: "As the earth rotates at night the stars appear to move through the sky, but instead of putting a camera on a tripod, I was actually lying on the ground, placing the view camera on my solar plexus, leaving the shutter open and then trying to stay still for two to three hours, so [that] the camera would rise and fall with my breath. I was really amazed that it actually worked, you can see each rise and fall of the chest and actually see the gradual arc of the star trail through the night sky."[1] Recording the rhythmic unity of the stars and his breath, these images are a testament to Charland's deep bodily connection to the cosmos and recall Ralph Waldo Emerson's "Transparent Eyeball," with its unfiltered absorption of nature.

Charland has recently pursued color separation techniques outdoors and in his studio. He takes long-exposure photographs of the sun setting or rising over bodies of water in Maine using three color-filtered, black-and-white negatives. The negatives are scanned and combined to create a composite digital image, which reveals a radiant spectrum that seems to fall into the ocean. Charland creates this rainbow effect through a sequence of exposure adjustments while taking the photographs. Through a similar color-separation process, Charland experiments with light shining on prisms such that the richly toned shadows form luminous diagrams that echo the sacred geometries of Robert Fludd (1574–1637), an English physician who merged occult beliefs and scientific studies.

SARAH MONTROSS

CALEB CHARLAND
(b. 1980)

*Camera Placed on My Chest While Lying on the Ground
at Night for More Than Two Hours*

from the series *SOLAR PLEXUS*

2016 pigmented ink print 40 × 32 in.
Collection of the artist

CALEB CHARLAND *Violet Surface Eaten by Bacteria* 2009 pigmented ink print 32 × 40 in.
(b. 1980)
 from the series *BIOGRAPHS* Collection of the artist

CALEB CHARLAND
(b. 1980)

A Color Spectrum with the Setting Sun, Bass Harbor,
Maine (Color Separation with Three Black and White
Paper Negatives)

2019 pigmented ink print 32 × 40 in.
Collection of the artist

CALEB CHARLAND
(b. 1980)

Lenses Spinning across the Surface of Black and White Photographic Paper #3 (Color Separation with Three Black and White Photograms)

2019 pigmented ink print 24 × 20 in.
Collection of the artist

CALEB CHARLAND
(b. 1980)

A Variety of Colors Created with the Shadows
of a Prism #1 (Color Separation with Three
Black and White Paper Negatives)

2019 pigmented ink print 24 × 20 in.
Collection of the artist

BORN 1975, EUGENE, OREGON

LIVES AND WORKS IN BEARSVILLE, NEW YORK

Anna Craycroft

Anna Craycroft is a multimedia artist whose projects address wide-ranging topics including early childhood education, psychology, craft design, and the histories of the moving image. Past works have also involved extensive research into fellow artists, such as Berenice Abbot. Craycroft primarily develops pieces that are site responsive and that may evolve while on display through collective public engagement or in collaboration with other artists. In so doing, her work prioritizes consensus building and witnessing as it fosters multivocal, durational exchange.

Some of Craycroft's past inquiries have focused on radical pedagogy and childhood, as both are laden with cultural projections about human potential. For *C'mon Language* at the Portland Institute of Contemporary Art, Oregon, in 2013, she developed a series of workshops and lectures by artists and educators modeled on concepts from the early education pedagogy of Reggio Emilia. Participants of all ages gathered together on furniture and used materials Craycroft designed for the exhibition. Topics for these sessions ranged from linguistics to basket weaving, each prompted by the common query "How do we make ourselves understood?"

As one of two artists-in-residence for *Visionary New England*, Craycroft conducted research into the teaching philosophies of Amos Bronson Alcott, cofounder of Fruitlands and the experimental Temple School in Boston, Massachusetts. Over the course of several months, she met with teachers and students of the Lincoln Nursery School located on the campus of deCordova Sculpture Park and Museum. The school also practices the Reggio Emilia method, one component of which involves teachers recording their students' activities with photographs, note taking, drawing, video, and sound in order to preserve each child's development and share in a cyclical process of exchange. These activities echo Alcott's classroom approach of listening to young students in democratic dialogue. Out of her visits and research, Craycroft created *Common Conscience* to be installed outdoors at deCordova. Developed in consultation with ecologists, landscape architects, and acousticians, the design of this installation derives from acoustic forms that shape, reflect, and refract sound. Following the precepts of Alcott's teaching methods, which promoted collective dialogue among students, *Common Conscience* brings together, in physical form, a focus on education and art that is central to deCordova's mission and to the surrounding region's history and culture.

SARAH MONTROSS

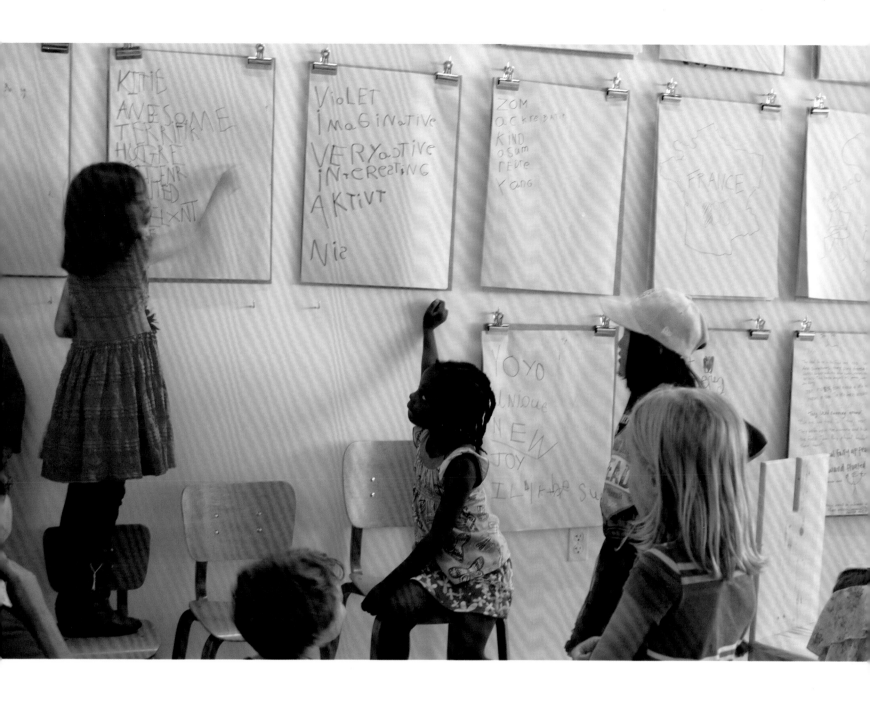

ANNA CRAYCROFT (b. 1975) *C'mon Language*

2013 Portland Institute for Contemporary Art, Portland, Oregon
Contributing guests the Butterflies Art Adventurers, students
from the Helen Gordon Child Development Center,
a Reggio Emilia–inspired preschool

ANNA CRAYCROFT (b. 1975) *C'mon Language*

2013 Portland Institute for Contemporary Art, Portland, Oregon
Contributing guest artist Matt Keegan leading Images Are Words,
a workshop on image-based language

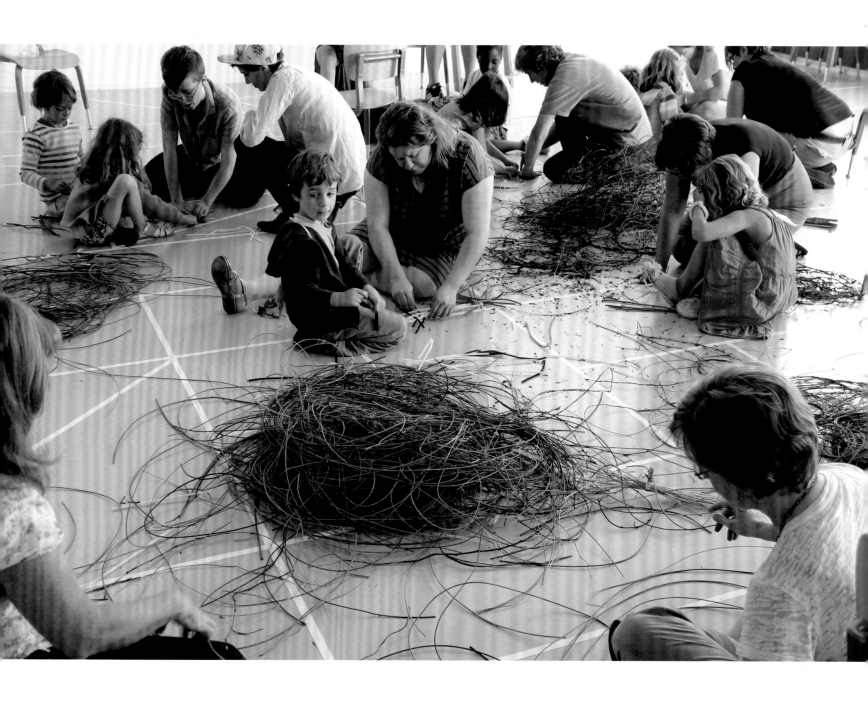

ANNA CRAYCROFT (b. 1975) *C'mon Language*

2013 Portland Institute for Contemporary Art, Portland, Oregon
Curator Kristan Kennedy (center) and other participants making baskets
during Random Weave, a basket-weaving workshop led by contributing
guest scholar Margaret Mathewson

ANNA CRAYCROFT (b. 1975) montage for *Common Conscience* 2019

Angela Dufresne

In Angela Dufresne's paintings, communities of fauns, satyrs, and other mythological creatures come into contact with humans within pastoral and woodsy settings. Presented in theatrical tableaux, the figures are engrossed in intimate or communal acts, from studying and reading to erotic groping. *Demenstration*, a monumental oil painting, depicts a social group communing in a grove below a highway. On the ground, kneeling figures look up in rapt attention at a lecturer who stands with outstretched arms and a miniskirt, staring into the face of a chimerical figure opposite her. Trees and boulders around the edges give way to the spaces under a bridge, including one that contains a glowing, blank film screen. The work suggests a session of furtive education, a sharing of secret knowledge across generations and genders that furthers the transfixing quality of world building in many of Dufresne's works.

Influenced by avant-garde filmmakers, like Chantal Ackerman and Carl Theodor Dreyer, who merge themes of desire, intimacy, and religion, Dufresne also makes video work based on personal experiences such as playing music with friends or exploring her body. She parlays her fascination with film and video into her canvases. Her paintings often suggest a heightened cinematic moment charged by highly individualized characters, although the narrative remains cryptic.

Dufresne is inspired by certain utopian philosophers, such as Charles Fourier, but remains critical of how such social experiments can become rigid and puritanical when put into practice. Her paintings often picture nude bodies that freely explore and enjoy sexual revelry. Queerness and transgender theory motivate Dufresne's way of picturing the world. Raised Catholic and initially rejected by her family when she came out as gay, Dufresne considers queerness a non-normative way of seeing the world. Even her canvases that do not allude to sexuality can be considered queer for the way in which they redefine historically entrenched conventions of figurative painting.

SAM ADAMS

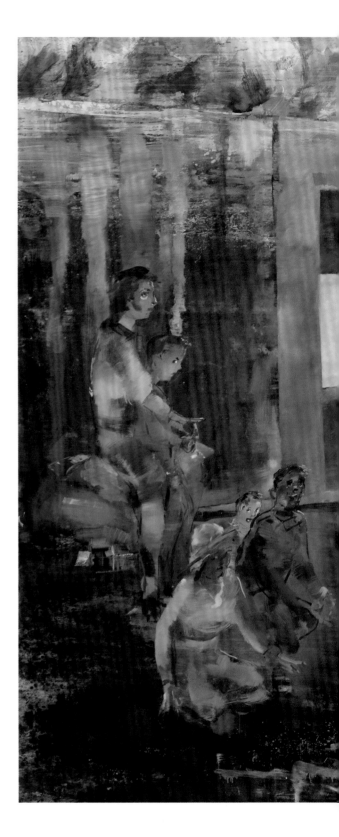

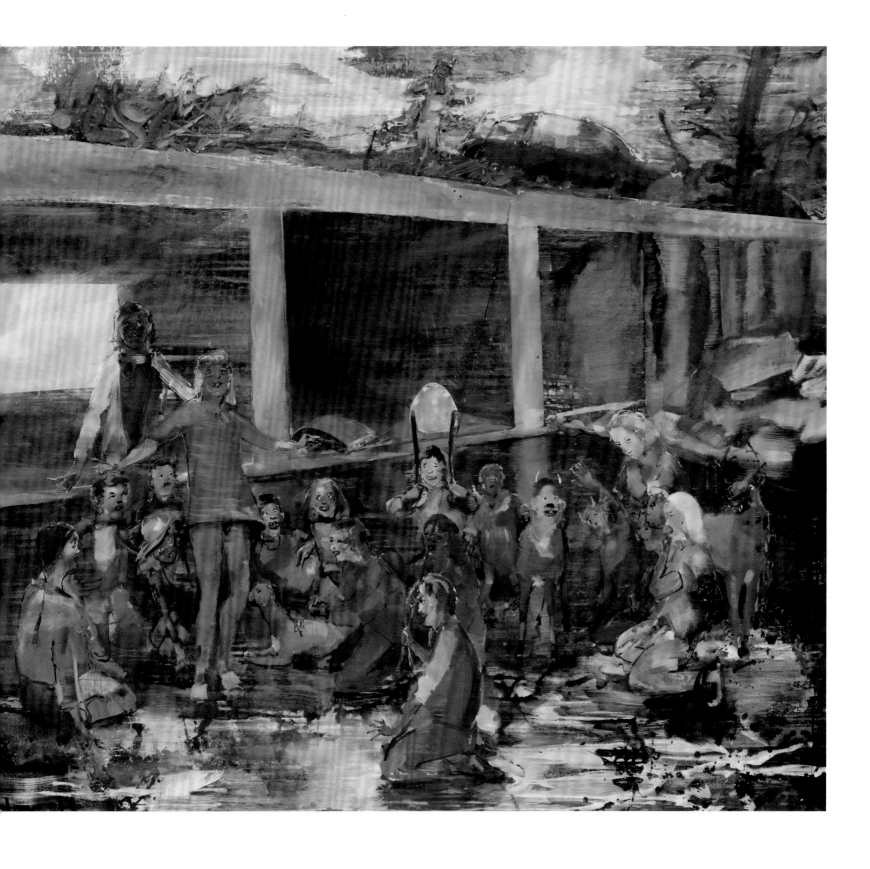

ANGELA DUFRESNE (b. 1969) *De-Menstration* 2015 oil on canvas 7 × 11 feet Collection of the artist

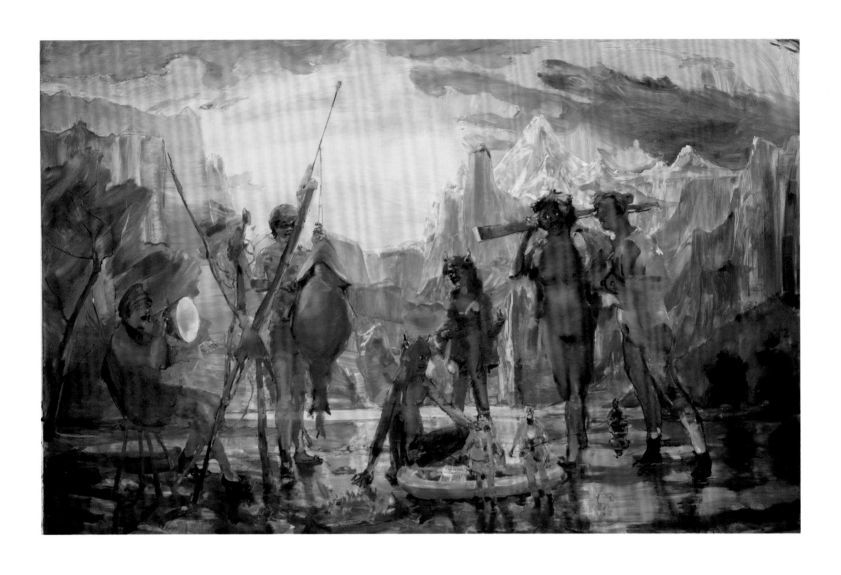

ANGELA DUFRESNE (b. 1969) *Catch Directions and Toys* 2015 oil on canvas 7 × 11 feet Collection of the artist

ANGELA DUFRESNE (b. 1969) Child of Nature 2013 oil on canvas 18 × 24 in. Collection of Olga Bergmann and Anna Hallin

ANGELA DUFRESNE (b. 1969) *To Learn Is to Forget*

2015 oil on canvas 4½ × 9 feet Collection of the artist

Sam Durant

BORN 1961, SEATTLE, WASHINGTON

LIVES AND WORKS IN BERLIN, GERMANY

Sam Durant's sculptures and installations expose the complexities and contradictions underlying the myths of American history and challenge fixed understandings or "monolithic reading[s]" of the past.[2] While his artwork of the 1990s revisits and critiques utopian initiatives of the twentieth century, including Mid-century Modernist architecture and countercultural movements of the 1960s and 1970s, his more recent projects have delved further into formative moments of US history. *Scenes from the Pilgrim Story: Myths, Massacres, and Monuments* (2006) addresses the country's origin story, when Europeans landed in Plymouth, Massachusetts, in the early seventeenth century and settled on the land of the Wampanoag people. Repurposing wax figures and large-scale dioramas from the defunct Plymouth Wax Museum, Durant reassessed the idyllic narrative of Native Americans and pilgrims living peacefully together. He reconfigured the positions and accessories of the mannequins and dioramas to show scenes of violence and brutality that depict the treatment of indigenous people by early settlers.

In 2016, Durant was commissioned by the Trustees of Reservations, a Massachusetts-based land conservation organization, to respond to the historic site known as the Old Manse. Located in Concord a few miles north of Walden Pond, the property and surrounding landscape share a rich history with the transcendental movement, having played host to figures such as Ralph Waldo Emerson, Amos Bronson Alcott, Margaret Fuller, Nathaniel and Sophia Hawthorne, and Henry David Thoreau. Durant's interventions at the Old Manse, titled *The Meeting House*, acknowledged the home's literary past while also calling attention to the lesser-known history of a community of formerly enslaved individuals living in the woods of Walden Pond. The site became a ripe environment in which to interrogate the foundations of the United States as a country built on slave labor and its lingering racist ideologies. Honoring the Old Manse's past as a site for revolutionary thinking, Durant also constructed a temporary pavilion for hosting public events such as readings, conversations, and communal meals.

Based on his research on the historical artifacts and furniture in and around the Old Manse, Durant also created a new body of sculptural work collectively shown in the exhibition *Build Therefore Your Own World* (Blum & Poe, Los Angeles, 2017). Taking its title from a passage in Ralph Waldo Emerson's 1836 essay "Nature," the exhibition included a series of hybrid sculptures that fuse replicas of the personal effects of white transcendentalists and African American writers and historical figures. In *Transcendental (Wheatley's Desk, Emerson's Chair)* (2016), Emerson's green writing chair is embedded in Phillis Wheatley's desk, on which she may have penned *Poems on Various Subjects, Religious and Moral* (1773). In this amalgamation, Durant asks the viewer to see these two writers' narratives as inextricably linked rather than as separate and distinct.

SCOUT HUTCHINSON

SAM DURANT (b. 1961) *Transcendental (Wheatley's Desk, Emerson's Chair)* 2016 painted wood 53¾ × 34¼ × 34½ in. Collection of deCordova Sculpture Park and Museum Courtesy of the artist and Blum & Poe, Los Angeles / New York / Tokyo

"Every spirit builds itself a house,
and beyond its house a world . . .
Build therefore your own world"

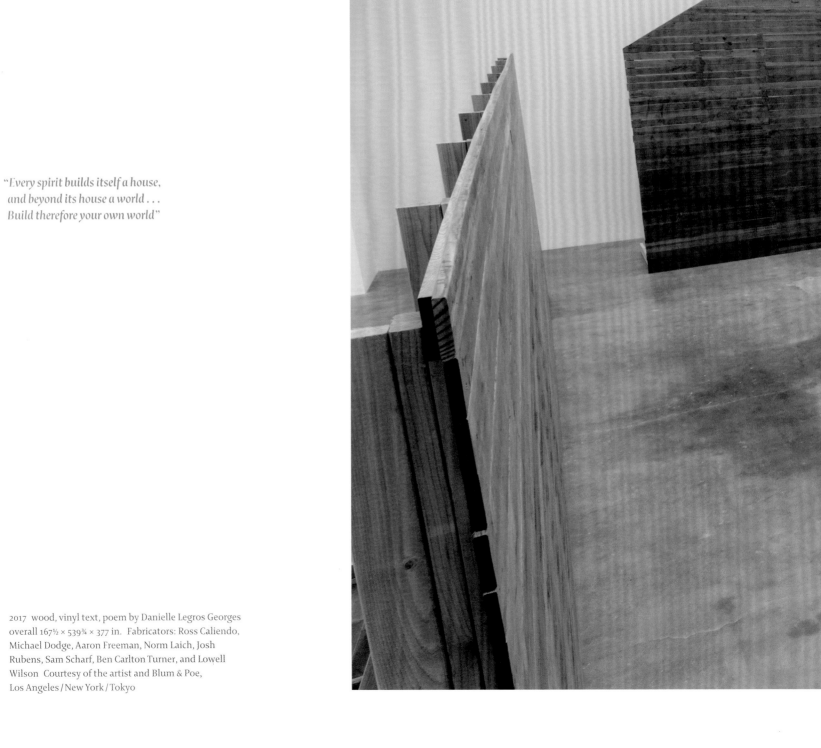

2017 wood, vinyl text, poem by Danielle Legros Georges
overall 167½ × 539¾ × 377 in. Fabricators: Ross Caliendo,
Michael Dodge, Aaron Freeman, Norm Laich, Josh
Rubens, Sam Scharf, Ben Carlton Turner, and Lowell
Wilson Courtesy of the artist and Blum & Poe,
Los Angeles / New York / Tokyo

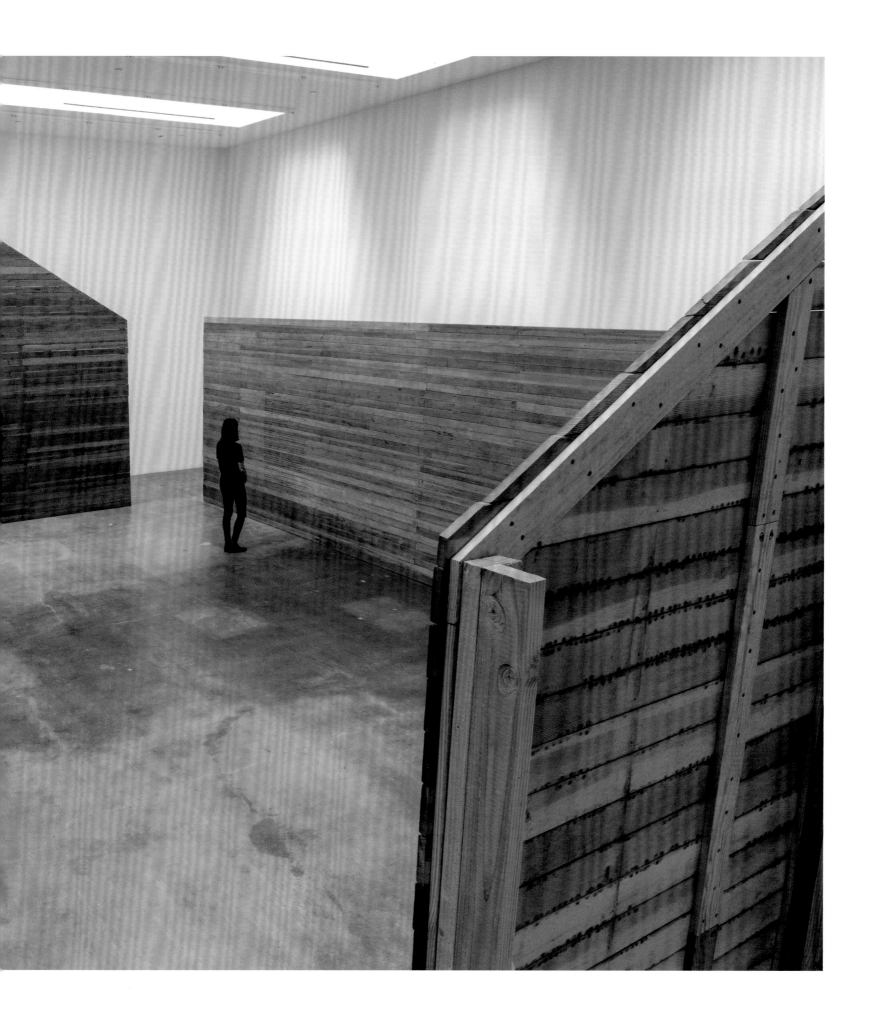

SAM DURANT *Dream Map, Ursa Minor* 2016 prison blanket, pennies, epoxy 61 × 81 in.
(b. 1961) Fabricator: Gloria Galvez Courtesy of the artist
 and Blum & Poe, Los Angeles / New York / Tokyo

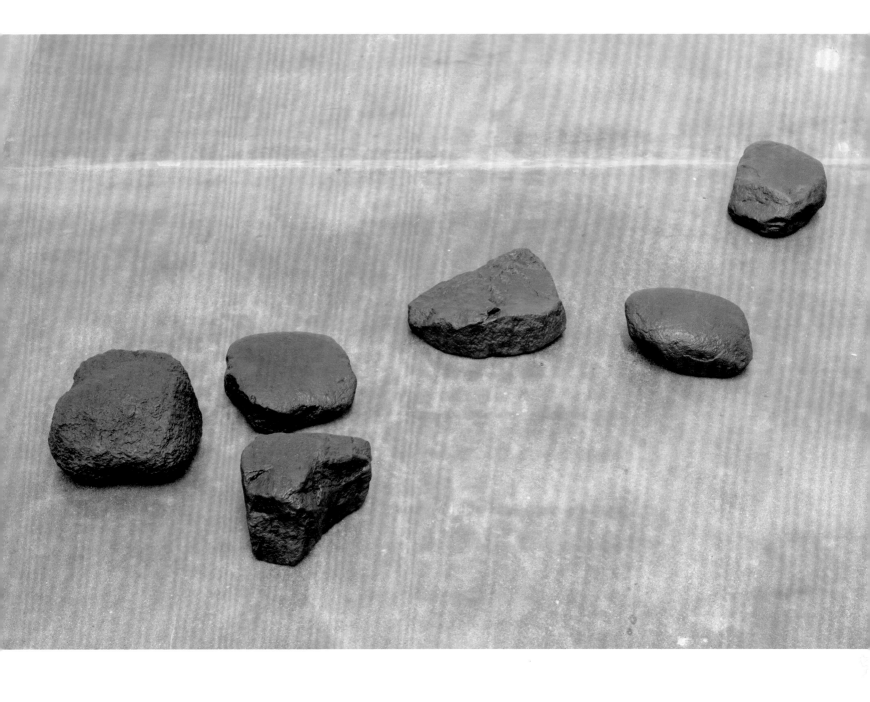

SAM DURANT *Fieldstones (after Robin Coste Lewis's Erasures)* 2016 bronze with patina six parts: 3½ × 10 × 6¾ in.; 3½ × 8 × 5⅞ in.; 4¼ × 9¼ ×
(b. 1961) 6½ in.; 2¾ × 7¾ × 7¼ in.; 3⅛ × 10¾ × 6⅝ in.; 4¼ × 8⅛ × 7¾ in. Courtesy of the
artist and Blum & Poe, Los Angeles / New York / Tokyo

Josephine Halvorson

Since 2007, Josephine Halvorson has painted intimate still lifes that range from antique wooden doors to slabs of concrete. Rather than existing in an illusionistic space, her subject matter presses up against the surface of the picture plane, filling the canvas and creating a trompe l'oeil effect. This sense of immediacy is heightened by the fact that Halvorson paints on a one-to-one scale. The space an object occupies in the world is extremely important to her, as is the concept of measurement and scale in relation to the human form. An act as simple as using one's thumb to determine proximity and proportion while painting demonstrates, for Halvorson, our need to understand "our own bodies in the world."[3]

In recent years, Halvorson turned her attention to the woods near her home in Western Massachusetts, walking until she finds a subject that speaks to her. Simply looking is an essential part of her practice; as she explains, "I have to be really tuned in so that when I do see something I can hear it calling to me, or catch its eye looking back."[4] She becomes receptive to her surroundings, carefully depicting moss-covered logs, peeling bark, and vignettes of the forest floor. Rather than working from a photograph in her studio, Halvorson prefers to paint in situ, completing each canvas outdoors and in a single sitting.

The finished work is not just a visual record but a way to measure time. Halvorson might spend anywhere from four to twenty hours on a painting. This intense, prolonged focus on a single subject recalls a meditative practice—the entire process is one of thoughtful contemplation, rigorous observation, and even endurance. Regarding one work that took fourteen hours to paint, Halvorson recalls, "I didn't see anyone all day. I got to witness the whole arc of the day in the painting. . . . I remember at one point thinking, 'There's no world outside of this painting . . . all I know right now is this.'"[5]

These sentiments are in line with a transcendentalist sense of communion with nature and echo the words of Henry David Thoreau, who wrote, "In my walks I would fain return to my senses. What business have I in the woods, if I am thinking of something out of the woods?"[6] But while Thoreau lamented that private landowners were encroaching on the uncorrupted wilderness, Halvorson willingly confronts these signs of human presence. Her eye is often drawn to notices that announce private property or warn against trespassing, as well as neon ribbons and spray-painted marks that indicate hiking trails or trees for removal. For Halvorson, these signifiers indicate our need to measure and demarcate the landscape based on a human scale.

SCOUT HUTCHINSON

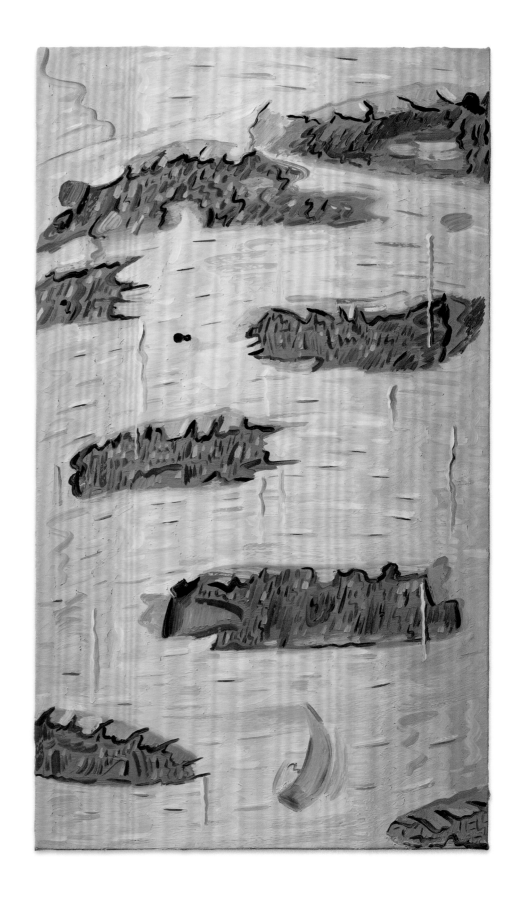

JOSEPHINE HALVORSON (b. 1981) *Birch Skin* 2017 oil on linen 24 × 14 in. Courtesy of Sikkema Jenkins & Co., New York

JOSEPHINE HALVORSON
(b. 1981)

Eye

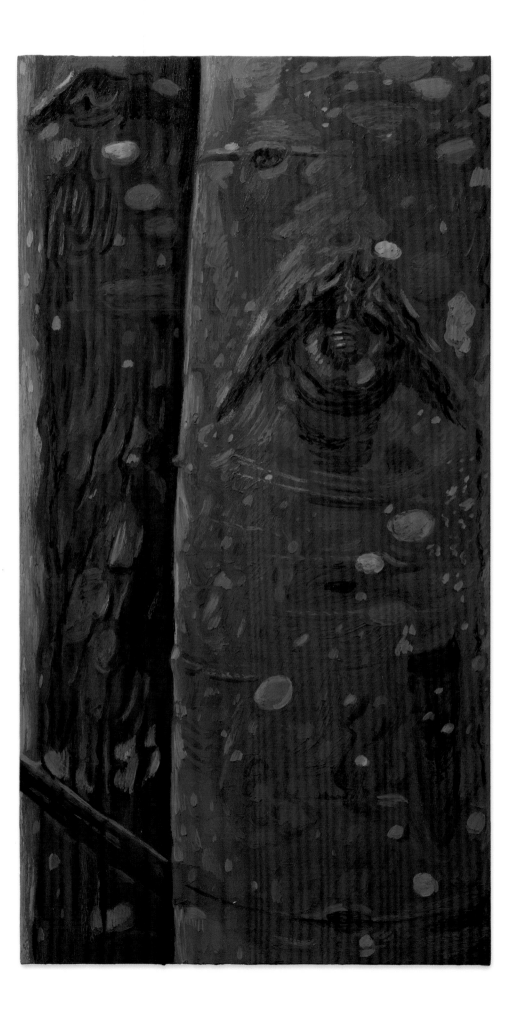

2017 oil on linen 30 × 16 in.
Courtesy of Sikkema Jenkins
& Co., New York

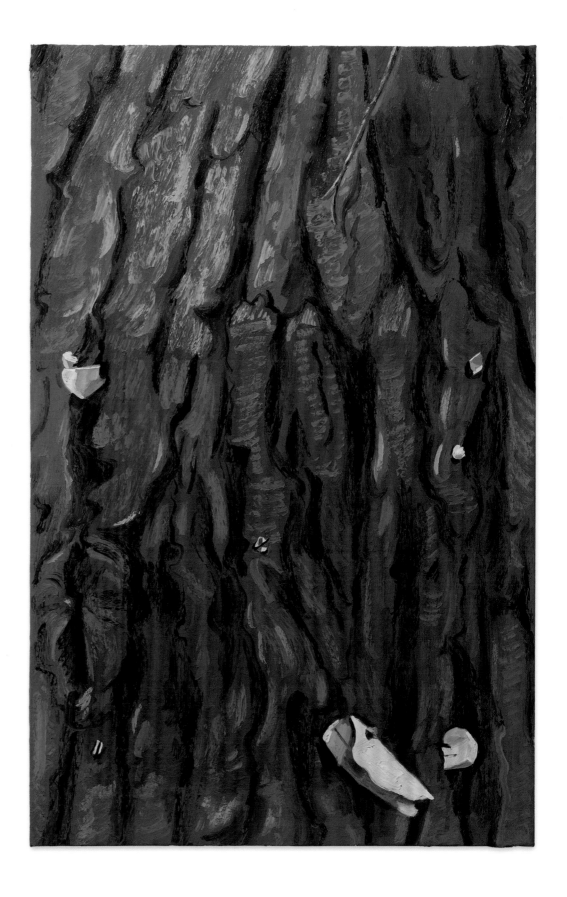

JOSEPHINE HALVORSON (b. 1981) *Ghost* 2017 oil on linen 23 × 15 in. Courtesy of Sikkema Jenkins & Co., New York

JOSEPHINE HALVORSON (b. 1981) *Broadsheet (Ring)* 2017 gouache and silkscreen on paper 22½ × 24½ in. Courtesy of Sikkema Jenkins & Co., New York

JOSEPHINE HALVORSON (b. 1981) *Broadsheet (Leaves)* 2017 gouache and silkscreen on paper 22½ × 24½ in. Courtesy of Sikkema Jenkins & Co., New York

Paul Laffoley

Over the course of a roughly fifty-year career, Paul Laffoley produced hundreds of diagrammatic paintings that synthesize the disciplines of science, mathematics, and technology with the intangible, spiritual realm. Though his work possesses the cool visual language of hard-edge Minimalism and Pop Art, Laffoley's paintings pulsate with a fervent energy. His canvases are composed of concentric patterns, futuristic symbols, and passages of hand-applied vinyl lettering that relate alien encounters and instructions for time traveling. Laffoley understood these works to be functional devices: repositories of knowledge or compass roses that direct the viewer to higher states of consciousness. His influences are eccentric and encyclopedic, ranging from comic books and science fiction novels to philosophy and alchemy. His father's interest in Eastern religions and the occult was also instilled in Laffoley at a young age.

Following his undergraduate education at Brown University and a brief stint studying architecture at the Harvard Graduate School of Design, Laffoley moved to New York City in the early 1960s to work for the artist and architect Frederick John Kiesler. While in New York, he was also briefly employed by Pop artist Andy Warhol to watch late-night television, during which time he became fascinated by the television test pattern—a fusion of technical diagram and radiating mandala that would later come to characterize Laffoley's paintings. He returned to Massachusetts permanently and in 1968 rented a utility closet in a building near Boston Common to use as a studio and library. This space was officially named the Boston Visionary Cell in 1971, with a mission "to develop and advance visionary art." Laffoley maintained his practice there until 2006.[7]

One of Laffoley's central concerns was the search for utopic space, a theme explored in many of his paintings and through proposals such as his 1973 design for the New England Center for Comparative Utopia, which would have been located at the site of a roller coaster in Revere Beach, Massachusetts. Inspired by Buckminster Fuller's 1969 text *Utopia or Oblivion: The Prospects for Humanity*, Laffoley produced several designs for a "healing architecture"—often plant-based structures intended to support increased populations with limited resources.[8] He believed that the realization of utopia entails unity between humanity and nature, but perhaps more importantly, as the work *Utopia: Time Cast as a Voyage* (1974) indicates, he imagined a realm in which "the individual and the collective aspects of consciousness can be resolved."[9]

SCOUT HUTCHINSON

PAUL LAFFOLEY
(1935–2015)

Alchemy: The Telenomic Process of the Universe

1973 oil, acrylic, ink, and lettering on canvas
73½ × 72½ in. Private Collection, Courtesy of
Kent Fine Art, New York (see Appendix)

PAUL LAFFOLEY
(1935–2015)

The Visionary Point

1970 oil and acrylic, ink, and Letraset on canvas
73½ × 73½ in. Courtesy of Kent Fine Art, New York
(see Appendix)

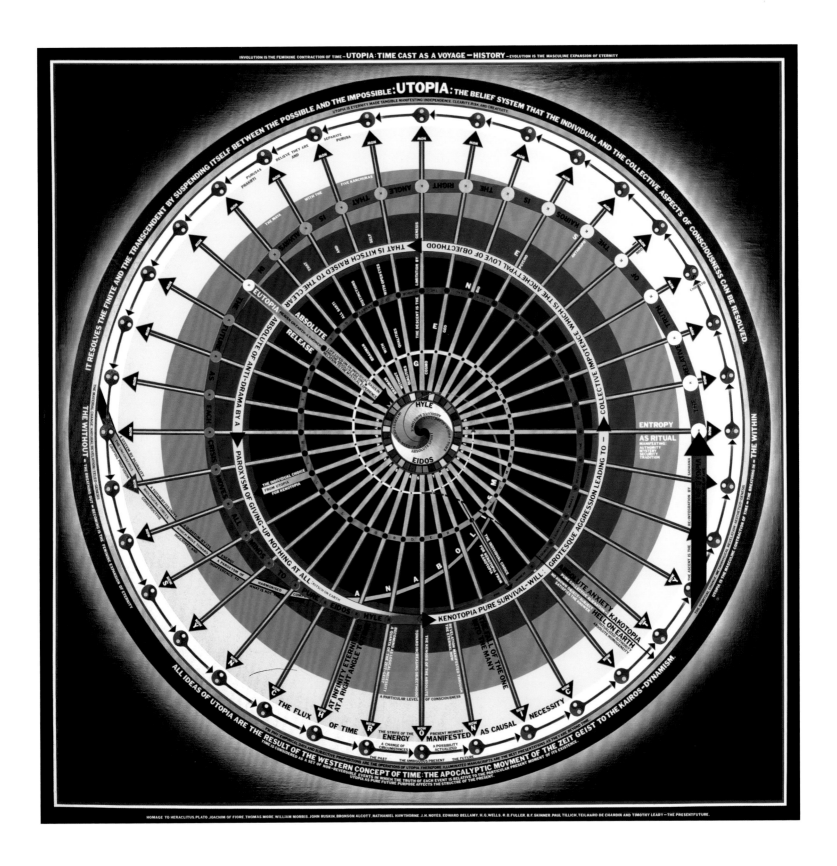

PAUL LAFFOLEY
(1935–2015)

Utopia: Time Cast as a Voyage-History

1974 oil, acrylic, and vinyl lettering on canvas
73½ × 73½ in. Mrs. and Mr. Elyse Benenson
(see Appendix)

The Unity Of Live Architecture

CONTINUITY

SEPARATION

CONTACT

HOMAGE TO KIESLER

PAUL LAFFOLEY
(1935–2015)

Homage to Keisler

1968 oil, acrylic, ink, and hand-applied vinyl letters on canvas
37½ × 37½ in. Courtesy of Kent Fine Art, New York (see Appendix)

PAUL LAFFOLEY
(1935–2015)

Gates of Brahman: The Cosmic Octave

1970 oil, acrylic, and hand-applied
vinyl letters on canvas 98 × 48 in.
Courtesy of Kent Fine Art, New York
(see Appendix)

PAUL LAFFOLEY

(1935–2015)

Xanatopia

1995 acrylic, ink, vinyl lettering, and collage on board 30 × 30 in.
Private Collection, New York (see Appendix)

BORN 1980, CONCORD, MASSACHUSETTS

LIVES AND WORKS IN LOS ANGELES, CALIFORNIA

Candice Lin

Candice Lin creates installations that connect organic cycles of growth and decay to systems of economics and trade that often expose the colonial roots of objects. Linking past and present, Lin merges topics from early modern medicine, botany, and religion to fears of miscegenation and invasive species with contemporary racist or sexist abuses. Some of her past projects have touched on New England's visionary history, including a work on paper that pictured the New England Puritan minister Cotton Mather defecating. Mather promoted inoculation against rampant diseases, like smallpox, and was a key figure in the Salem witch trials. Other works from this series aligned recent women's protests with the amplification of voices of female Spiritualist mediums during the nineteenth century.

For *Visionary New England*, Lin continues a project titled *La Charada China* that involves her study of global trade routes during the nineteenth century across China, the Caribbean, Europe, and New England. For her installation at deCordova, she focuses on the impact in New England of the opium trade, the rise of forced and contract labor supplied by Chinese immigrants following the abolition of slavery, and the import of luxury goods to the region, from sugar to porcelain. This outdoor installation features an earthen bed of red clay and guano with plantings of sugarcane and opium poppy seeds that grow over the course of the exhibition, as these "invasive" species commingle with deCordova's cultivated terrain. Lin draws connections between the trade in opium (an addictive substance that generates altered states of consciousness) led by wealthy Boston barons and their simultaneous support of transcendentalism, a philosophy that offered its own degree of visionary viewpoints and escapism. In particular, several women connected to transcendentalism, such as Sophia Peabody Hawthorne, wife of Nathaniel Hawthorne, and Edith Emerson Frobes, daughter of Ralph Waldo Emerson, were tied to New England's merchant culture of trade with China through marriage and family. They and other women were also regularly treated with opium pills or laudanum (a tincture made with opium) for headaches and other ailments.

SARAH MONTROSS

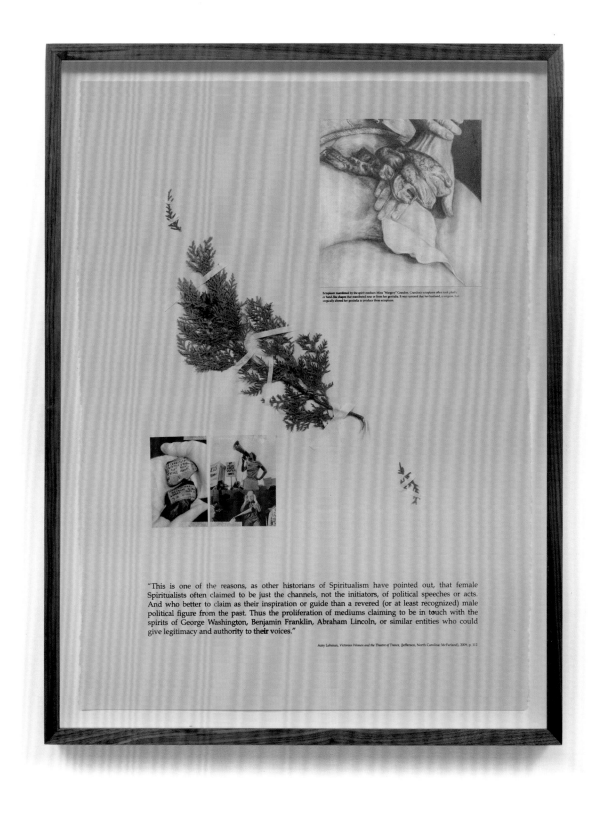

"This is one of the reasons, as other historians of Spiritualism have pointed out, that female Spiritualists often claimed to be just the channels, not the initiators, of political speeches or acts. And who better to claim as their inspiration or guide than a revered (or at least recognized) male political figure from the past. Thus the proliferation of mediums claiming to be in touch with the spirits of George Washington, Benjamin Franklin, Abraham Lincoln, or similar entities who could give legitimacy and authority to their voices."

Amy Lehman, *Victorian Women and the Theatre of Trance*, (Jefferson, North Carolina: McFarland), 2009, p. 112

CANDICE LIN *The Hand of an Important Man* 2015 graphite, archival pigment–printed images, dried juniper,
(b. 1979) silkscreened text on paper sheeting, video 33 × 25¾ × 2¾ in.
Courtesy the artist and François Ghebaly, Los Angeles

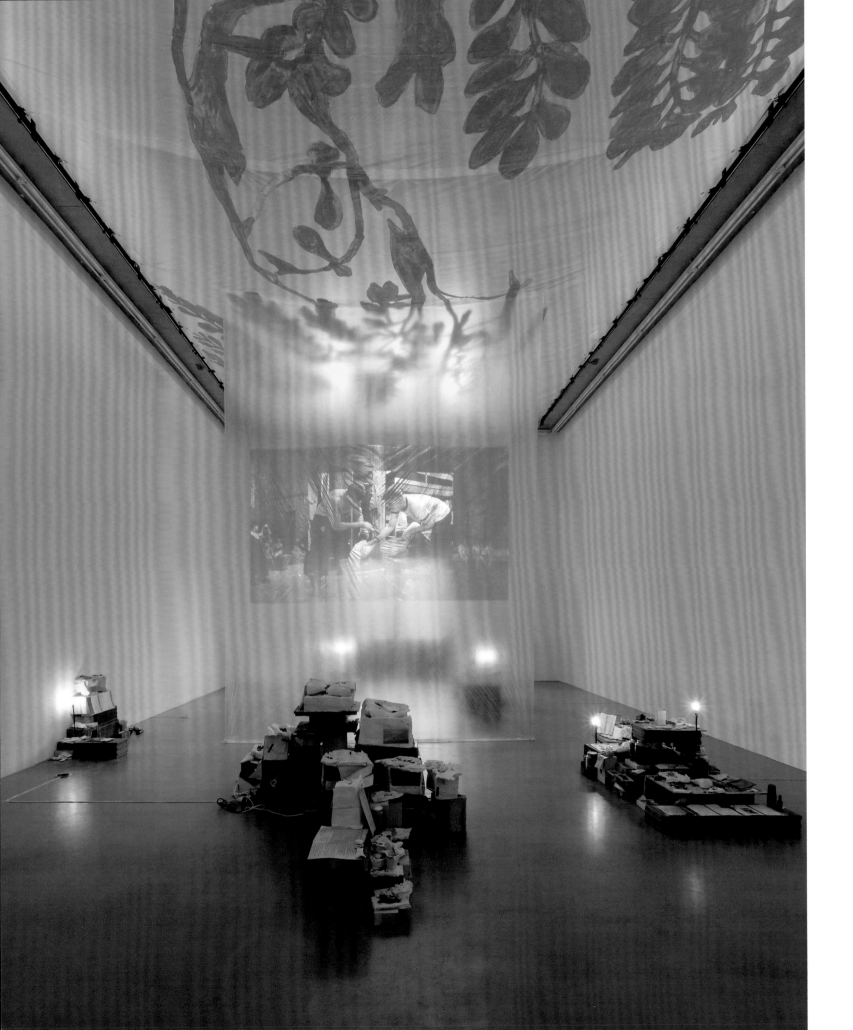

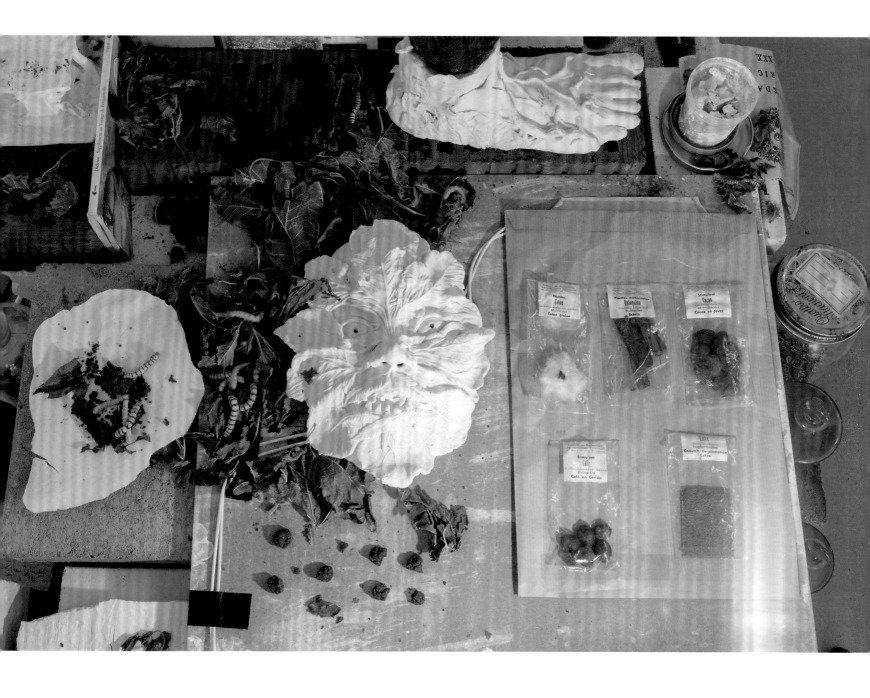

CANDICE LIN (b. 1979) *A Hard White Body, a Soft White Worm* 2018 installation view, Portikus, Frankfurt porcelain objects, porcelain slip, water, distillation system, urine, bricks, plants, porcelain, wood, books, photographs, drawings, dried plants, remnants of dead mushrooms, glass jars, hot plate, burnt sugar, kettle, pitcher, pumping system, dead silkworms, cacao pod, detox tea, plastic sheeting, video dimensions variable; video: 12-min. loop Courtesy of the artist; François Ghebaly, Los Angeles; and Portikus, Frankfurt

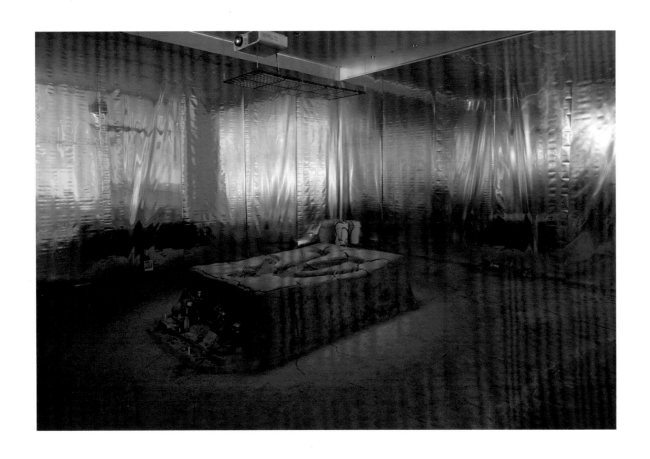

CANDICE LIN (b. 1979) *La Charada China*

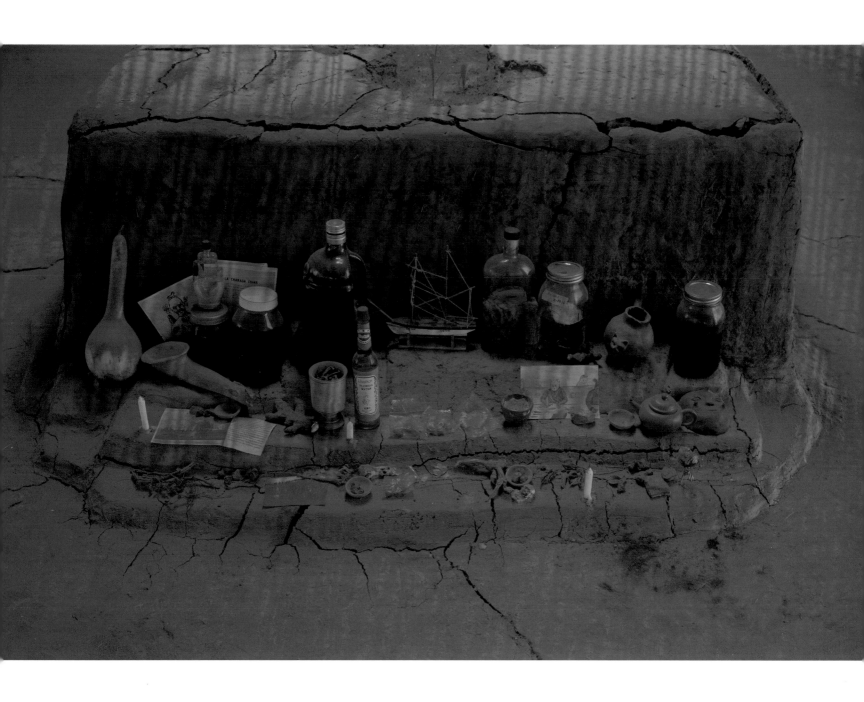

2018 installation views, Hammer Museum, Los Angeles earth, red clay
from the Dominican Republic and California, guano, cement, seeds of
various plants, grow lights, reflective Mylar, wooden and metal armature,
soaker hose, pumping system, video dimensions variable; video:
13:45 min. Courtesy of the artist and François Ghebaly, Los Angeles

Michael Madore

Born to a French Canadian family, Michael Madore grew up in Hartford, Connecticut, and studied art and literature at Trinity College during the late 1970s, focusing on medieval manuscript illumination and nineteenth-century artists and illustrators such as William Dadd and J. I. Grandville. Following several years in New York City, he returned to his home state and, on the advice of his psychiatrist, entered graduate school and earned his MFA at Yale University. Rather than subscribing to tenets of postminimalism or appropriation art that were prominent at the time, Madore honed a fascination with self-taught and untrained artists as well as groups like the Chicago Imagists. His work developed into a self-aware manner of painting that involves highly detailed line work, suggesting interconnected organic worlds of swirling linear tendrils, like venation or nervous systems, and populated by, among other things, crystalline architecture, orchids, and woodpeckers.

Madore's inspirations are vast, and his manner of art making is syncretic—in his work he weaves together ideas from naturalist classification systems, psychoanalytic literary theory, garden design, and space colonization.

Long fascinated by architecture and cartography, he also makes reference to premodern eras, picturing medieval castles, nineteenth-century Anglo-German nomenclature and botanical illustration, and romantic Germanic literature. One ongoing project involves Madore's speculations regarding the effects of global warming and other shifts in the environment on Labrador, a remote region in northern Canada. These works on paper picture a landscape, with its rocky mountains and distinct flora and fauna, adapting to much warmer temperatures with the creation of new hybrid species that now dominate this once-inhospitable terrain. Landscapes are often surrounded by spinning amoeba-like forms and flowering plants, some of which Madore labels with designations that imply the need for new taxonomies in this future world. While interested in the effects of climate change, Madore's project is not aimed at activism. "It is a way for me to project what are some of the changes that will affect boreal forests. Birds begin to migrate, and plants as well," says Madore. "For me, it's just a kind of way to pursue my interests in flora, fauna and mutagenicity."[10]

SARAH MONTROSS

MICHAEL MADORE (b. 1954) *Zillertal, Sektor 68, from the series Potting Shed* 2019 ink, pen, watercolor on paper 25 × 19 in. Courtesy of the artist

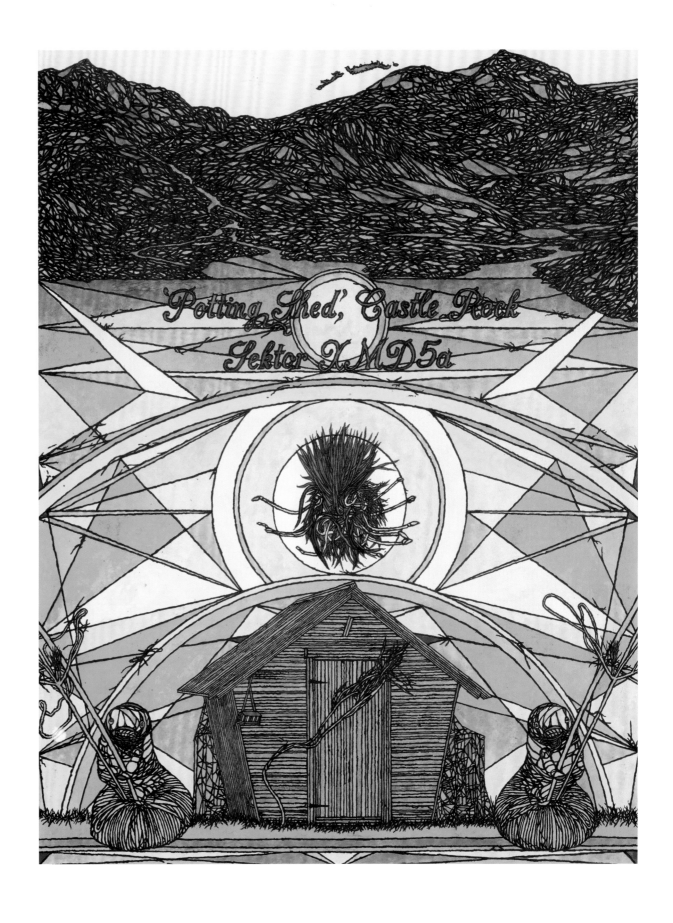

Within the illustration:

'Potting Shed', Castle Rock

Sektor XMD5a

MICHAEL MADORE (b. 1954) *Castle Rock, Sektor XMD5a, from the series Potting Shed* 2019 ink, pen, watercolor on paper 25 × 19 in. Courtesy of the artist

MICHAEL MADORE (b. 1954) *Garden Scheme, Sektor 7Fi* 2018 ink, pen, watercolor on paper 25 × 19 in. Courtesy of the artist

Biosensors, Sector MXc-d

MICHAEL MADORE (b. 1954) *Biosensors, Sektor MXc-d* 2017 ink, pen, watercolor on paper 25 × 19 in. Courtesy of the artist

MICHAEL MADORE (b. 1954) *Labrador 2073* 2017 ink, pen, watercolor on paper 25 × 19 in. Courtesy of the artist

Labrador 2088

MICHAEL MADORE (b. 1954) *Labrador 2088* 2017 ink, pen, watercolor on paper 25 × 19 in. Courtesy of the artist

LIVES AND WORKS IN NEW
HAVEN, CONNECTICUT, AND
NEW YORK, NEW YORK

BORN 1969,
PHILADELPHIA, PENNSYLVANIA

Kim Weston

Advanced audio and visual technology and spiritualism have a long and interwoven history. Devices invented to record and measure the material world are often employed as tools for accessing the immaterial beyond, and technologies like telegraphy and radio have been used as conduits for spectral voices and supernatural encounters—a relationship most notable in the late nineteenth-century art of spirit photography.[11] Kim Weston extends this tradition into the twenty-first century with her photographic series *Seen, Unseen*, in which she uses a digital camera to capture spiritual phenomena that cannot be perceived by the naked eye. Prompted by her own near-death experience in 2012, Weston developed an interest in the liminal space between life and death. Through this lens, she began photographing her extended family in South Carolina but has more recently turned her attention to her Native American heritage (she is part Mohawk) by attending and photographing powwows along the East Coast.[12]

Dissatisfied with her initial documentary approach to the ceremonies, Weston realized that the static quality of her images failed to convey the true essence of the events. She remarks that "so much happens in that circle that you can't explain."[13] Positioning herself on the ground by the drum so she could feel the beat resonate throughout her body, she began to take long-exposure photographs that track the dancers' movements through time. In these works, human forms dissolve into amorphous shapes and their elaborate regalia is transformed into a flurry of color and light against a black background. As she explains, "I use my camera to capture what I feel when I'm there. . . . These images are a direct result of my spiritual experience."[14]

The photographs' large scale creates an enveloping presence. In past installations, Weston also placed at the foot of each photograph objects that possess ceremonial significance: turtle shells, which represent, in Weston's words, "Mother Earth, foundation, home, time, fear, courage, endurance, life and possibility,"[15] rest atop piles of red silk pouches stuffed with tobacco that are traditionally used in ceremonies and shared to show appreciation or gratitude. The accompanying scent of tobacco—an element that can be sensed but not seen—echoes Weston's photographic records of the spiritual world and furthers her investigation into the shadowy space between presence and absence. For the presentation of her work in *Visionary New England*, Weston was inspired by the missing and murdered Indigenous girls and women across North America. Large photographs from powwows in New England encircle a massive collection of red silk prayer bundles. Weston aims for visitors to circulate among the photographs and leave with one prayer bundle each as "a symbol of thanks and acknowledgment of prayers needed to bring awareness and change to this violent crisis."[16]

SCOUT HUTCHINSON

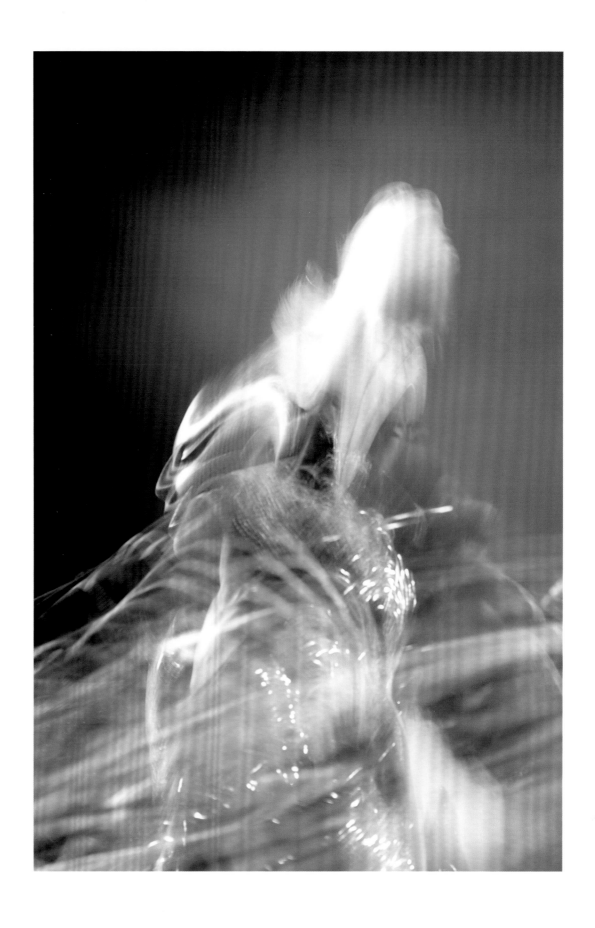

KIM WESTON (b. 1969) *Grace,* from the series *Layers of the Soul*

2018 archival photographic inkjet print, edition 5
60 × 40 in. Morse College, Yale University

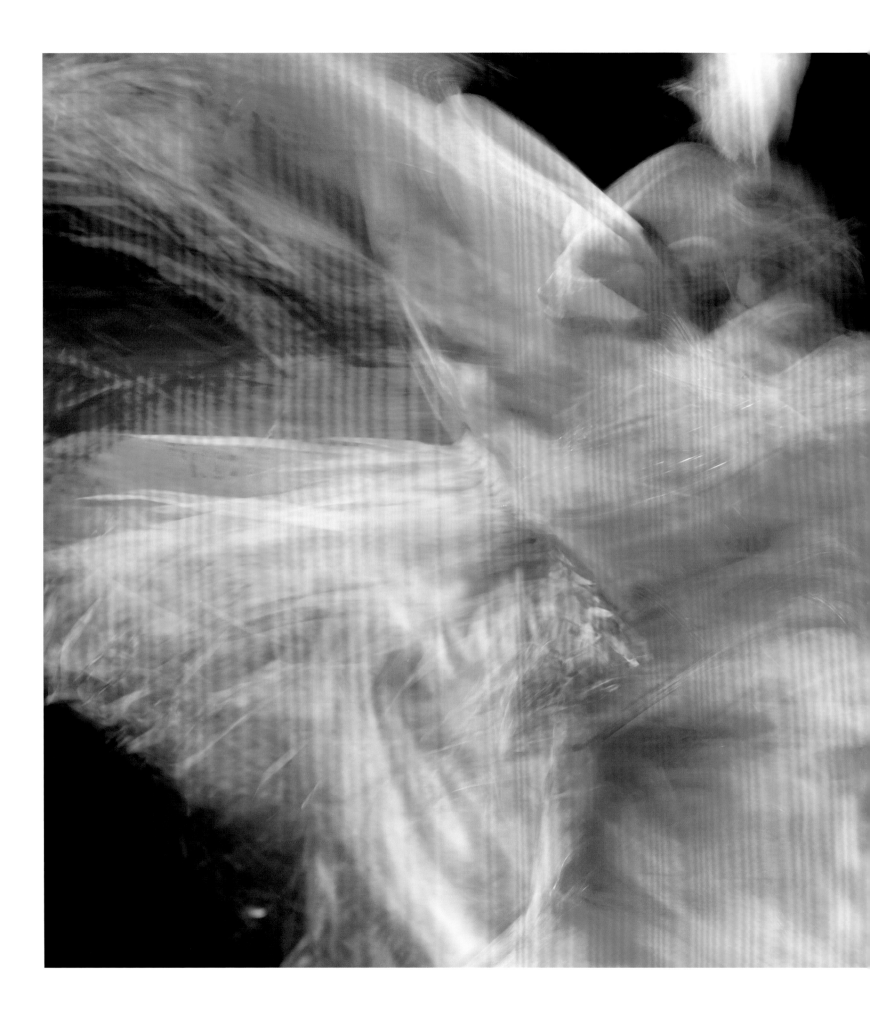

KIM WESTON
(b. 1969)

Medicine,
from the series
Layers of the Soul

2018 archival photographic inkjet print, edition 5
40 × 60 in. Morse College, Yale University

KIM WESTON (b. 1969) *Passion Fruit, from the series Layers of the Soul*

2018 archival photographic inkjet print, edition 5
40 × 60 in. Morse College, Yale University

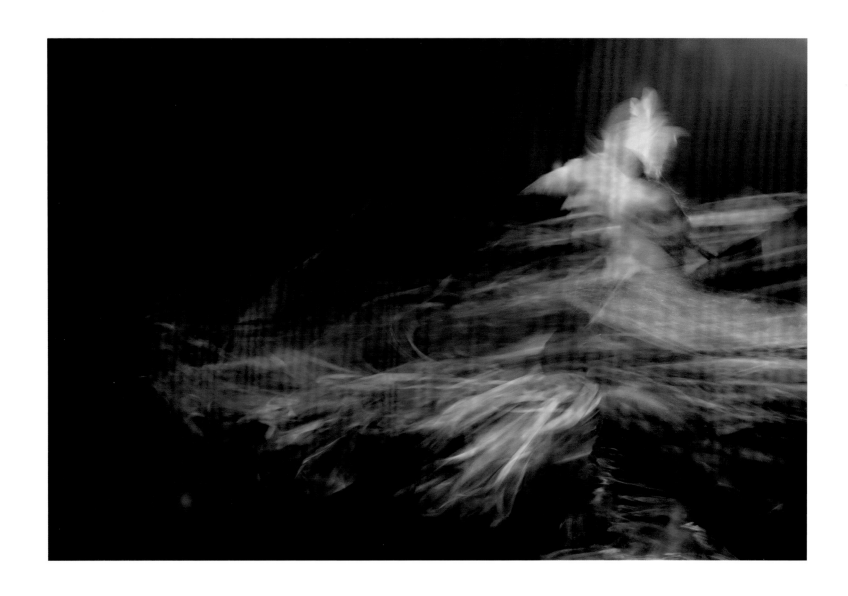

2018 archival photographic inkjet print, edition 5
40 × 60 in. Morse College, Yale University

KIM WESTON (b. 1969) *Reflections*, from the series *Layers of the Soul*

KIM WESTON
(b. 1969)

Traditional,
from the series
Layers of the Soul

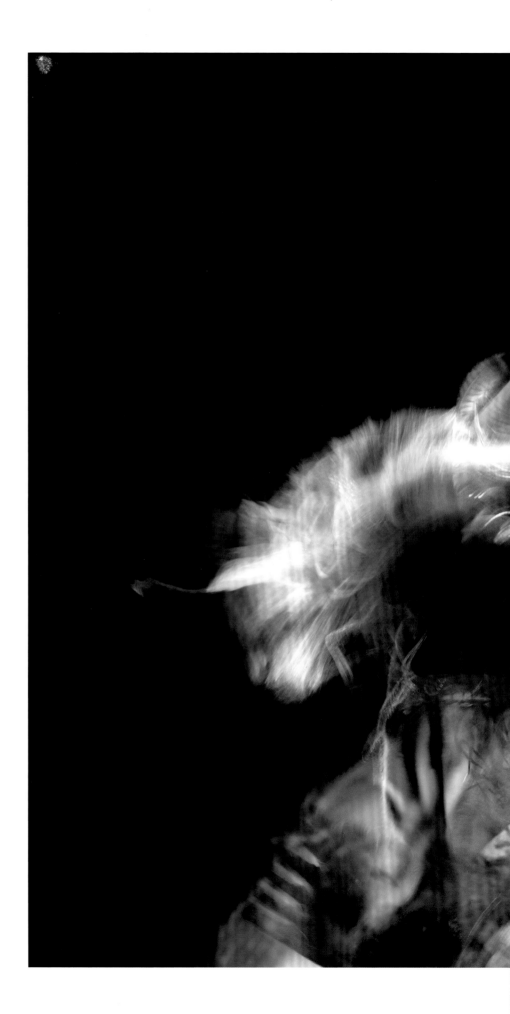

2018 archival photographic inkjet print, edition 5
40 × 60 in. Morse College, Yale University

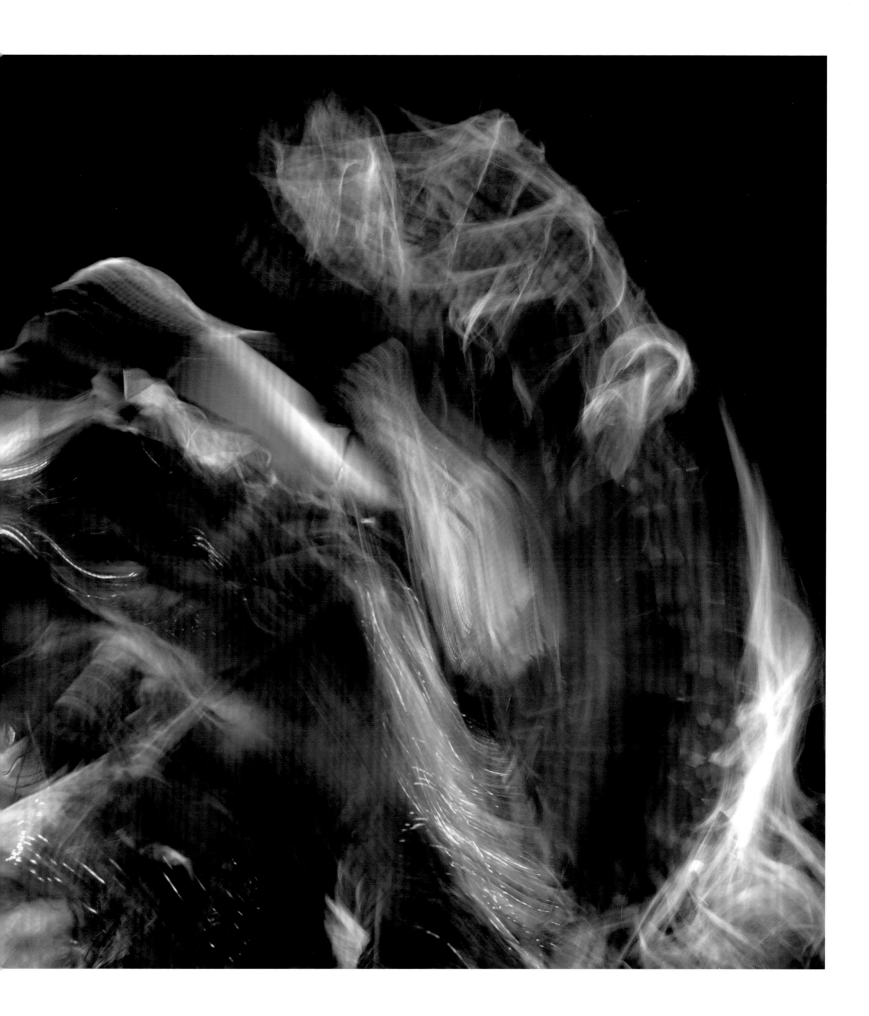

1

Caleb Charland in "Caleb Charland: Photographing Science," YouTube, September 26, 2016, https://www.youtube.com/watch?v=sJaItlSKUnw.

2

Sam Durant, "Interview with Sam Durant," by Rita Kersting, in *Sam Durant*, ed. Michael Darling (Ostfildern-Ruit, Germany: Hatje Cantz Publishers, 2002), 59.

3

Josephine Halvorson, "Josephine Halvorson," by Jo-ey Tang, *Artforum*, August 2, 2016, https://www.artforum.com/interviews/josephine-halvorson-talks-about-her-project-at-storm-king-art-center-62425.

4

Josephine Halvorson, "Josephine Halvorson with Phong Bui," by Phong Bui, in *Tell Me Something Good: Artist Interviews from The Brooklyn Rail*, ed. Jarrett Earnest and Lucas Zwirner (New York: David Zwirner Books, 2017), 193.

5

Halvorson, "Josephine Halvorson with Phong Bui," 195.

6

Henry David Thoreau, *Walking* (Auckland: Floating Press, 2008), 10.

7

Douglas Walla, "The Navigator," in *The Essential Paul Laffoley: Works from the Boston Visionary Cell*, ed. Douglas Walla (Chicago: University of Chicago Press, 2016), 6.

8

Paul Laffoley, in Betti-Sue Hertz and Ceci Moss, *Dissident Futures* (San Francisco: Yerba Buena Center for the Arts, 2014), 110.

9

Paul Laffoley, *Utopia: Time Cast as a Voyage*, 1974, oil, acrylic, and vinyl lettering on canvas, 73½ × 73½ in., Collection of Elyse and Lawrence B. Benenson.

10

Michael Madore, quoted in John Adamian, "The Insider Outsider," *Take*, March 6, 2017, http://www.thetakemagazine.com/the-insider-outsider/.

11

See Sas Mays and Neil Matheson, eds., *The Machine and the Ghost: Technology and Spiritualism in Nineteenth- to Twenty-First-Century Art and Culture* (Manchester, UK: Manchester University Press, 2016), 6.

12

The intertribal powwow is an important celebration of Native American culture and community articulated, as scholar Tara Browner explains, "through the medium of music and dance." See Browner, *Heartbeat of the People: Music and Dance of the Northern Pow-Wow* (Chicago: University of Illinois Press, 2004), 1.

13

Kim Weston, "Kim Weston—Seen, Unseen," *Vimeo*, c. 2014, https://vimeo.com/94612367.

14

Kim Weston, "Photographer Interview: Kim Weston," by Qiana Mestrich, *Dodge & Burn*, May 13, 2014, https://dodgeburnphoto.com/2014/05/photographer-interview-kim-weston/.

15

Weston, "Photographer Interview."

16

Kim Weston, email to Scout Hutchinson, May 29, 2019.

Visionary New England Sites and Communities

SCOUT HUTCHINSON

This list presents a small selection of notable historical and existing communities and organizations throughout the six New England states from the nineteenth century to the present. These groups focused on spirituality, communal living, arts and literature, social and educational reform, and the natural world.

SHAKER VILLAGES

The Shaker religion developed out of Quakerism in the eighteenth century and is so named because of the frenzied dance its worshippers practice during services. Shakers prefer to live separately from society, establishing villages where members live and work communally. Because Shakers believe in God's dual nature as both male and female, women have often assumed leadership roles in Shaker communities. With their emphasis on religion, simple living, shared labor, and egalitarianism, Shaker villages served as appealing models for many of the experimental communes that arose in New England throughout the nineteenth and twentieth centuries. Though Sabbathday Lake Shaker Village (New Gloucester, Maine, 1783–present) is the only remaining active village, historic sites include the Hancock Shaker Village (Pittsfield, Massachusetts, 1783–1960), Canterbury Shaker Village (Canterbury, New Hampshire, 1792–1992), and the Enfield Shaker Community (Enfield, Connecticut, 1792–1917).

DOGTOWN (CAPE ANN, MASSACHUSETTS, C. 1690–PRESENT)

The site of an English settlement on the north shore of Massachusetts, this community had significantly dwindled by the early 1800s. Once abandoned, the area became empty pastureland, which Henry David

Thoreau walked in 1858 and called "the most peculiar scenery of the Cape."[1] In the early twentieth century, Roger Babson, a native of nearby Gloucester and founder of Babson College, purchased much of the land and began carving words and phrases like "truth," "spiritual power," and "prosperity follows service" into the granite boulders scattered across the fields (fig. 4.1). He explained that he was "trying to write a simple book with words carved in stone instead of on printed paper."[2] Around this time, artist Marsden Hartley visited Gloucester and began a series of paintings of Dogtown. He was fascinated with the "sense of eeriness [that] pervades all the place. . . . [It is] forsaken and majestically lovely, as if nature had at last formed one spot where she can live for herself alone."[3]

AFRICAN UNION MEETING HOUSE AND SCHOOL HOUSE SOCIETY (PROVIDENCE, RHODE ISLAND, 1820S–C. 1840)

The African Union Meeting House, built in 1820–21 near Brown University, was the first all-black church and school in Providence. The meeting house was not only a place of worship and learning; it offered space apart from white oppression in which local African Americans could gather and discuss political and social issues relevant to their community. Originally a multi-denominational church, the African Union Meeting House eventually became the Meeting Street Baptist Church. Though the original structure was torn down in the late nineteenth century, the congregation exists today as the Congdon Street Baptist Church.

FIG. 4.1 Carved boulder in Dogtown, Massachusetts.

HOLLY HOME (PROVIDENCE AREA, RHODE ISLAND, C. 1841–C. 1843)

Located north of Providence, this communal farm was cofounded by a small group of Rhode Island–based Unitarians who were concerned chiefly with simple living, the abolitionist movement, and transcendentalism. In 1841 the members of Holly Home published several issues of the *Plain Speaker*, a transcendentalist newspaper. The publication's mission mirrored the community's ideals: "The noblest man is he who works and with his own hands ministers to his wants,—the greatest, he who discards wealth and aspires to poverty,—the truest, he who obeys the conviction of his own soul."[4] The group asked Amos Bronson Alcott to join their community as a mentor, but Alcott declined, later establishing Fruitlands in Harvard, Massachusetts.

BROOK FARM (WEST ROXBURY, MASSACHUSETTS, 1841–C. 1847)

Founded in 1841 by the Unitarian minister George Ripley and his wife, Sophia Willard Dana Ripley, Brook Farm had strong ties to the transcendental movement and was host to several of its key figures, including Ralph Waldo Emerson, Margaret Fuller, and Henry David Thoreau. The site included the main farmhouse, or "The Hive," a working farm, and an alternative school, the Brook Farm Institute of Agriculture and Education. George Ripley claimed the community's mission was "to insure a more natural union between intellectual and manual labor than now exists; to combine the thinker and the worker, as far as possible, in the same individual."[5]

HOPEDALE COMMUNITY (MILFORD, MASSACHUSETTS, 1841–C. 1856)

Situated on a tract of farmland near Milford, the Hopedale Community was founded by the Unitarian minister Adin Ballou, who envisioned it as a "universal religious, moral, philanthropic, and social reform Association."[6] Ballou shared many of the ideals of his friend George Ripley, who established Brook Farm, including the rejection of slavery and support for women's rights. The community originally consisted of around thirty members; by 1851 that number had grown to approximately 175, developing into a small, self-sufficient village complete with a school, chapel, factory, and bank. Though Hopedale ultimately failed due to financial troubles, Ballou pinpointed a spiritual deficit in its members as the root problem. He surmised that "the movement was too far ahead of and above the world, in its then existing or present state of advancement, to be practicable."[7]

NORTHAMPTON ASSOCIATION OF EDUCATION AND INDUSTRY (FLORENCE, MASSACHUSETTS, 1842–1846)

Unlike many agrarian utopian communities of its time, the Northampton Association of Education and Industry (fig. 4.2) was centered around a communally owned silk mill and its surrounding farmland. Balancing principles of labor, education, and religious tolerance, its members were inspired primarily by the teachings of the writer and abolitionist William Lloyd Garrison, and they believed that "the rights of all are equal without distinction of sex, color or condition, sect or religion."[8] In 1843 the formerly enslaved activist Sojourner Truth came to live at the association, where she met other notable figures in the abolitionist movement like Frederick Douglass and Wendell Phillips.

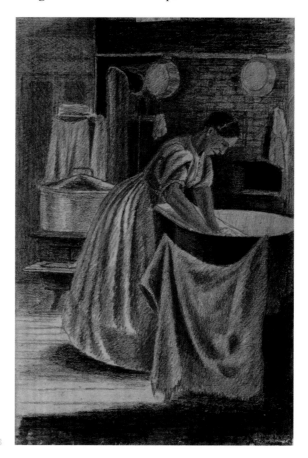

FIG. 4.2 Charles C. Burleigh Jr. (1848–1882), untitled, pencil on paper, 6¾ × 4½ in. Courtesy of Historic Northampton, Northampton, Massachusetts.

FRUITLANDS (HARVARD, MASSACHUSETTS, 1843)

Located roughly thirty-five miles outside Boston, Fruitlands was cofounded by transcendentalists Amos Bronson Alcott and Charles Lane as an experiment in escaping the ills of capitalism and government. Alcott hoped that the members of Fruitlands—primarily his and Lane's immediate family members—would exist in "healthful labor and recreation," working the ninety-acre plot of land as a self-sustaining (and vegan) community.[9] The project's spiritual, material, and dietary asceticism, coupled with a poor harvest, caused the members to disband later that same year after only six months at the commune. A young Louisa May Alcott lived with her sisters and mother on the settlement.

THE HARMONIAL BROTHERHOOD (HARTFORD, CONNECTICUT, 1851–?)

Originally from New York, Andrew Jackson Davis was a magnetic healer and medium known as the "Poughkeepsie Seer." When he moved to Hartford in 1850, Davis encountered a community of like-minded Spiritualists and began to publish a multivolume text titled *The Harmonial Philosophy*. Out of these writings grew the Harmonial Brotherhood, an organization that sought to marry spirituality and mysticism with prominent social reform movements of the day, including abolitionism and women's rights. Davis explained that the brotherhood would not meet in any formal religious structure but would "assemble in the distant groves—we will take pews under the spreading boughs of some old lofty oak."[10] Out of the Hartford Brotherhood grew several similar groups throughout New England and the Midwest.

APPLEDORE ISLAND (MAINE, C. 1861–1894)

Part of the Isles of Shoals off the coast of Maine and New Hampshire, Appledore Island was a popular summer destination for New Englanders in the late nineteenth century. The island served as the setting for an informal literary and arts salon, at the center of which was the writer and poet Celia Thaxter, operator of the island's hotel. Her frequent guests included Ralph Waldo Emerson, Childe Hassam, Sarah Orne Jewett, Henry Wadsworth Longfellow, and Ellen Robbins, who were taken with the island's rugged terrain and Thaxter's charming cottage garden. The artists' community began to dissipate after Thaxter's death in 1894 and ended when the hotel burned down in 1914.

SUMMER SPIRITUALIST CAMPS (C. 1865–PRESENT)

In the late nineteenth century, a large number of Spiritualist camps began to emerge in New England, which has been credited as the birthplace of the Spiritualist camp meeting movement. Most camps began as tent cities in wooded or coastal locations that gradually developed into established communities composed of residential cottages, hotels, and temples. At these summer retreats, members participate in séances, lectures, and sessions with healers, as well as more traditional outdoor recreation, uniting the spiritual realm with the natural world. Some of the better-known camps include Lake Pleasant (Montague, Massachusetts, 1874–present), Onset Bay Grove (Wareham, Massachusetts, 1877–present), Camp Etna (Carmel, Maine, 1876–present), and Pine Grove Spiritualist Camp (Niantic, Connecticut, 1882–present).

FIRST SPIRITUAL TEMPLE (BOSTON, MASSACHUSETTS, 1883–PRESENT)

This church was established by Marcellus Seth Ayer, a native of Maine who sought a way to synthesize his passions for religion, education, and science. After receiving divine inspiration, he organized the Spiritual Fraternity, a religion that blends Christian theology with Spiritualism and believes that all beings—living and deceased—are unified with God as one spirit. The original building (now the Kingsley Montessori School) was constructed in Boston's Back Bay in 1885; the congregation later moved to Brookline before relocating to Cape Cod. The First Spiritual Temple is also home to the Ayer Institute, a library dedicated to the study of "spiritualism, mediumship, parapsychology, and a variety of religious thought."[11]

SARA BULL HOME (CAMBRIDGE, MASSACHUSETTS, C. 1890–1911)

The philanthropist Sara Chapman Bull organized salon-style meetings called "Cambridge Conferences" in her home at 168 Brattle Street, assembling notable artists, writers, philosophers, and activists

including Frederick Douglass and Gertrude Stein. Interested in interfaith religion, Bull invited the Hindu monk Swami Vivekananda, who is credited with introducing the Vedanta philosophy to the Euro-American world in the late nineteenth century, to lecture at her home in 1894. Bull eventually helped orchestrate the founding of what is now the Ramakrishna Vedanta Society in Boston in 1909.

GREENACRE/GREEN ACRE BAHÁ'Í SCHOOL (ELIOT, MAINE, 1894–1899/1899–PRESENT)

Originally a hotel, the Green Acre building was transformed into a center for religious and intellectual studies in 1894 by the visionary Sarah Jane Farmer. The school was a popular summer destination for the spiritually inclined; it hosted an eclectic array of guest lecturers, from D. T. Suzuki to W. E. B. Du Bois, and attracted artists, poets, and musicians, including William Ordway Partridge, Marsden Hartley, and Mark Tobey. In 1899 Farmer was introduced to the Bahá'í faith, which continues to be the focus of the Green Acre School today.

STAR ISLAND CORPORATION (STAR ISLAND, NEW HAMPSHIRE, 1896–PRESENT)

Located off the coast of New Hampshire among the Isles of Shoals, Star Island and its rambling hotel were converted into a summer conference center by Unitarian Church members Thomas and Lilla Elliot in 1896. The Elliots' nonprofit organization, the Isles of Shoals Summer Meeting Association (now the Star Island Corporation), officially purchased the island in 1915. The island attracted visitors such as Nathaniel Hawthorne and the American Impressionist painter Childe Hassam. Affiliated with the Unitarian Universalist Association, the Star Island Corporation continues to host seasonal retreats, with topics that include religion, meditation, science, and the arts.

VEDANTA CENTRE (BOSTON AND COHASSET, MASSACHUSETTS, 1909–PRESENT)

The Vedanta Centre of Boston was founded by the Hindu monk Swami Paramananda, a disciple of Swami Vivekananda, with the help of Cambridge resident Sara Chapman Bull. In 1929 a second center was established south of Boston in Cohasset. Though grounded in Hindu philosophy, Vedanta (roughly translated: "supreme wisdom") teaches

that "all religions are paths leading to the same goal" and embraces interfaith worship.[12] The Cohasset center's temple was built in 1959 and was designed by then-director Srimata Gayatri Devi (fig. 4.3), the first Indian woman to be ordained to teach Vedanta in the Western world.

FIG. 4.3 Srimata Gayatri Devi at the Cohasset Vedanta Centre Temple of the Universal Spirit, which she designed in the 1950s. Courtesy of Ananda Ashrama, La Crescenta, California.

JOHANNES KELPIUS LODGE (ALLSTON, MASSACHUSETTS, 1917–PRESENT)

This Rosicrucian lodge is named for Johannes Kelpius, a seventeenth-century German mystic and Pietist who emigrated in 1694 to rural Pennsylvania, where he and his followers lived communally and called themselves the "Mystics of the Wissahickon." Kelpius has come to be considered the grandfather of Rosicrucianism, a belief system that combines elements of Jewish and Christian mysticism with alchemy, Egyptology, and the occult.

AMERICAN SOCIETY FOR PSYCHICAL RESEARCH (BOSTON, MASSACHUSETTS, 1885–PRESENT)

Founded in Boston in 1885, the American Society for Psychical Research (ASPR) investigated paranormal and psychic phenomena. The organization was eventually divided between members who believed in Spiritualism and mediumship and those whose work was grounded in laboratory science and physics. An offshoot organization, the Boston Society for Psychical Research (BSPR), formed in 1925. One

of its members, Joseph Banks Rhine, published the 1934 text *Extrasensory Perceptions* and coined the term *parapsychology*, the study of mental phenomena such as telepathy and hypnosis. In 1941 the BSPR was reintegrated into the ASPR, which is now located in New York.

ORGONON (RANGELEY, MAINE, 1942–PRESENT)

Encompassing a 175-acre property of woodlands and meadows in the Rangeley Lakes region of Maine, Orgonon was the home and research center of Austrian American psychoanalyst Wilhelm Reich. There Reich developed therapeutic treatments, including a mechanism called the Orgone Energy Accumulator—a boxlike structure that Reich believed had the power to harness energy and cure physical and mental illness—and instruments with the power to alter the weather. Many avant-garde cultural figures such as William S. Burroughs, Jack Kerouac, and J. D. Salinger were drawn to his work. The site, which includes Reich's house, laboratory, and archives, now operates as the Wilhelm Reich Museum at Orgonon.

FIG. 4.4 Andrija Puharich, seen here in silhouette, testing the abilities of alleged psychics and mediums in copper-lined "Faraday cages" at his Glen Cove lab in Rockport, Maine. Courtesy of Andy Puharich.

FIG. 4.5 Lucy Horton (b. 1945), *Martha with the New Team*, Frog Run Farm, Vermont, 1972. Personal collection of Mary Mathias.

ROUND TABLE LABORATORY OF EXPERIMENTAL ELECTROBIOLOGY (GLEN COVE, MAINE, C. 1949–1957)

Parapsychologist Andrija Puharich (fig. 4.4), who studied extrasensory perception and used psychedelics for some of his experiments, established this coastal laboratory in the late 1940s with the financial help of wealthy area families. Puharich invited

mediums, psychics, and artists to Round Table, and his research interests gradually expanded into areas like mysticism and extraterrestrial life. Aldous Huxley, who visited Round Table in the mid-1950s, explained that Puharich's "aim is to reproduce by modern pharmacological, electronic, and physical methods the conditions used by the shamans for getting into a state of travelling clairvoyance and, if he succeeds, to send people to explore systematically 'the Other World.'"[13] When financial backing for the laboratory failed in 1957, Puharich moved to Mexico to pursue his research.

VERMONT COMMUNES OF THE 1960S

During the 1960s, the green hills of Vermont drew members of the burgeoning hippie culture from nearby urban centers. It is estimated that more than fifty communes were established in the state between 1965 and 1975, each with its own unique mission (fig. 4.5). Members of the Maple Hill Commune in Plainfield, for example, operated a farm and organized demonstrations protesting the Vietnam War. Members of Free Vermont, a group of activists who collaborated with the Black Panthers and formed an alternative children's school, lived at Red Clover commune in Putney. Packer Corners Farm in Guilford was home to a group of writers, including Raymond Mungo, the author of the 1970 memoir *Total Loss Farm: A Year in the Life*, and Alicia Bay Laurel, who wrote and illustrated *Living on the Earth*. Members also collectively published the alternative magazine *Green Mountain Post* between 1969 and 1977.

With its strong literary ties and emphasis on nature, Packer Corners recalls the transcendentalist movement of a century before.

HARMONY RANCH AND THE PULSA COLLECTIVE (NEW HAVEN AND OXFORD, CONNECTICUT, 1966–1973)

In 1966 a group of roughly ten artists, engineers, musicians, and computer programmers formed the Pulsa Collective, the New Haven chapter of the organization Experiments in Art and Technology (EAT). The Pulsa Collective sought to create a public and participatory art via indoor and outdoor installations composed of light and sound that were activated by "perceptible wave energies."[14] While the collective operated an event space in New Haven, where artists such as Nam June Paik, Richard Teitelbaum, and La Monte Young were invited to perform, the group lived on Harmony Ranch, a communal farm in Oxford (fig. 4.6). There they grew their own food and created experimental works using natural phenomena such as wind and rain.

CUMBRES (DUBLIN, NEW HAMPSHIRE, 1969–1971)

This community was formed by Cesareo Pelaez, who had worked with the psychologist Abraham Maslow at Brandeis University in Waltham in the 1960s. Inspired by Maslow's theories on personal growth and fulfillment, Pelaez wanted to create a space where people could "live together and develop their inherent spirituality."[15] Members of Cumbres—the Spanish word for "peaks" or "summits"—lived in an old inn, shared chores and meals, practiced the Chinese martial art of tai chi, and attended lectures on religion, psychology, and meditation.

THE BOSTON VISIONARY CELL (BOSTON, MASSACHUSETTS, 1971–2006)

The Boston Visionary Cell, founded by Paul Laffoley, aimed "to develop and advance visionary art" that possesses "elements of the sacred, the magical and the mystical woven into themes that are by their nature timeless, universal and transcendental."[16] Though the certificate issued by the Commonwealth of Massachusetts recognizing the group's incorporation lists nine founding members, the Boston

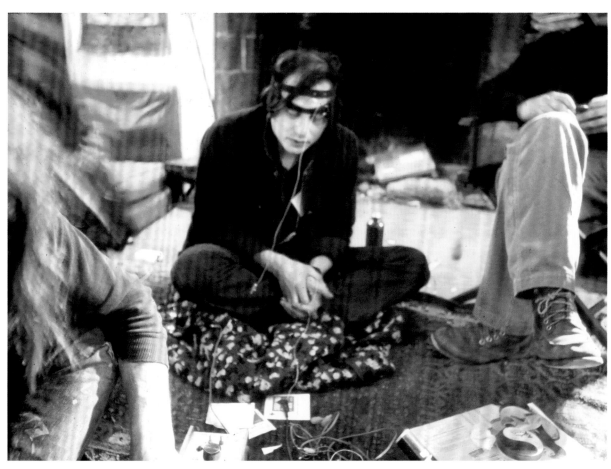

FIG. 4.6 A Pulsa brainwave experiment with Serge Tcherepnin at Harmony Ranch, 1970.

FIG. 4.7 The Boston Vision-
ary Cell headquarters, 2000.
Photo by Abelardo Morell.

Visionary Cell was primarily Laffoley's project. Its
headquarters were based in his studio and library
located off of Boston Common (fig. 4.7).

MAPPING OUT UTOPIA: 1970S BOSTON-AREA COUNTERCULTURE

A zine published in three separate volumes, *Mapping
Out Utopia* (2017) catalogues notable 1970s counter-
cultural communities and sites located in Boston,
Cambridge, and the nearby suburbs. Artist and
librarian Tim Devin conducted extensive research
into the rise and fall of alternative movements in
the greater Boston area, explaining how "folks were
exploring different ways of living and fighting the
patriarchy, taking control of their own health, tak-
ing control of their own businesses . . . as a way to
change society."[17] Devin leads guided tours based
on the listings published in *Mapping Out Utopia*.[18]

1

Henry David Thoreau, *The Writings of Henry David Thoreau: Journal XI*, ed. Bradford Torrey (Boston: Houghton Mifflin, 1906), 179.

2

Roger Babson, *Actions and Reactions: An Autobiography of Roger W. Babson* (New York: Harper & Brothers, 1950), 255.

3

Marsden Hartley, *Somehow a Past: The Autobiography of Marsden Hartley* (Cambridge: MIT Press, 1997), 144.

4

William Chace, quoted in Leo Stoller, "Christopher A. Greene: Rhode Island Transcendentalist," *Rhode Island History* 22 (October 1963): 104.

5

George Ripley, quoted in Bonnie Hurd Smith, "The Women of Brook Farm," Boston Women's Heritage Trail website, accessed February 11, 2019, https://bwht.org/brook-farm/.

6

Adin Ballou, quoted in John Humphrey Noyes, *History of American Socialisms* (Philadelphia: J. B. Lippincott & Co., 1870), 123.

7

Adin Ballou, quoted in Alison Cornish and Jackie Clement, "The Hopedale Community," Unitarian Universalist Association website, 2011, https://www.uua.org/re/tapestry/adults/river/workshop13/178780.html.

8

"Northampton Association of Education and Industry," Historic Nothampton website, accessed February 12, 2019, http://www.historic-northampton.org/highlights/education industry.html.

9

Amos Bronson Alcott, quoted in Thomas Blanding, "Paradise Misplaced: Bronson Alcott's Fruitlands," *The Concord Saunterer* 6, no. 4 (1971): 4.

10

Andrew Jackson Davis, "The Principles of Nature: The Constitution of the Harmonial Brotherhood; as Written by Andrew Jackson Davis, and Delivered before the Brotherhood, May 4th, 1851," *The Spirit Messenger* 1, no. 46 (June 21, 1851): 366.

11

First Spiritual Temple website, accessed March 24, 2019, http://www.fst.org/.

12

"About Vedanta," Ananda Ashrama website, http://www.anandaashrama.org/aboutvedanta.htm.

13

Aldous Huxley, quoted in Christopher Partridge, *High Culture: Drugs, Mysticism, and the Pursuit of Transcendence in the Modern World* (Oxford: Oxford University Press, 2018), 305.

14

Pulsa, "Notes on Group Process," c. 1968, page 1, https://archive.org/details/Pulsa-NotesOnGroup ProcessCa1968/page/n3.

15

Edward B. Fiske, "Commune Built by 'Republican Types,'" *New York Times*, September 5, 1970, https://www.nytimes.com/1970/09/05/archives/commune-built-by-republican-types.html.

16

Paul Laffoley, quoted in Jeanne Marie Wasilik, ed., *Paul Laffoley: The Boston Visionary Cell* (Boston: Kent Fine Art, 2013), 6.

17

Rena Karasin, "'Mapping Out Utopia': How Our Legacy of Counterculture Lives On," *Scout Cambridge*, March 1, 2019, https://scoutcambridge.com/mapping-out-utopia-how-our-legacy-of-counter culture-lives-on/.

18

For more information, visit Tim Devin's website, www.timdevin.com.

SAM ADAMS

Mediums, clairvoyants, and spiritualists communicate using a range of visual and acoustic technologies. Beginning in the early 1800s, journals, novels, and instructional books were central to the dissemination and promotion of spiritualist, utopian, and paranormal ideas. This section highlights texts and films with particular New England relevance.

UTOPIAN AND SPIRITUALIST TEXTS

The Blithedale Romance (1852), by Nathaniel Hawthorne (1804–1864), is a fictional account based on his experiences at the utopian community Brook Farm in West Roxbury, Massachusetts.

Modern American Spiritualism (1870) is the work of Emma Harding Britten (1823–1899), an English thinker married to Boston Spiritualist William Britten.

An immensely popular utopian science-fiction novel, *Looking Backward: 2000–1887* (1888), by Edward Bellamy (1850–1898), imagines Boston in the year 2000, when private property has been abolished and all industry has been nationalized.

In *Borderland of Psychical Research* (1906) and other texts, James H. Hyslop (1854–1920), briefly the head of philosophy at Smith College, outlined his influential theory of reincarnation.

Charlotte Perkins Gilman (1860–1935), a feminist author from Connecticut, wrote the utopian novel *Herland* (1915; fig. 5.1), which imagines a society of women who reproduce without sex and live free of war and conflict. Later commentators identified racist undertones in the book due to the practice of eugenics within this imagined society.

Referencing Henry David Thoreau's *Walden* (1854), behavioral psychologist B. F. Skinner's novel *Walden Two* (1948; fig. 5.2) offered a blueprint for many postwar utopian communities. Elise Lemire's study *Black Walden: Slavery and Its Aftermath in Concord, Massachusetts* (2009; fig. 5.3) unearths historical accounts of freed slaves and their children in the area, such as Zilpah, an African American woman mentioned by Thoreau whom locals called a "witch."

Based in Connecticut, Edward Warren (1926–2006) and Lorraine Warren (1927–2019) founded the New England Society for Psychic Research in 1952 (not associated with the American Society for Psychical Research, founded in Boston in 1885) and authored numerous studies on the paranormal, including *Ghost Hunters* (1989), episodes of which are frequently adapted for film and television.

VISIONARY FILM

Geographically distant from Hollywood, New England has nonetheless inspired experimental filmmakers since the 1920s. The birth of cinema, combined with the death toll of World War I, led to moving-image experiments—sometimes intended to invoke the deceased, as spirit photography had decades before,

FIG. 5.1 Cover of Charlotte Perkins Gilman's *Herland* [1915] (New York: Pantheon, 1979), designed by Louise Fili with collage by Joan Hall.

FIG. 5.2 Cover of B. F. Skinner's *Walden Two* [1948] (New York: Macmillan, 1968).

FIG. 5.3 Cover of Elise Lemire's *Black Walden: Slavery and Its Aftermath in Concord, Massachusetts* (Philadelphia: University of Pennsylvania Press, 2009), with Lydia Hosmer's *A Fishing Party*, 1812, Concord Museum, Massachusetts.

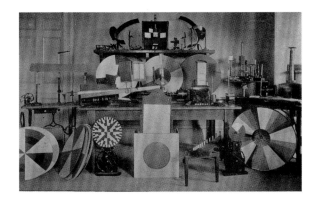

and at other times used to stage magic tricks. For some Spiritualists and mediums, the novel experience of the cinema, with its darkened auditorium and spectral images, served as a gateway to seeking out séances and communing with spirits.

Although the German psychologist and film scholar Hugo Münsterberg (1863–1916) denounced Spiritualists, psychical ideas influenced his writings. As director of Harvard University's Experimental Psychology Laboratory from 1892 until 1916, Münsterberg amassed a collection of devices for testing perception (fig. 5.4) while also writing on film theory in *The Film: A Psychological Study* (1916).

Hiram Percy Maxim (1869–1936) of Connecticut founded the Amateur Cinema League in New York in 1926. His film *Mag the Hag* (1925; fig. 5.5) is a "trick picture" or "photoplay" in which a talisman appears to transform objects and people. He was one of many amateur filmmakers in New England who contributed to a filmic parallel of spirit photography in which technical advances merged with, and in some cases displaced, occult beliefs.

The Austrian psychoanalyst Wilhelm Reich (1897–1957) coined the term *orgone*, a vital energy in the atmosphere. In 1942 he moved to Rangeley, Maine, and established the Orgone Institute. The album *Cloudbusting* (1985; fig. 5.6) by singer Kate Bush (b. 1958) pays homage to a machine by Reich that produced rain by unblocking

orgone in the sky. In Bush's music video she activates a cloudbuster as the FBI arrests Reich for his controversial ideas.

Recent and ongoing moving-image projects indicate the swelling interest in spiritualism and the supernatural since the 2010s:

The Witch (2015, 92 min.), directed by Robert Eggers (b. 1983), focuses on a family banished from a Puritan Plymouth Colony amid the religious culture of 1630s New England.

In the video *Another Voice* (2018, 9:39 min.) by Argentine artist Nicolas Gullotta (b. 1983), two psychic mediums communicate with the spirit of a New England lake in order to bring to light the past of the Abenaki tribe, a Native American group that settlers largely pushed out of New England.

Salacia (2019; fig. 5.7), by Boston-born filmmaker Tourmaline (b. 1983), draws on a tradition of black fantasy and folktales such as Virginia Hamilton's *The People Could Fly*. *Salacia* is set in Seneca Village, a free-black community destroyed to construct Central Park, New York, and the film's protagonist is a black trans woman and sex worker in the 1830s who faces racism, transphobia, and incarceration. A reflection on intergenerational trauma caused by the transatlantic slave trade, *Salacia* takes its title from the ancient Roman goddess of the sea and Neptune's wife.

Set in the 1830s–1840s, *Those Who Wait* (in postproduction as of this writing), directed by Chani Bockwinkel (b. 1988) and Taylor Burdenski (b. 1989), examines religious fervor in New England through a queer, feminist lens, concentrating on a group of Millerites, or followers of the Baptist preacher William Miller, who held that the second coming of Jesus Christ would occur in or before 1843.

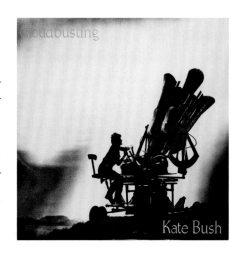

LEFT, TOP
FIG. 5.4 "Instruments for Experiments on Sight," in *Psychological Laboratory of Harvard University* (Cambridge, MA: Harvard University, 1893).

LEFT, BOTTOM
FIG. 5.5 Still from Hiram Percy Maxim, *Mag the Hag*, 1925, film, 15:47 min. Hiram Percy Maxim Collection, Northeast Historic Film.

RIGHT, TOP
FIG. 5.6 Album cover for Kate Bush's *Cloudbusting*, 1985 (Kate Bush Music Ltd.), designed by BSS Design with photography by John Carder Bush.

RIGHT, BOTTOM
FIG. 5.7 Still from Tourmaline's *Salacia*, 2019, video, color and sound, 06:04 min. Courtesy of the artist.

Thought-Forms

PAUL LAFFOLEY

NOTE: Beginning in the late 1980s, Paul Laffoley began drafting texts later called "Thought-Forms" to accompany his paintings and aid viewers in understanding their subject matter. Laffoley eventually considered these texts, written after the paintings were completed, to be integral to the corresponding artworks and displayed them together in exhibitions. See plates for corresponding artworks.

Homage to Kiesler 1968

SUBJECT Frederick Kiesler, Sculptor, Painter, and Visionary Architect.

SYMBOL EVOCATION The Search for Continuity in Nature.

In the early 1960s, right after my dismissal from the Harvard Graduate School of Design, I was compensated by fate in the form of a year's apprenticeship with Kiesler. Born in 1890 in Cernavti [Cernavodă], Romania, he nevertheless claimed Vienna as his birthplace. He became the youngest member of the de Stijl group in 1923. Arriving in America in 1926, he was quickly absorbed into the permanent avant-garde of New York City until his death in 1965. Known affectionately as the "Space" or "Egg Man"—because he advocated curved-shell over post-and-beam construction—his major architectural work that was built is the *Shrine of the Book*, or the Dead Sea Scrolls Museum in Jerusalem. The architect Philip Johnson always referred to Kiesler as the "greatest unbuilt architect of the 20th century," but upon the occasion of Johnson's ninetieth birthday celebration, which was held in 1996 at the Department of Architecture, Columbia University, Johnson rose before the assembled architects to declare that the thinking and visual forms of Kiesler would soon be entering the general practice of architecture. Johnson's remarks were actually briefer than my description. He got up and said, "Kiesler is next," and sat down—this to an audience already stunned by the energy of a man entering his tenth decade.

I have always thought of Kiesler as the prototype of the Bauharoque man, surviving by always throwing hooks and lines into the future. During the year I spent in his public sculpture studio in Union Square, I worked on many of his important pieces in terms of final presentation for exhibitions. One day he called me "a dreamer." To this day, I have not been able to decide whether I had received a compliment or an insult.

The Visionary Point 1970

SUBJECT The connection between that which has no history and that which has only history.

SYMBOL EVOCATION The Instant of Revelation.

Plato (c. 428–c. 347 BCE) in *The Timaeus* (c. 360 BCE) describes the three elements that compose the universe.

These elements suddenly appeared out of nowhere as a result of the titanic clash between the two most cosmic principles: reason (*nous*) and necessity (*ananke*). Reason as causal predictability attempts to overrule necessity by persuasion. Necessity as brute fact attempts to resist reason by the unpredictability of its wandering or errant cause. The nature of the collision is somewhat similar to the thought experiment of Romantic 19th-century physics, which only hints at what happens when the irresistible force finally meets the immovable object.

While this cosmology purports to explore fully the implications of the initial explosion, there immediately arise rejoinders on the part of the interlocutor, Timaeus of Locri. He recognizes the sublime terror one experiences approaching the very heart of revelation. The Triune that emerges is: first, the realm of the unchanging forms, the domain of the uncreated, the indestructible, the unmodifiable, the uncombinable, the imperceptible to the physical senses, is known only by thought—in essence, that which has no history. Second, the realm of the copies that bear the same name as the form, but detected by the physical senses, comes into existence and vanishes from a particular place and time, and during its existence is in constant motion. This realm is apprehended by opinion aided by sense data—in essence, it is that which has only history. Third, the nurse of becoming, the receptacle, or space that is eternal and indestructible and provides a position for everything that comes to be, but unlike time, which is ranked among the works of the intellect and has a form or archetype (eternal duration or aevum), space has no archetype and exists in its own right, as does the realm of form.

There are, however, two direct portals to revelation in the exposition of Timaeus: first, the nature of the relationship of being with becoming or the forms and their copies. It is spoken of as follows: "and the things which pass in and out of it (space) are copies of the eternal realities whose form they take in a wonderful way. That is hard to describe—we will follow this up some other time." Timaeus never does! Second, the way in which we as humans know about space, "which is apprehended without the senses by a sort of spurious reasoning and so is hard to believe in. We look at it indeed in a kind of dream and say that everything that exists must be somewhere and occupy some space, and that what is nowhere in heaven or earth is nothing at all. And because of this dream state we are not awake to the distinctions we have drawn and others akin to them and fail to state the truth about the true and unsleeping reality."

Timaeus is not indulging in metaphor. The dream state being referred to is the lucid dream brought to such a primordial and tupiodal (manifesting) state that we are placed in a position to witness universal

creation and destruction directly. In the 18th century the German philosopher Immanuel Kant (1724–1804) took Plato's ideas of time and space and placed them on the same footing or ontic status. To the raw data of sensation, Kant held that we contribute the forms of space and time. Space is the form of the external sense, and time is the form of the internal sense. We never experience anything, said Kant, except that it is in space and time.

Yet we never *experience* either space or time. Space and time in which we order phenomena, therefore, must come not from sensation but from within. We are literal co-creators of the universe utilizing this capacity for revelation. I suspect that lucid dreaming or its variations are involved in how the copies are made from the platonic forms, thus explaining how becoming unites with being.

The Visionary Point, therefore, is that moment in time when a viable time machine begins to operate and has the capacity to access the entire past and future of human history from that fatal present. It is an instant of time that can be described as the meeting of time moving forward and time moving backward, and it becomes the point in time that exactly precedes the beginning moment of the mystical experience of the entire earth.

The Gate of Braham: The Cosmic Octave 1971

SUBJECT The Eternal Imperishable Absolute, the supreme Brahman is the dual reality of the Vedanta. It has no equivalent in the religions of dualism, all of which require a personal god. This state of Nirvana does not mean mere annihilation but rather entry into another mode of existence. This is the abode of immortality. It is only accessible by the Mystical Experience. In the East this is called *Samadhi*. At its highest level it is known as *asamprajanya*, where one's personal karma is broken.

SYMBOL EVOCATION The Seven Chakras (or wheels) are centers of subtle energies, which are activated without physical motion. These energies are often called *Prana* or *Kundalini*. They exist within the astral body of a person, and when activated they become the force structure of the mystical experience.

Alchemy: The Telenomic Process of the Universe 1973

SUBJECT The Alchemical Process

SYMBOL EVOCATION Traditional Western Magic

During the Middle Ages, the magical practices of ancient Egypt, Greece, and Rome became codified as alchemy (the power and techniques of universal transformation) with the study of the Qabalah as its energy source. This is a perfect analogy of the way Christianity became the creative extension of Judaism. However,

alchemy, then at its mature power, was considered just another Gnostic heresy, and the personal practice of it as an example of blasphemy. The distinction between magic and religion that was accepted by the medieval world was neatly summed up in 1920 by the synoptic chronicler of the occult Lewis Spense when he wrote, "It has been that religion consists of an appeal to the gods, whereas magic is the attempt to force their compliance." This is why alchemy is often called the confused precursor of the modern sciences of chemistry and physics—which it is not. Science appeals to the myth of invariance in nature (the "laws" of nature) in order to euphemize out of existence the gradual hubris as a result of attempting a complete control of nature (never the intent of alchemy). In a certain sense, both chemistry and physics could be viewed as failed forms of alchemy.

When Leonardo da Vinci (1452–1519) separated alchemy into what we now call art *and* science, he not only began the Italian Renaissance and the modern world, but he also discovered a way to keep the enterprise of magic alive right under the nose of the church. The price that was paid by the rest of humanity was: (1) traditional magic had to go underground into secret organizations that became the world of the occult—the hidden; and (2) over the next 500 years, there occurred a very unhealthy separation between the intellect and the passions at the societal level. The operating nomenclature of alchemy as it applies to the major substances of transformation are: (A) the Body, (B) the Soul, and (C) the Spirit, which were rendered as mass, consciousness, and energy during the International Gothic period and into the Renaissance. The Church considered the Body, the Soul, and the Spirit to be its exclusive property, and its obvious attempt at the theological neutering of these sacred concepts into the secular forms simultaneously accomplished two tasks: (1) it gave science, a new and fast-rising bureaucracy of learning and authority, something of its own to chew on besides the Church's authority; and (2) allowed the Church the leverage to quietly push alchemy off the stage of knowledge and into oblivion— or at least that is what it thought that it did.

The final paroxysm of tension between thinking and feeling, which spiked at the end of the 19th century, was eloquently recorded by the philosopher/historian Sigfried Giedion, in *Space, Time, and Architecture: Growth of a New Tradition* (1941–67). Ostensibly a polemic for modernism in architecture, it became, for me, one of the major influences in the current revival of alchemy because it documents the transforming power of a willful and impassioned vision for a present and future world.

Utopia: Time Cast as a Voyage-History 1974

SUBJECT The Dynamics of the Intentional Community

SYMBOL EVOCATION Heaven on Earth

Utopia is essentially the alchemical task of resolving consciousness as a manifestation of collective will with consciousness as a manifestation of one's immiscible self. Utopic space is the bringing together of the temporal ecstasy of the imagination—the control of the will as pure becoming that is morality—with the atemporal dream of reason—the freedom of the will as pure being that is transcendence. The structuring symbol of utopia is the breathing out and breathing in of the universe. The feminine breath is the breathing out, the great release, when the one falls instantly and without effort into the many. This is the breathing out that gives form—*eidos*—to matter—*hyle*. The masculine breath, the breathing in, is the long and arduous struggle back from the many to the one.

The path of utopia unfolds in a non-oppressive environment free from all power structures, whether they are hierarchies, holiarchies, or heteroarchies. The form of the utopic path is expressed as the major fractal of the manifest universe—the logarithmic spiral. The spiral path, composed of an infinite number of equiangular sections, makes an infinite number of revolutions around the one as it moves closer and closer to the one—also known as the source, the urgrund, and divinity. Utopia is the path, the moving ever toward the one, but never arriving. This is because utopia is a societal imperative. If the path actually arrived at the one it would lose the necessary socially occurring aberrations of the utopic, of which there are four. Each aberration exists as a vector subpath within the larger logarithmic spiral. These subpaths build tension and create energy within the system; however, their control is crucial because if the tension they produce is not harvested, the entire path will veer off its utopic direction and may well suffer a collapse into one of the boundary, or non-utopic, spaces, which would then suddenly become dominant.

The non-utopic spaces are: (1) *Eutopia*, in which life is lived in direct relation to the mystical experience and any stake in, connection to, or responsibility for the common good is abdicated. In this space the ego believes that it has become God; its vector leads directly to the one source of all. (2) *Kakatopia*, or dystopia, in which lives are lived in the knowledge of their mutual alienation, in mutually repellent spaces. This is the literal bad place and space; its vector continues the initial falling of the one into the many beyond its necessity. (3) *Kenotopia*, in which lives are lived in a space of comfort and ignorance, free of stress, striving, or goals. This is the space of kitsch; its path is a circle, without any angular tension. The circular vector of kenotopia can occur at any fixed distance from the one, depending on when the life veered off the true path of utopia; this accounts for different levels of taste even in the realm of kitsch. (4) *Oligotopia*, in which a group of lives develops a system by which they can leave the path of utopia and enter kenotopia en masse. This is the space of the bureaucratic; its vector veers away from the one until it is stopped when it runs into a pre-existing kenotopic space.

The Thanaton III 1989 (see page 22)

SUBJECT The Third Visitation of Quazgaa Klaatu.

SYMBOL EVOCATION The Earth-Mother as a Tower of Tortoises Supporting the World.

On December 31, 1988, at 10:37 p.m., while giving a talk on the sidewalk outside 500 Boylston Street in Boston, I was visited by the alien Quazgaa Klaatu, who manifested as a body of light. In a photograph taken by Steve Moskowitz, who was attending the New Year's Eve event, a bright nimbus covers my entire body and my seven chakras. This was the third visitation of Quazgaa Klaatu. The first was on September 13, 1951, in Los Angeles; the second was on January 25, 1967, in South Ashburnham, Massachusetts. In both earlier arrivals, Quazgaa Klaatu appeared in a humanoid mode, as a one-meter-high reptilian-featured hermaphrodite who communicated telepathically.

On its third arrival, Quazgaa Klaatu communicated with me by making direct contact with my chakra system. I was left with the knowledge of how to (1) link life to death in a continuous experience; (2) utilize the resulting thanatonic energy to travel faster than the speed of light, turn matter into consciousness and back again, alter evolution at will, and exist simultaneously at every moment of time; and (3) move the entire universe into the fifth dimensional realm and say when in history it is possible for this to happen.

I also received other information that I could not understand. Since this information was given to me directly but not for me per se, it must be communicated to others who may be better prepared than I to receive it, which is why I was also shown how to make this painting. *The Thanaton III* is a psychotronic—or mind-matter interactive—device. It is activated by approaching the painting, stretching out your arms, touching the upright hands, and staring into the eye. When you do this, new information will come to you through the active use of the divine proportion, which is the proportion of life connecting to death.

Xanatopia 1995

SUBJECT The Utopic Space of Pantisocracy.

SYMBOL EVOCATION Lucid Dream Composition of *Kubla Khan: Or a Vision in a Dream*. Homage to Samuel Taylor Coleridge.

In 1794, the Romantic poet and visionary Samuel Taylor Coleridge (1772–1834)—who was enthralled with William Godwin (1756–1836), the father of political anarchism and a proponent of communal living—met the poet Robert Southey (1774–1843), who, like many Romantics, was also captivated by Godwin's radical idealism. Very soon after their meeting, Coleridge and Southey dove into the planning of a utopian community, Pantisocracy. Its specific location was to be an island in the Susquehanna River in Pennsylvania, which they planned to remake into a *vesica piscis* (fish bladder) shape. Although the two poets were seriously working on making Pantisocracy a reality, soon enough it became clear that there were insurmountable problems and it was not going to happen. But the image of a utopic, wondrous land did not lose hold in Coleridge's mind.

In 1797, sometime between July 4 (the twenty-first anniversary of the Declaration of Independence of the United States) and July 14 (the eighth anniversary of the Fall of the Bastille and the beginning of the French Revolution), Coleridge wrote "Kubla Khan." More correctly, the poem was presented to him in totality in a three-hour dream. This was an esemplastic event, in which Coleridge was aware that he was dreaming and was willing to suspend his disbelief in order to interact with the imagery of his dream. Today this would be called lucid dreaming. The vision began when Coleridge, an inveterate armchair traveler, happened to be reading *Purchas His Pilgrimes* by Samuel Purchas (ca. 1577–1626), a compiler of travel writing, and came across the sentence "Here the Khan Kubla commanded a palace to be built, and a stately garden thereunto. And thus ten miles of fertile ground were inclosed with a wall." At that moment, Coleridge fell into a deep sleep and instantly began to dream in the most vivid manner. He endured a forced REM cycle, induced no doubt by a combination of his normal dosage of Boston opium (laudanum with a shot of sulfuric acid) plus a prescribed anodyne (alcohol, ether, and ethereal oil). When he awoke, Coleridge had enough material for a poem of three hundred lines, all pre-composed, "in which all the images rose up before him as things, with a parallel production of the correspondent expressions, without any sensation or conscious effort" (as the notes accompanying the publication of the poem put it). He immediately began to write it all down but was interrupted by the visit of a man who had come on business. He owed the man a large debt. When Coleridge returned to his work after more than an hour, he realized that he had lost from his waking memory all but a vague remnant of his vision and the few lines that he had been able to transcribe, which are now the poem "Kubla Kahn," about 54 lines.

THE ANIMISTIC LANDSCAPE

Andriote, John-Manuel. "The History, Science and Poetry of New England's Stone Walls." *Earth*, May 19, 2014.

Cameron, Kenneth Walter. *Emerson and Thoreau as Mythologists, or, Building One's Spiritual World.* Hartford, CT: Transcendental Books, 1997.

Denton, William, and Elizabeth M. F. Denton. *The Soul of Things; Or, Psychometric Researches and Discoveries.* Boston: William Denton, 1873–74.

Durant, Sam. "Build Therefore Your Own World," exhibition proposal to Blum & Poe, 2016, reprinted in Sam Durant, *Build Therefore Your Own World.* Los Angeles: Blum & Poe and Black Dog, 2017.

Elliot, Clare Frances. "William Blake's American Legacy: Transcendentalism and Visionary Poetics in Ralph Waldo Emerson and Walt Whitman." PhD diss., University of Glasgow, 2009.

Emerson, Ralph Waldo. *Nature.* Boston: James Munroe and Company, 1836.

Hall, David D. *Worlds of Wonder, Days of Judgment: Popular Religious Belief in Early New England.* Cambridge, MA: Harvard University Press, 1969.

Hardack, Richard. *"Not Altogether Human": Pantheism and the Dark Nature of the American Renaissance.* Amherst: University of Massachusetts Press, 2012.

Kimmerer, Robin Wall. *Braiding Sweetgrass: Indigenous Wisdom, Scientific Knowledge and the Teachings of Plants.* Minneapolis: Milkweed Editions, 2013.

McKanan, Dan. *Eco-Alchemy: Anthroposophy and the History and Future of Environmentalism.* Oakland: University of California Press, 2018.

Merchant, Carolyn. *Ecological Revolutions: Nature, Gender, and Science in New England.* Chapel Hill: University of North Carolina Press, 1989.

Storm, Jason Josephson. *Myth of Disenchantment: Magic, Modernity, and the Birth of the Human Sciences.* Chicago: University of Chicago Press, 2017.

IS SPIRITUALISM TRUE?

Britten, Emma Hardinge. *Modern American Spiritualism: A Twenty Years' Record of the Communion between Earth and the World of Spirits.* New York: Emma Hardinge Britten, 1870.

Buckland, Raymond. *The Spirit Book: The Encyclopedia of Clairvoyance, Channeling, and Spirit Communication.* Canton, MI: Visible Ink, 2001.

Colbert, Charles. *Haunted Visions: Spiritualism and American Art.* Philadelphia: University of Pennsylvania Press, 2011.

Davis, Andrew Jackson. *The Principles of Nature: Her Divine Revelations and a Voice to Mankind.* New York: S. S. Lyon and W. Fishbough, 1847.

Denton, William. *Is Spiritualism True?.* Boston: William Denton, 1874.

Dexter, John W., and George T. Edmonds. *Spiritualism.* New York: Partridge and Brittan, 1853.

Dods, John Bovee. *Six Lectures on the Philosophy of Mesmerism, Delivered in the Marlboro Chapel, Boston.* New York: Fowler and Wells, 1850.

Evans, Arthur. *Witchcraft and the Gay Counterculture: A Radical View of Western Civilization and Some of the People*

It Has Tried to Destroy. Boston: Fag Rag Books, 1978.

Gunning, Tom. "Haunting Images: Ghosts, Photography, and the Modern Body." In *The Disembodied Spirit*, exh. cat., edited by Alison Ferris. Brunswick, ME: Bowdoin College Museum of Art, 2003.

Horowitz, Mitch. *Occult America: The Secret History of How Mysticism Shaped Our Nation*. New York: Bantam Books, 2009.

Knapp, Krister Dylan. *William James: Psychical Research and the Challenge of Modernity*. Chapel Hill: University of North Carolina Press, 2017.

Kuzmeskus, Elaine M. *Connecticut in the Golden Age of Spiritualism*. Charleston, SC: History Press, 2016.

Moore, William D. "'To Hold Communion with Nature and the Spirit-World': New England's Spiritualist Camp Meetings, 1865–1910." In *Perspectives in Vernacular Architecture, 7, Exploring Everyday Landscapes*, edited by Annmarie Adams and Sally MacMurray. Knoxville: University of Tennessee Press, 1997.

Rhine, Joseph Banks. *Extra-Sensory Perception*. Whitefish, MT: Kessinger, 2007.

Shattuck, David James. *Spirit and Spa: A Portrait of the Body, Mind and Soul of a 133-Year-Old Spiritualist Community in Lake Pleasant, Massachusetts*. Greenfield, MA: Delta House, 2003.

Tumber, Catherine. *In Search of the Higher Self: Feminism and the Birth of New Age Spirituality, 1875–1910*. Lanham, MD: Rowman and Littlefield, 2002.

TEACHING UTOPIA

M. Arauz, Rachael. "The Best Ideals of Socially

Useful Living: Haystack, 1950–60." In *In the Vanguard: Haystack Mountain School of Crafts, 1950–1969*, edited by M. Rachael Arauz and Diana Jocelyn Greenwold. Berkeley: University of California Press, 2019.

Bellamy, Edward. *Looking Backward, 2000–1887*. Boston: Ticknor and Co., 1888.

Cameron, Kenneth Walter, Amos Bronson Alcott, Ralph Waldo Emerson, and Henry David Thoreau. *Concord Harvest: Publications of the Concord School of Philosophy and Literature, with Notes on Its Successors and Other Resources for Research in Emerson, Thoreau, Alcott and the Later Transcendentalists*. Edited by Kenneth Walter Cameron. Hartford, CT: Transcendental Books, 1970.

Delano, Sterling F. *Brook Farm: A Retrospective and Celebration*. Villanova, PA: Villanova University, 1991.

———. *Brook Farm: The Dark Side of Utopia*. Cambridge, MA: Belknap Press of Harvard University Press, 2004.

Francis, Richard. *Fruitlands: The Alcott Family and Their Search for Utopia*. New Haven: Yale University Press, 2010.

———. *Transcendental Utopias: Individual and Community at Brook Farm, Fruitlands, and Walden*. Ithaca, NY: Cornell University Press, 1997.

Hayden, Dolores. *Seven American Utopias: The Architecture of Communitarian Socialism, 1790–1975*. Cambridge, MA: MIT Press, 1976.

Jennings, Chris. *Paradise Now: The Story of American Utopianism*. New York: Random House, 2017.

Kinkade, Kathleen. *A Walden Two Experiment: The First Five Years of Twin Oaks Community*. New York: Morrow, 1973.

Kuhlmann, H. *Living Walden Two: B. F. Skinner's Behaviorist*

Utopia and Experimental Communities. Urbana: University of Illinois Press, 2005.

Laurie, Bruce. *Rebels in Paradise: Sketches of Northampton Abolitionists*. Boston: University of Massachusetts Press, 2015.

McCuskey, Dorothy. *Bronson Alcott, Teacher*. New York: Macmillan Company, 1940.

Muñoz, José Esteban. *Cruising Utopia: The Then and There of Queer Futurity*. New York: New York University Press, 2009.

Noble, Richard, ed. *Utopias*. Documents of Contemporary Art. London: Whitechapel Gallery, 2009.

Peabody, Elizabeth Palmer, Henry Perkins, Samuel N. Dickinson, James Munroe and Company, and Leavitt, Lord, and Co. *Record of a School: Exemplifying the General Principles of Spiritual Culture*. Boston: James Munroe and Company, 1835.

Ronda, Bruce A. *Elizabeth Palmer Peabody: A Reformer on Her Own Terms*. Cambridge, MA: Harvard University Press, 1999.

Schmidt, Leigh Eric. *Restless Souls: The Making of American Spirituality*. New York: Harper Collins, 2005.

Skinner, B. F. *Walden Two*. New York: Macmillan, 1948.

Steim, Marjorie. "Beginnings of Modern Education: Bronson Alcott." *Peabody Journal of Education* 38, no. 1 (July 1960).

VISIONARY ART HISTORY

Adams, Henry, and Marcia Brennan, *Modern Mystic: The Art of Hyman Bloom*. New York: Distributed Art Publishers, 2019.

Bookbinder, Judith. *Boston Modern: Figurative Expressionism as Alternative Modernism*.

Hanover, NH: University Press of New England, 2005.

Crow, Thomas. *No Idols: The Missing Theology of Art*. Seattle: University of Washington Press, 2017.

Davidson, Abraham A. *The Eccentrics and Other American Visionary Painters*. New York: E. P. Dutton, 1978.

Doss, Erika. "Visualizing Faith: Religious Presence and Meaning in Modern and Contemporary American Art." In *Coming Home! Self-Taught Artists, the Bible, and the American South*, edited by Carol Crown. Exh. cat. Memphis, TN: Art Museum of the University of Memphis, 2004.

Kornhauser, Elizabeth Mankin, with contributions from Patricia McDonnell. *Marsden Hartley: American Modernist*. New Haven: Yale University Press, 2002.

Morin, Francis. *The Quiet in the Land: Everyday Life, Contemporary Art and the Shakers*. Portland: Institute of Contemporary Art at Maine College of Art, 1997.

Osgood, Nancy. "Josiah Wolcott: Artist and Abolitionist." *Old Time New England*, Summer/Spring 1998.

Tuchman, Maurice, Judi Freeman, and Carel Blotkamp et al. *The Spiritual in Art: Abstract Painting 1890–1985*. New York: Abbeville Press, 1986.

This catalogue accompanies the exhibition *Visionary New England* presented at deCordova Sculpture Park and Museum from April 24 through September 13, 2020. The exhibition was organized by Sarah Montross, Senior Curator.

The Andy Warhol Foundation for the Visual Arts

HENRY LUCE FOUNDATION

This exhibition has been supported in part by the generosity of the Luce Foundation, the Andy Warhol Foundation for the Visual Arts, and the National Endowment for the Arts.

deCordova
Sculpture Park and Museum | t trustees

deCordova Sculpture Park and Museum
51 Sandy Pond Road
Lincoln, MA 01773
decordova.org

The Trustees of Reservations
200 High Street
Boston, MA 02110
thetrustees.org

The MIT Press
One Rogers Street
Cambridge, MA 02142
mitpress.mit.edu

Library of Congress Control Number: 2019915647
ISBN 978-0-262-04398-4

Produced by Lucia|Marquand, Seattle
luciamarquand.com
Designed by Zach Hooker
Edited by Kristin Swan
Typeset in Enigma 2 by Maggie Lee
Proofread by Laura Iwasaki
Printed in China by C & C Offset Printing Co., Ltd.

DETAILS

Except as noted, details derive from the plates, beginning on page 64.

Front cover: Caleb Charland, *A Color Spectrum with the Setting Sun, Bass Harbor, Maine (Color Separation with Three Black and White Paper Negatives)*

Back cover: Sam Durant, *Dream Map, Ursa Minor*

Vellum endsheets: Paul Laffoley, *The Visionary Point*; Josiah Wolcott, *Brook Farm with Rainbow* (fig. 1.8); Josephine Halvorson, *Broadsheet (Ring)*; Angela Dufresne, *Child of Nature*

Page 8: Hyman Bloom, *The Harpies* (fig. 1.2)

Page 28: Kim Weston, *Traditional*

Page 36: Candice Lin, *La Charada China*, installation view

Page 40: Michael Madore, *Labrador 2088*

Page 48: Angela Dufresne, *Demenstration*

Pages 62–63: Josephine Halvorson, *Broadsheet (Leaves)*

Page 131: Detail, Gayleen Aiken, *The Funny Happy Raimbilli Cousins, Music, Hobbies, Me—the Artist, Granite-Shed-Plants, Mills, Big Farm House in the Summer*